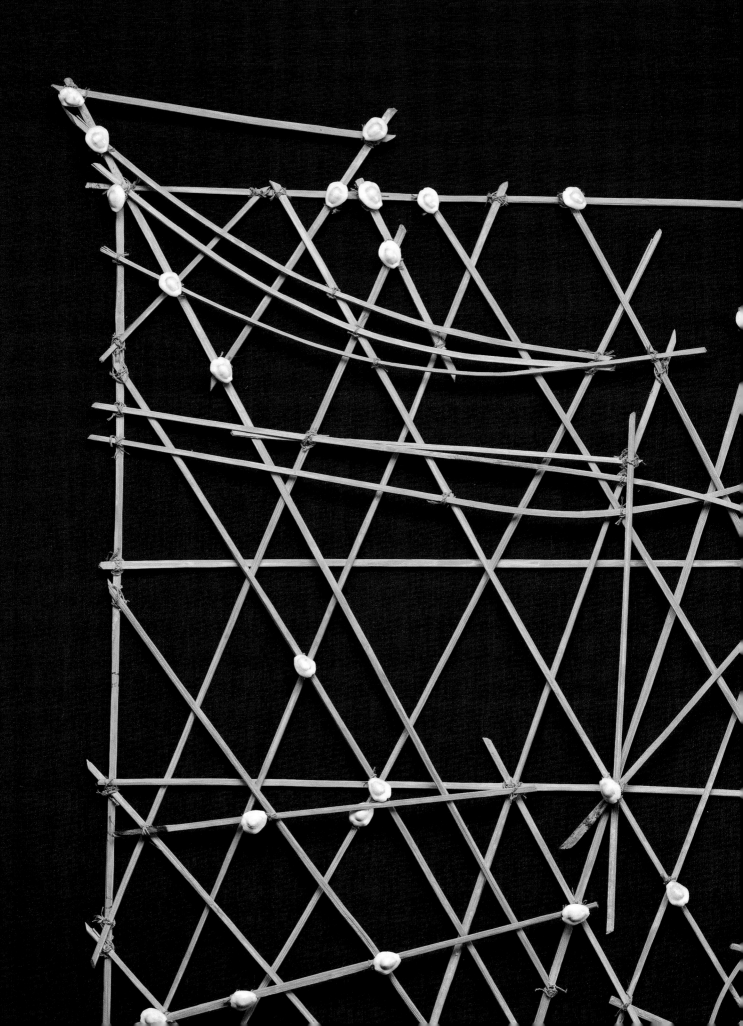

# From the South Seas

**MFA PUBLICATIONS** | **A DIVISION OF THE MUSEUM OF FINE ARTS, BOSTON**

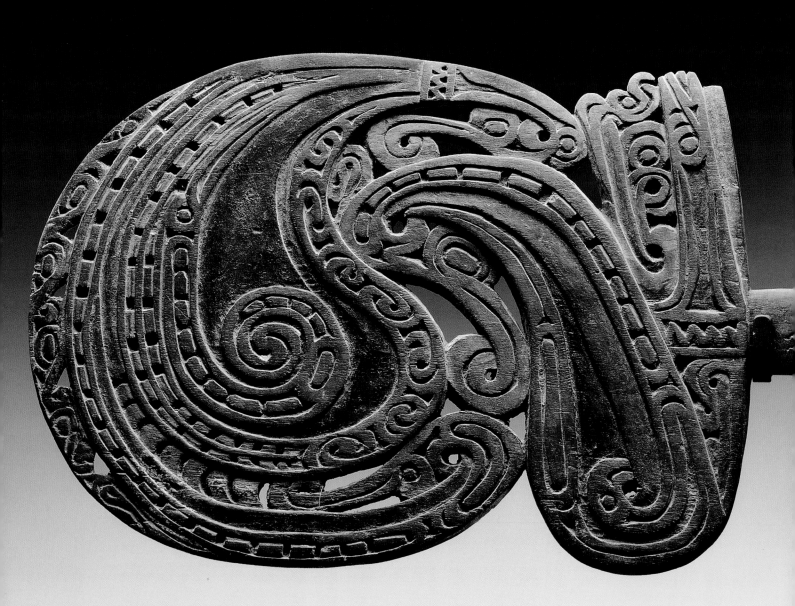

Oceanic Art in the Teel Collection

EDITED BY CHRISTRAUD M. GEARY

ESSAYS BY MICHAEL GUNN AND CHRISTRAUD M. GEARY

CATALOGUE BY WILLIAM E. TEEL WITH CHRISTRAUD M. GEARY AND STÉPHANIE XATART

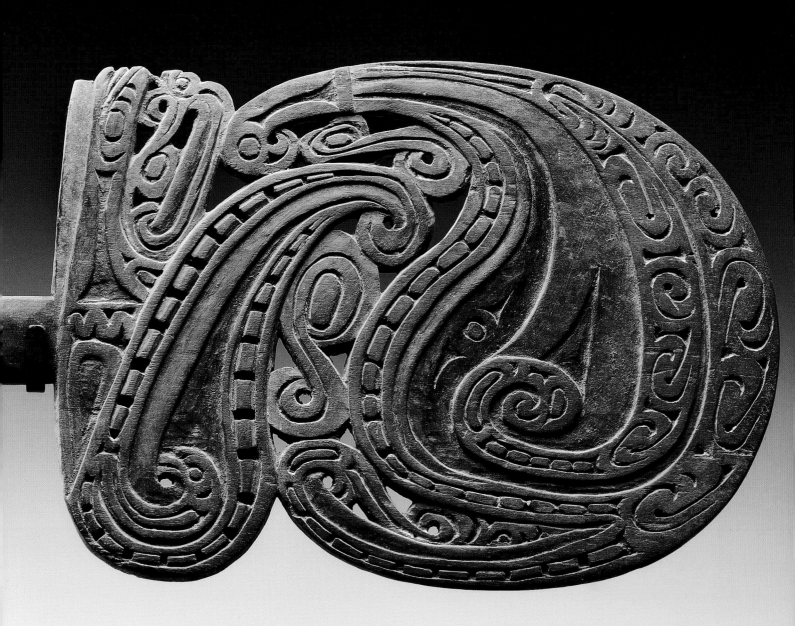

MFA PUBLICATIONS
a division of the Museum of Fine Arts, Boston
465 Huntington Avenue
Boston, Massachusetts 02115
www.mfa-publications.org

© 2006 by Museum of Fine Arts, Boston
ISBN 0-87846-697-5
Library of Congress Control Number: 2005938089

For a complete listing of MFA Publications, please contact the
publisher at the above address, or call 617 369 3438.

Front cover: *Kepong* or *ges* mask (detail of no. 58, p. 118)
Back cover: *Kavat* helmut mask (no. 55, p. 115)

All photographs of works in the William E. and Bertha L. Teel
Collection and the Museum of Fine Arts, Boston's collection are
by David Mathews / the Photo Studios, Museum of Fine Arts,
Boston. Photography © 2006 Museum of Fine Arts, Boston.

Trade distribution:
Distributed Art Publishers / D.A.P.
155 Sixth Avenue, 2nd floor
New York, New York 10013
Tel.: 212 627 1999  ·  Fax: 212 627 9484

FIRST EDITION
Printed in Italy
This book was printed on acid-free paper.

THIS BOOK IS DEDICATED

TO THE MEMORY OF

BERTHA LANDAU TEEL

# Contents

Director's Foreword     8

Fragments of History: Art from Oceania     11

    MICHAEL GUNN

From the South Seas:
Life Histories of Works in the Teel Collection     18

    CHRISTRAUD M. GEARY

Map of Oceania     32

Catalogue

    WILLIAM E. TEEL WITH CHRISTRAUD M. GEARY
    AND STÉPHANIE XATART

    1. Indonesia     36

    2. Melanesia: Western New Guinea     48

    3. Melanesia: The Sepik River Region     58

    4. Melanesia: Southeastern New Guinea     84

    5. The Melanesian Islands     104

    6. Micronesia     132

    7. Polynesia     138

Bibliography     152

Acknowledgments     157

Figure Illustrations     158

# Director's Foreword

Since our newly installed African and Oceanic galleries opened in 2003, hundreds of thousands of visitors have been able to admire the beauty of objects from sub-Saharan Africa and the South Seas — the region encompassing the Pacific islands that make up Oceania. On weekdays, schoolchildren sit in front of the cases and trace the bold forms of sculptures in their sketchbooks. Gallery instructors lead groups of children or adults on tours, and professors bring their students from nearby colleges and universities to hold classes in these spaces. The galleries have become an important and recognized part of the Museum's fabric.

William E. and the late Bertha L. Teel envisioned such a lively scenario when they generously began donating works from their collection to the Museum in 1991 and when William funded the position of the curator of African and Oceanic Art in 2003. They had been advocates of African and Oceanic art for decades in a metropolitan area whose venerable institutions seemed oblivious to these arts, and they had carefully and passionately assembled a systematic collection of great depth and aesthetic merit. It was Bertha who favored African objects, and William whose taste tended toward Oceanic art. It was Bertha who bought works with passion when she discovered them, and William who meticulously researched each object that caught his eye, before acquiring it. When Bertha passed away in 1995, William continued to build their legacy, and to this day he remains an active collector.

This catalogue, which follows a similar publication of the Teels' African holdings, highlights a selection of outstanding objects, the core of their Oceanic collection. The Teels have already donated some of the works to the MFA, and others remain promised gifts. Many of the objects are exhibited in the Museum's galleries and can also be admired on the Museum's Web site (www.mfa.org). As in the previous endeavor, William, a retired publisher, actively participated in the publication process — from the conception of the book to its final design. We are profoundly grateful to him.

*From the South Seas* is a labor of love, the result of a lifetime of collecting and studying Oceanic art. It celebrates William E. and Bertha L. Teel's achievement and shares their joy in Oceanic art with the larger public. We at the MFA are proud and grateful that the Teels entrusted the Museum with these beautiful objects and chose us to implement their unique vision.

MALCOLM ROGERS
*Ann and Graham Gund Director*
*Museum of Fine Arts, Boston*

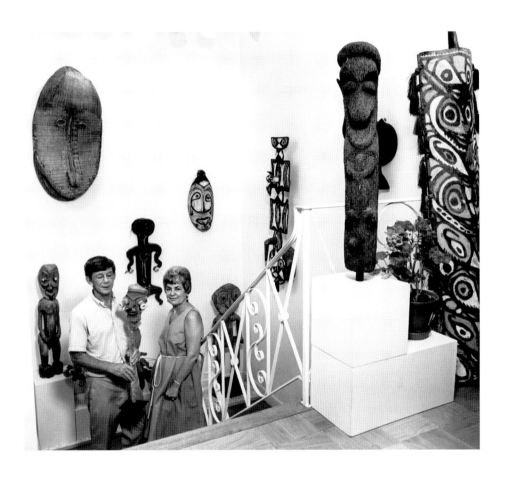

William E. and Bertha L. Teel
in their home, 1972

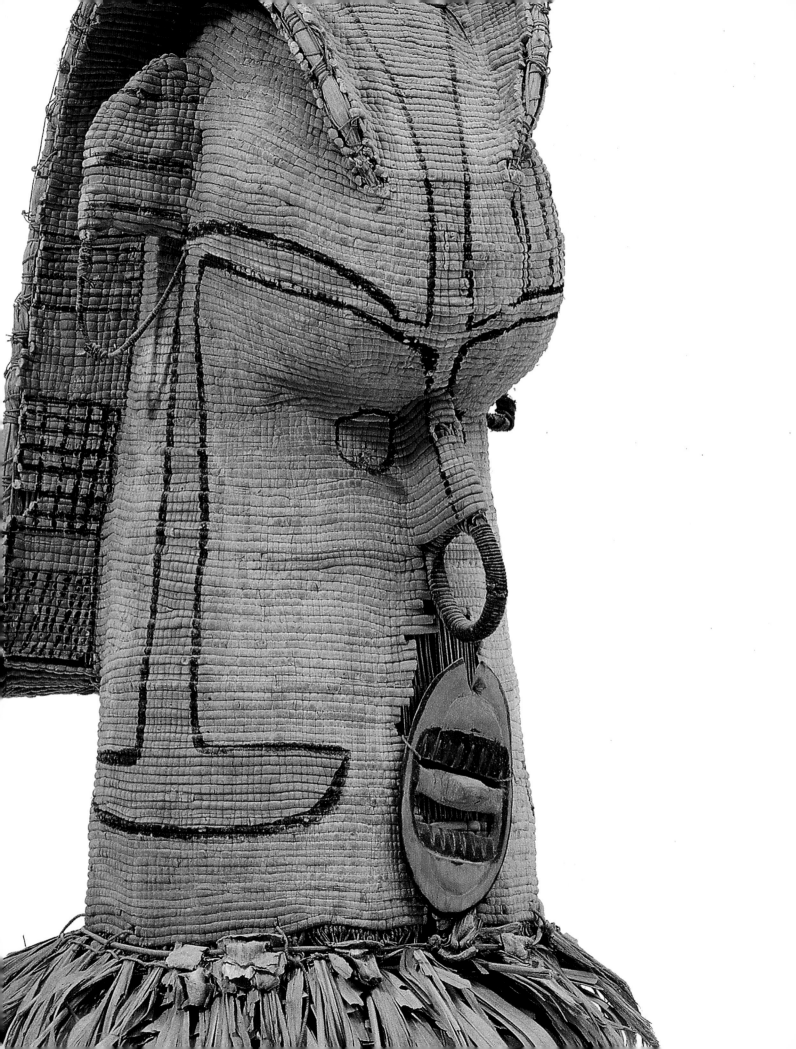

# Fragments of History: Art from Oceania

**MICHAEL GUNN**

Oceanic art is a mysterious realm for most Westerners. When we first encounter it in a gallery of a museum, we perhaps sense that there is something in these strange masks that is a little frightening. Nearby are clubs that look as though they mean business, and next to them are some unusual wooden objects that look like forks. None of them are what the Western viewer would call pretty, but the artistry is quite evident. The labels cite places such as the Solomon Islands, Kiribati, Fiji, and Vanuatu that sound like place-names in a storybook or a far-off world.

The vast region of Oceania in fact extends from the large island of New Guinea in the west, to New Zealand (Aotearoa) in the south, Easter Island (Rapanui) in the east, and Hawai'i in the north. Included in this watery realm are mountains almost sixteen thousand feet (five thousand meters) high, ancient remnants of the former continent of Gondwana, volcanic islands, atolls, and a hidden tropical paradise. About ten million people live in the region today. For the purposes of this catalogue, we are also interested in Island Southeast Asia, which consists of the Indonesian islands other than Bali and Java. There are between eight hundred and one thousand languages in the overall region, a statistic that gives some sense of the vast diversity of the peoples.

Each area in Oceania historically had its own art style. Some of these styles were restricted to a single valley, or even just one village. Others became widespread when dozens of different peoples adapted them as their own. Most styles probably started with a single creative individual whose representation of a concept was adopted by his or her people and then passed from one generation to the next. In some regions, objects surviving from ten generations ago are barely distinguishable from those made recently. In other areas, the inhabitants seem to have continually modified their art traditions. Generally, there are about 450 distinctly different sculptural art styles within the Oceanic region.[1] Some peoples worked with three or four styles; others used only one or two. Many groups had no sculptural arts and expressed themselves in noncollectable art forms such as poetry or face painting.

Perhaps the most important thing to understand about Oceanic art is that, in a tradition common to many cultures, objects were not made as "works of art" and were not produced for sale. Masks, sculptures, songs, dances, and body paint were created and used as part of the lives of the villagers and their neighbors. Some were produced to act as an interface between humans and the unknown forces that controlled their lives. Others were made to serve as documents to mark legal transactions between individuals or groups of people, or between a group of people and the world in which they lived. Still others were created for drama, for discourse, for love. Rarely, though, were they created to generate an income for an artist. Knowledge of the context in which works of art were made and utilized is crucial to our understanding of the objects in this book. This essay introduces the history of the Oceanic peoples, their relationships with one another and with the natural world, and the art traditions that developed to facilitate those relationships and to express the complex belief systems of the cultures.

## A World of Islands

Oceania is a world of islands, of small groups of people living in villages, growing and hunting their own food. In the past they depended entirely upon their own resources for survival. Often their greatest threat was not famine or disease but the warlike attitude of their neighbors or the people on the next island. The largest island by far is New Guinea — huge, mountainous, swampy, and covered in forest. People have been living there for at least sixty thousand years. They came to New Guinea from the west, from the eastern archipelago of what is now Indonesia. Prior to reaching this archipelago, they had come from mainland Southeast Asia, well before the people who now live in Asia arrived there. The main road through New Guinea was most likely the highlands. Fertile and free of malaria, this series of linked broad valleys separated by high passes gave access to lateral valleys that led down to the heavily forested but disease-ridden lowlands.

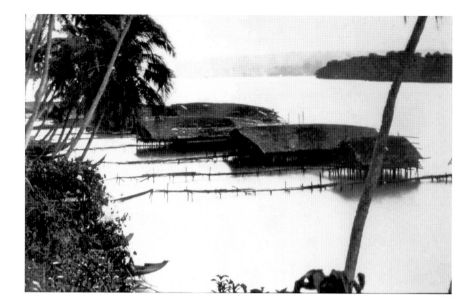

Fig. 1. Houses on stilts in a lagoon, Teluk Cenderawasih (formerly Geelvink Bay), Papua Province (formerly Irian Jaya), Indonesia, about 1880

Opposite:
Fig. 2. Inside a men's house in Kambot village, Middle Sepik region, Papua New Guinea, 1929

Fig. 3. Exterior of a men's house in Kambot village, Middle Sepik region, Papua New Guinea, 1955

We do not know how many groups of people moved into New Guinea over the highlands route. Linguists discern several dozen main language groups or phyla, suggesting there were many waves of people moving into the Pacific region from the islands to the west. As the indigenous people kept no written records, linguistic evidence is one of the few ways we have of making some sense of possible migration patterns over tens of thousands of years.

The situation became less complicated about five thousand years ago when a very strong group of people speaking one or more Austronesian languages started to migrate south from Taiwan, displacing the languages used by the previous inhabitants of most of Southeast Asia. Eventually they moved in two different directions. One group headed west and reached Madagascar, off the east coast of Africa. Another group traveled east and, thirty-five hundred years ago, began to occupy coastal locations along the north coast of New Guinea.[2]

Evidence suggests they were not continuous voyagers, at least not in the early phase of their travels. They often established villages of houses that stood on stilts offshore, in shallow and protected bays (fig. 1). Most likely they developed relationships with the people who already lived on the shore, for they needed land to cultivate gardens. Many of these Austronesian-speaking peoples made pots, a tradition they maintained as they moved farther east. It seems likely that they settled in a location for a number of generations, until eventually one group would move further east along the coast to establish a new village. By the time they reached the eastern part of New Britain, New Ireland, the Solomon Islands, Vanuatu, and New Caledonia about three thousand years ago, they were a dominant force. Today, almost all the languages spoken on these island groups are Austronesian. In this region, the settlers developed a very distinctive style of pottery that is known as Lapita, after the village site on New Caledonia where this pottery was first documented by archaeologists in the mid-twentieth century.

At about the same time that this group was moving south into New Caledonia, another group of Austronesian-speaking peoples sailed upwind from New Caledonia across 850 kilometers of open ocean to reach Fiji, then moved on to Tonga and Samoa — all island groups that were totally uninhabited by humans. By this stage, they had developed the skills of both long-distance sailing and navigation, and over the next two thousand years they located and then settled all the habitable island groups in the Pacific Ocean, from Tahiti in central Polynesia to Easter Island in the far east and Hawai'i in the north, reaching New Zealand in the south about eight hundred years ago. The peoples we now know as the Polynesians are all those living in the islands of the open Pacific that had been uninhabited before the Austronesian-speaking voyagers found them.

Of course the Austronesian settlers who inhabited Tahiti were not the same as those who took over much of New Ireland, who in turn were quite different from those who now live in the islands off the north coast of the far western part of New Guinea. More than a hundred generations separate the Aus-

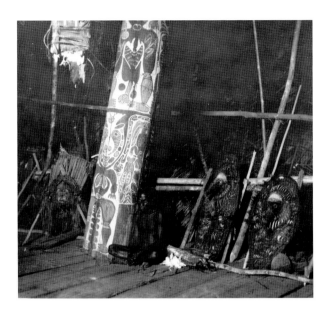

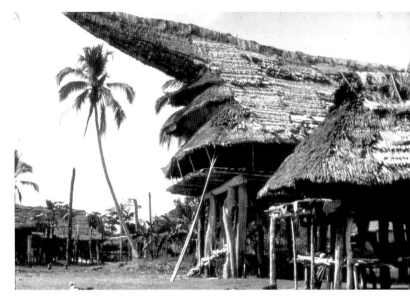

tronesian settlement of these regions, but their languages are closely linked, much as all the Latin-based languages in Europe have strong correlations. The inhabitants of Polynesia are, in fact, so closely related that today they refer to each other as cousins, or big brother and little brother. When Captain Cook left Tahiti in 1767, he took with him a priestly young Tahitian man who was able to speak with the very surprised Maori in New Zealand when he arrived there several months later. Further west, the language relationships are more complicated, for a longer period of time has elapsed, and in Island Melanesia the Austronesian-speaking people had to form relationships with the inhabitants who already lived there.

## The Life Force and the Ancestral Realm

Although the vast majority of people living in the Oceanic world did not develop writing as a means of documenting the transactions of their lives, they did live within a legal framework that each society adapted for itself. People or family groups owned land and passed on ownership of their land to the next generation. There were many ways of establishing ownership of this and other property, and some of those ways involved the creation of objects to commemorate a significant person in the history of a family. We tend nowadays simply to label these works of art as ancestor figures, without really thinking of the context that led to their creation.

In many cases, the ancestor would have been a strong male (or, in some cases, female) leader, someone who es-

tablished the presence and validity of his people on a piece of land — be it a valley in the New Guinea highlands or an entire island in a remote part of Polynesia. After a number of generations, the active memory of an ancestor loses its connection with the living people — there is no one alive who can remember him. But because the memory of a founding ancestor is an important organizing focus for the community, the people tend to remember him for the life force from which he came. For instance, if a man's essential life force was derived from a shark, then after four or five generations his descendants begin to remember him as a shark rather than as a human. In many Oceanic societies, a person's life force takes precedence over what we think of as personality.

Honoring an ancestor by creating an image or emblem of him (or her) — for example, a sculpture, painting, or dance movement — was the main means by which a family or even larger group of people could establish and reestablish its claim to a piece of land, and could renegotiate its ongoing relationships with its neighbors. When such an image was integrated inside a house where men gathered, along with other ancestor images, a powerful statement was created, and visitors were very aware of the strong historical claims that their hosts had upon the land, its people, and its productivity (figs. 2, 3).

Fertility was and still is a main concern of people living in Oceania, for without fecundity there is no food and no future generation. Humans have never been able to completely understand the power that enables life to continue one generation after another, and there has always been a degree of

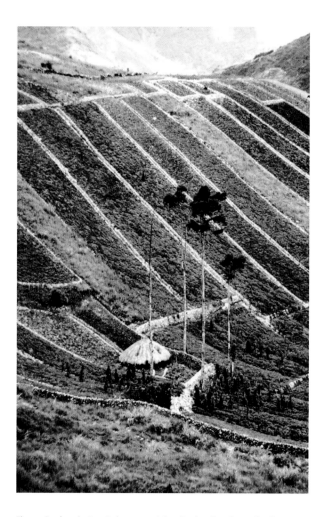

Fig. 4. Gardens in New Guinea mountains, Dani region, Papua Province (formerly Irian Jaya), Indonesia, 1989

strength of the life force through ritual activity, which ranges from garden magic to scarification and initiation. This idea has never been centralized under the control of a single authority, as global religions have been. As a consequence of this freedom, there is an almost bewildering variety of interpretations throughout Oceania of the interaction between the life force and humans.

Gardeners in Oceania became experts in the art of cultivation. Some of the earliest gardens on earth were created in the highlands of New Guinea about nine thousand years ago (fig. 4). Hunters developed skills that continue to amaze outsiders with their extraordinary sensitivity to their environment, their ability to track animals, and the fact that they take only what they need. Generally, the intimate relationship with the environment that was found among many Oceanic peoples included an understanding that humans were only one manifestation of the life force among many — that every tree, every animal, and every bird had a life. Beyond this, they also recognized that there were many forces that were not visible to people and yet could influence their lives in many unpredictable ways. Some of these forces Westerners loosely refer to as "spirits," because often we do not understand what the villagers try to tell us. Many of the early Christian missionaries did not appreciate the traditional beliefs of the people, and a large proportion of missionaries who work among Oceanic cultures today still do not. They misinterpret "spirits" as "devils" or "heathen gods" and consequently work to kill off the villagers' sensitive understanding of the environment.

The truth of the matter is that many Oceanic peoples had come to a reasonably balanced working relationship with their world long before Western belief systems entered their lives. This relationship often entailed an interaction with unknown forces, and part of this interaction involved a medium such as an art object that was created to personify or to help visualize these unknown forces. Significant works of art usually were created for an episode of critical transition, such as when the responsibility for maintaining the balance of the environment was passed from one generation to the next. This

mystery involved in the process of reproduction. But people everywhere have long been aware that they are part of the process of life, and most have been alert to the fact that their very existence depends upon their ability to encourage life to perpetuate. Many of the more persistent ideas that developed within the Oceanic world were those concerned with fertility and growth.

Interestingly, the basis of the Australian Aboriginal concept of "The Dreaming" is also found in many parts of New Guinea and Island Melanesia where people have been living for tens of thousands of years. Today, in the lingua franca of Tok Pisin (Bird Talk) in Papua New Guinea, the root of this idea is known as *masalai*. Central to this concept is the recognition that there are special places in the land that are sources of life, and that people are responsible for maintaining the

period is generally known as initiation and usually involved two groups — leaders and initiates. The leaders were the adult men who knew their world and its uncertainties, but who also knew the history of their people and how they had managed to survive for generations in a swamp or mountain valley or coral atoll. The initiates were the next generation of leaders, boys who knew something of life, such as how to fish and hunt, but who generally knew nothing of women, nothing of their people's history, and nothing other than rumors about the life forces that surrounded them, ready to crush them when they dropped their guard.

Initiation was often a very frightening occasion. The boys were secluded for months beforehand, separated from their mothers and sisters, then kept in the company of men and the stories of their people. When the men judged the boys to be ready, they prepared a dramatic and personified interpretation of the life forces that continually threatened their existence, and when the night of the initiation finally arrived, the boys were beaten by some very strange beings — men wearing bizarre masks representing one or more of the forces that surrounded their lives. Some of these forces may have been crocodile spirits, for in certain parts of New Guinea men and crocodiles can share the same life force. Others may have been birds carrying strange messages. Many others represented spirits or life forces that have no equivalent in the English language. This was the process by which boys became men. In some cases, the masks survived, were eventually collected by traders, and were sent on their way to the Western art market.

### Works of Art Then and Now

Some objects that we display as art were merely images from the past, re-created to provide a visual body to a history or story that validated a people's existence. But in other parts of Oceania, the people found a way to somehow take a dead person's spirit or life force and induce it to take up residence in a wooden or stone sculpture. We do not know how this was achieved, or what is actually trapped inside the sculpture, but many people who work professionally with art objects from Oceania have found — through unusual happenings in their interactions with the objects — that a small percentage of them are still activated, still "lively."

Other objects seem to contain life forces that are not human but are tangibly "lively" in inexplicable ways. Most of these lively works date from the precontact period, the time when people created works of art for their own purposes and had no idea that any people existed other than those in their valley or in their island group. Such objects usually were made very carefully, with every mark and shape deliberately carved into their bodies. These are the works that were labelled "gods" or "spirit figures" by Westerners who sought to destroy their influence upon the people who created and owned them. Very few of these remain in the villages of Oceania; most are now in museums, with one or two in the hands of private owners. Although the liveliness endures in many of these art objects, the nature of this power is unknown. Generally, the works are treated as visual objects that are relics of a forgotten past, fragments of history, and trophies of the wealthy. The force of Christianity has crushed any serious attempt at understanding their nature, and those who knew how to work with their power are long dead.

Nonlively pieces such as combs or mats, fish hooks or adze blades, baskets or fish traps can be some of the most surprising objects in terms of their aesthetic composition. These are things that people spent countless careful hours creating, and they can be very beautiful. Like all utilitarian objects, they can be endowed with attributes that are not at all obvious to an outsider. A special fish hook, for example, will always catch a fish if used by one man, yet slip off the line when used by another. A special comb can help win a love when all the others have proved useless. Some objects such as baskets can be astounding in their beauty, a fence can be planted with a very organic sense to it, and a house can be built so that the view over the surrounding bay is actually enhanced by its integration with the landscape. Outsiders have almost wept for

joy when walking along a path around the side of a mountain and being surprised by a beautiful, compact village with houses that look as though they had grown there like mushrooms.

The art objects we now see and try to understand within Western art museums are only a small proportion of the artistic achievements of the Oceanic peoples. Many objects were intentionally destroyed after they were used, for their purpose may have been to express or illustrate the crisis of a particular moment, such as the death of a leader. After that moment passed, the works became a relic of something that needed to be forgotten. Other objects were used many times; taken out and cleaned, then freshly painted, they would be used again and again in a rite that had its origin hundreds or perhaps thousands of years ago. These ancient works were most sought after by missionaries and other emissaries of the Western world. Some ended up in museums or private collections, but most were burned at the stake as symbols of a world to be discarded. What is left today is a mixture of the old and the forgotten — survivors, shells empty of their meaning.

Many of the objects now in museums, however, were created long after their people were converted to Christianity. Some were made to show the outside world what they had been as a strong and independent people — images of an almost forgotten past. These art objects still have validity, for they represent a people in the process of change, with one foot in their traditions, the other groping for a future that may have some meaning for them. But the great works of Oceanic art are those that were created when the people made them for their own purposes, to help them understand their own world and their place in it.

We have many ways of looking at a work of art. Primarily, an Oceanic object can be attributed to a place, or at least to a region, on the basis of style. For example, a work from northern New Ireland shares many characteristics with other works from that region. But identifying an object with a region by style does not tell us anything about why the work was created. Most figurative pieces were made for some form of ritual context. In northern New Ireland, for instance, the ritual

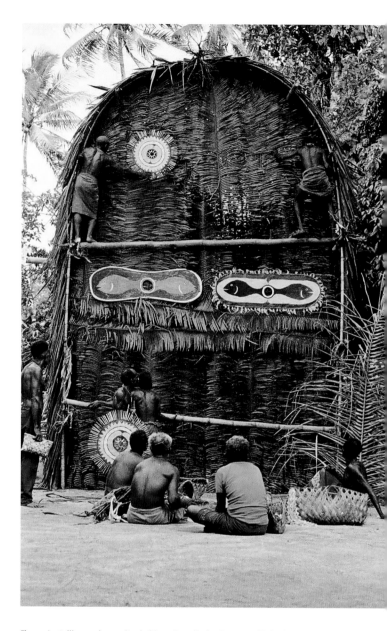

Fig. 5. Installing *malagan* ritual objects in a display house, Pekinberiu village, Tabar, New Ireland, 1984

tradition known as *malagan* was the dominant tradition and was used to honor the recently dead. A person who owned the rights to use *malagan* could commission one or more works of art for display in ritual context, to be publicly seen to honor the dead of the clan he or she had married into. These art objects may be figurative or other types of sculptures, or masks that enabled men to perform various ritual functions. But *malagan* was not the only art-producing tradition in this region, and many objects thought to have been used in this context

may well have been associated with some of the other non-sacred art-producing traditions such as *kipang* or *bual*. Luckily, these cultural traditions are still practiced, and we are able to travel to New Ireland and gain a clearer understanding of these customs and the art connected with them from the people who live there today (fig. 5).

The same is true of many of the art traditions that were used in other parts of Island Melanesia, such as New Caledonia, Vanuatu, the Solomon Islands, Manus, and New Britain. Perhaps 90 percent of the art traditions that were in use 120 years ago have now died out, but the people living in these places have stories and songs and other links to the past that can help us understand something of the ways of the people who lived five generations ago. This also is the case with the island of New Guinea. Much knowledge has been lost, but in some regions contact with Western ideas occurred within our lifetimes, and we are able to talk with the old people who are now accessible to us and reach some form of understanding about the context of the early works of art.

We are fortunate in that many of the art-producing regions of Oceania have been relatively well documented by Westerners who lived with the people for some length of time. The region on the northwestern tip of New Guinea, today known as Teluk Cenderawasih but previously known as Geelvink Bay, is a well-studied area. So are the Asmat region on the southwestern coast of New Guinea and parts of the Papuan Gulf. Much of the Sepik region has been well documented, but other areas are poorly known; in many places, the art traditions died out shortly after contact with the West. Anthropologists today record what they can, but their interests are often focused on Western concerns such as gender, or how the people adapt to change and to the influence of the outside world. The world

that existed when the great works of art were created is now, in most places, a forgotten world. What was known is dying with the old people.

Polynesia is in some ways the most documented region of Oceania, but in other ways this documentation can be seen as a reflection of Western eyes looking at a foreign world. The earliest missionary accounts that are of value to us are mainly those of "idols" that were burned or taken away. We are lucky if we find a name of any kind attached to a work of art; more usually when we encounter an object in a museum, we can say it is a Marquesan stilt step, for example, because there are hundreds of similar stilt steps from the Marquesas Islands now in museums around the world. But when we ask what the figures represented, we still find only very elusive answers.

Much of the mystery remains. But thanks to researchers such as anthropologists, linguists, art historians, and ethnobotanists who have spent years living with village people in remote areas, we know much more today about the effect that the material world had on life in Oceania. It is only by learning about the belief systems and cultural practices of their makers that we can begin to understand the true nature of the works of art illustrated on the following pages. This essay has touched on some of these values and traditions as a backdrop for the objects, and the catalogue intends to indicate further tracks and paths through the outer layers of the mystery.

1. The best overview of Oceanic art to date is Kaeppler, Kaufmann, and Newton 1997.
2. For a comprehensive discussion of Austronesian voyaging and the prehistory of Oceania, see Kirch 2000.

# From the South Seas:
# Life Histories of Works in the Teel Collection

CHRISTRAUD M. GEARY

Oceanic objects now displayed as works of art in museums and private collections around the world acquired life histories of their own as they migrated from the South Seas to different settings abroad. Their journey usually began on an island, where skilled artists created them for use in contexts such as initiation ceremonies, funerals, or celebrations. The people who employed them endowed them with meanings, which could change over time even in the original settings. When Western collectors of many backgrounds and motivations acquired the objects by various means and removed them from their place of origin, they considered them curiosities, artifacts, or — at a later stage — unique works of art, depending on when, how, and for what purpose they appropriated them. In most instances, the objects' meanings shifted as they circulated in their new environments, moving from private collections to different types of museums and, at times, back again into private hands.[1] This essay focuses on the roots and routes of several important works from the Teel Collection and examines their journeys and changing significance as part of larger historical and cultural processes that shaped the world in Oceania and in the West.[2] Four stories about different ways objects migrated and acquired meanings not only illustrate particular biographies but also parallel trajectories of many other objects that left the South Seas. The objects now seem to live in a diaspora, similar to peoples who left, were removed, or were exiled from their homelands and spread around the globe forming their own new communities.

## Objects on the Move

The history of Oceanic works of art now in European and American collections began in the late sixteenth century when the first European vessels reached the South Pacific and seafarers brought objects back from these distant realms. Considered "curiosities" and odd, yet at times skillful, creations by their new owners, they often ended up in so-called curiosity cabinets of wealthy collectors — next to exotic biological and zoological specimen, sea shells, and fossils. Few of these early

Oceanic objects have survived into the present. The eighteenth century, the Age of Enlightenment, witnessed the grand voyages of explorers, culminating in the travels of the Englishman Captain James Cook, who visited the South Pacific three times between 1768 and 1779, before he was killed during a confrontation with local people on the island of Hawai'i (or Big Island). Cook's voyages served scientific purposes, and he took along eminent scholars who accumulated large collections — still curiosities — that are now among the earliest and most famous museum holdings from the Pacific.

In the nineteenth century the economic exploitation of the South Pacific intensified and the exodus of crafted objects increased. Crews of whaling ships brought back souvenirs and curious things. New economic opportunities attracted sailors, traders, and adventurers, who tried to make their fortunes. Sandalwood was the first valuable trade item, followed by *bêches-de-mer*, or sea cucumbers, marine animals that in dried form were in high demand as a delicacy in China. Finally copra — the dried meat of the coconut from which the coconut oil is extracted — appeared as a commodity; European merchants in the South Seas and South Asia developed this commercial product in the 1860s. Many trading companies existed now, among them the Hamburg-based Johan Cesar Godeffroy & Son Company. From the 1850s onward, Godeffroy vessels sailed the South Seas to trade in these profitable goods and, as we will see below, to gather artifacts.[3]

Objects from Oceania came through other channels, as well. Members of the London Missionary Society arrived in Tahiti as early as 1796 and from there moved further on to Pacific islands including Hawai'i and New Guinea. They confiscated and burned many ritually significant objects, "pagan idols" in their eyes, but also shipped artifacts back to England for educational and fundraising purposes in their home congregations. Dutch missionaries settled in northwest New Guinea as early as 1850, and Germans arrived in the Pacific in the 1880s. Just like their British counterparts, they began collecting objects for their congregations and small missionary museums. In their eyes, the objects, which had a certain

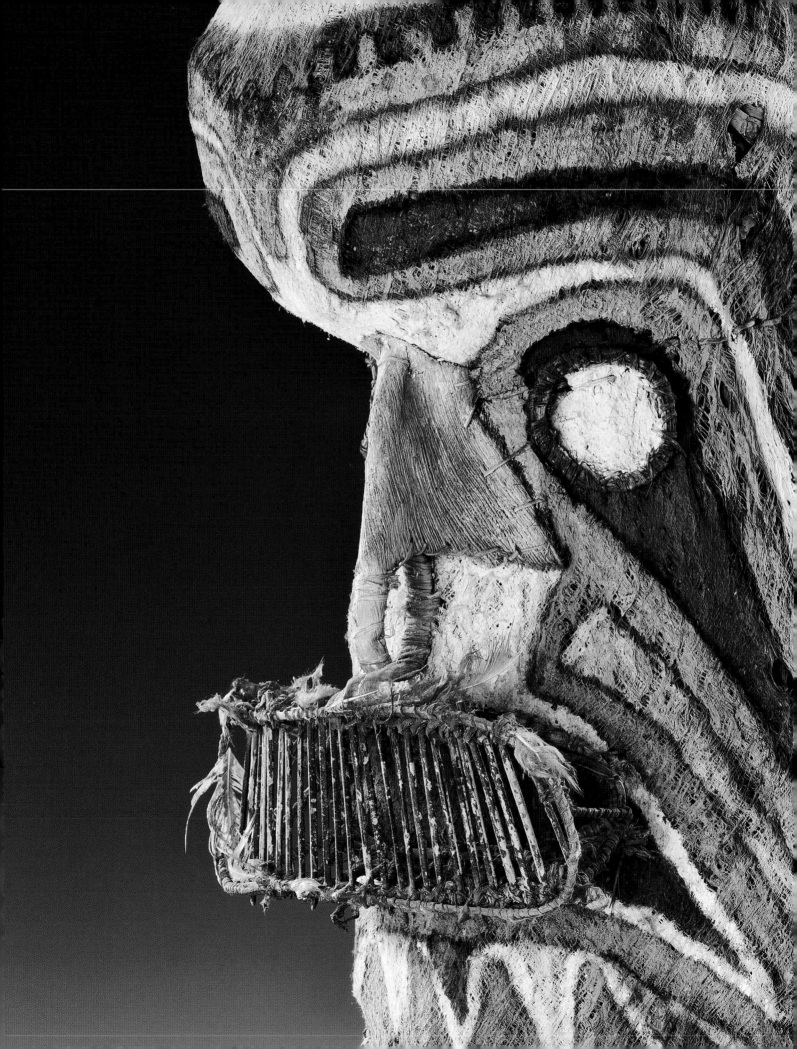

exotic aura, attested to the backward nature of the inhabitants and, when on display, helped them in their fundraising effort for the missionary work.

Movements of objects intensified after 1884, when — at the height of the European scramble for possessions in Africa and Oceania — Germany gained control over the northeastern part of the island of New Guinea, the Bismarck Archipelago and a few smaller island groups, Samoa, and several Micronesian islands. In the same year, the southeastern sections of New Guinea became a British protectorate (British New Guinea), until handed over to Australia in 1905 and renamed Territory of Papua.[4] The Dutch had claimed western New Guinea in 1828, and the region remained under Dutch control until it became part of the newly independent Indonesia in 1963. During this complicated colonial history, large quantities of objects flowed to the countries that administered these realms.

Where did all these artifacts go? Germany is a good case in point. The establishment of ethnographic museums accompanied the imperial expansion (as it did in the other countries), since the museum-based academic disciplines of physical anthropology and ethnography helped to classify the populations in these new territories and promoted public interest in the colonies.[5] At the dawn of the colonial period, Western views of peoples in the South Pacific vacillated between visions of noble cultures on idyllic and remote islands and images of ferocious populations in other regions, such as the island of New Guinea; both impressions were ethnocentric and misleading. German museums competed actively for objects from the colonies because the study of material culture played a critical role in German anthropological theory in the late nineteenth and early twentieth centuries, when scholars perceived certain types of objects, such as weapons and tools, as indicators of cultural evolution and historical relationships between peoples. They sent out scientific expeditions that collected on a large scale, the most famous among them the Hamburg South Seas Expedition (1908–10), whose participants produced a series of scholarly works covering most of the German territories in the Pacific.[6]

Museum professionals, scholars, and trading companies were the main players in this rapidly evolving and lucrative artifact market. Two prominent businesses involved in the South Pacific trade were the Hernsheim Company (Hernsheim & Co.) and the German New Guinea Company (Neu Guinea Compagnie), which, under imperial privilege, ran German New Guinea from 1885 to 1898. Their agents collected hundreds of thousand of objects during their voyages and then sold them to the highest bidders. Collectors felt a sense of urgency, because the life of the peoples in the Pacific was changing rapidly as modern ways made inroads. Anthropologists needed to salvage as much information, including objects, as they could in order to document these ways of life before the cultures "vanished" — a frequent term in the writings of the time period.

## A German Consul and a Mask from New Ireland

Our first story, the journey of a New Ireland *kepong* or *ges* mask that the Teels purchased in 1977 from an art dealer, unfolded in this milieu (no. 58).[7] It exemplifies the role of big companies' representatives in the Pacific and the collecting strategies of German ethnographic museums, in this case the museum in Leipzig. Some of that museum's most remarkable Oceanic collections came from the well-known Godeffroy & Son Company mentioned above. In 1861 Johan Cesar Godeffroy had founded his own private museum in Hamburg, called the Museum Godeffroy. He was deeply interested in the artifacts brought back by his employees and hired a permanent staff to take care of his growing collections. But when the company ran into financial difficulties and folded, it was forced to offer these objects for sale. In 1885 the Museum für Völkerkunde zu Leipzig (Museum of Ethnology at Leipzig) acquired the so-called Godeffroy *Schausammlung*, that is, objects that had been on display in the Museum Godeffroy — one of the best-documented nineteenth-century collections from the Pacific.

The stunning *kepong* or *ges* mask with the inscription "ME10259, Neu Mecklenburg, Weber" on its rim is linked with

the Godeffroy enterprise, although it did not come to Leipzig directly through the Godeffroy sale. According to the Leipzig records, a Consul Weber had collected the mask in Neu-Mecklenburg (now New Ireland) and donated it to the museum in 1888, three years after the Museum Godeffroy collection had arrived. Theodor Weber (1844–1889) worked for Godeffroy & Son. The company sent him to its trading operation in Apia on the island of Samoa at age eighteen and just two years later put young Weber in charge of the entire establishment. He founded plantations for the company, married a Samoan woman, rose to prominence in Samoa and in Germany, and in 1872 became German consul in Samoa. The famed Scottish writer Robert Louis Stevenson described Weber as "the mainspring and headpiece of this great concern [Godeffroy], until death took him." Stevenson praised Weber as "an artful and commanding character; in the smallest thing or the greatest, without fear or scruple; equally able to affect, equally ready to adopt, the most engaging politeness or the most imperious airs of domination," whose name, even after his death, lived on in the songs of Samoa.[8]

How and when Weber acquired the mask remains open to conjecture. One of the many captains of Godeffroy's ships could have brought it to him in Samoa, but he also might have purchased it in New Britain or New Ireland, where he went at least once, in 1878, to investigate the death of one of the company's collectors/agents.[9] Like many of his contemporaries donating objects to ethnographic museums, Weber must have felt that he contributed to science, a noble pursuit that also granted societal recognition.

Before the mask moved into the museum, it had an entirely different meaning: it was part of the *malagan* traditions of the peoples in northern New Ireland. Renowned specialists created stunning polychrome sculptures that took center stage during memorial celebrations, which were marked by lavish displays and performances and brought prestige to their sponsors (nos. 57, 59; fig. 5, p. 16).[10] Five types of masks with different roles appeared on the occasion of *malagan* ceremonies. *Kepong* or *ges* masks, worn by groups of young men, belonged to the lower-ranking, so-called "cleaning" masks (no. 58). At the end of the ceremonies, the masked figures roamed the village and through their actions cleansed the community — that is, returned the community contaminated by the death to its normal state.[11]

This mask is one of the estimated fifteen thousand *malagan* works from New Ireland now in collections around the world, many of which left New Ireland at the end of the nineteenth and the beginning of the twentieth century.[12] Why this large number? One answer derives from the life cycle of such works in their original setting, for at the end of the *malagan* celebrations many sculptures were discarded or destroyed. When the first collectors arrived on the scene, people simply added another means of removal by selling them. The collectors' fascination with these objects provides another answer. They admired their stunning forms, although they still perceived them as artifacts.

In the Leipzig museum, this *kepong* or *ges* mask was one of several masks from New Ireland. Its catalogue card states that it was *ganz ähnlich* (quite similar) to another mask, and thus a "duplicate."[13] The fact that it was redundant made it less relevant in Leipzig, because the other specimen represented this type of object and allowed scholars to draw conclusions about the makers and users in New Ireland. The museum decided to sell or trade such objects and so, in the 1970s, deaccessioned the mask, a common museum practice to this day. By then, works from New Ireland had acquired art status. As the mask migrated from Leipzig through several art dealers to the Teel Collection, and then to its new location in the Museum of Fine Arts, Boston, it became a unique work of art, appreciated for its unusual design and aesthetic qualities.

## A "German Professor" and Witu Islands Masks

The second story concerns a polychrome wooden helmet mask and two intriguing bark-cloth masks from the Witu Islands off the northwest coast of New Britain.[14] Their importance as a group of related works and their association with Richard

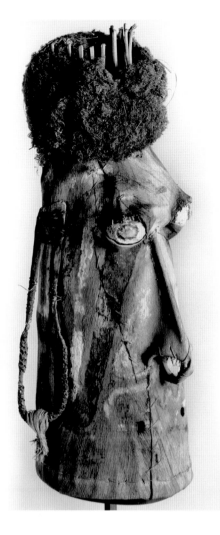

Fig. 6. Helmet mask from the Witu Islands, Papua New Guinea, second half of the nineteenth century, William E. and Bertha L. Teel Collection

Parkinson published his research in articles and books, earning the nickname "German Professor." He collected and sold more than ten thousand objects to clients, among them the Field Museum in Chicago, the Australian Museum, and most importantly, German ethnographic museums.[15]

Although collecting and selling provided Parkinson with a steady income, he was not motivated by profit alone. For many of the field collectors, societal and scholarly recognition were equally important, and Parkinson's relationship with the Dresden museum is a good example. In 1891 Parkinson contacted Adolf Bernhard Meyer, the museum's director, after he had read Meyer's 1889 article about masks from New Guinea and the Bismarck Archipelago in the museum's journal.[16] According to Meyer, Parkinson corrected mistakes and supplemented the information contained in that essay. A friendly correspondence ensued, and as a result Parkinson donated splendid collections of masks and carvings to the museum in 1893 and 1894, making the Dresden holdings — according to Meyer's assessment — the most complete and richest from the Bismarck Archipelago in all of Germany.[17] The gift included the two Witu bark masks now in the Teel Collection.

In 1895 Meyer and Parkinson published an article about the Dresden donation, which besides the two Witu bark-cloth masks contained many *malagan* carvings from New Ireland. Although Witu masks and headdresses feature prominently in plate VIII in the essay, Parkinson admitted that he knew little about them (fig. 7). "Concerning masks in the French Islands [Witu Islands], I actually discovered them only after repeated visits, when a native took me to a hollow tree from which he produced different ones. I cannot say whether the hollow tree was the actual storage location. That the masks were used during certain festivities, which are connected with dancing, was clearly demonstrated to me through pantomimes. I do not know much more."[18] In another section of the essay, he mentioned bark masks in the form of large conical helmets, worn over the head and resting on the masker's shoulders with leaves covering the masker's upper body and legs (compare no. 53). Parkinson's comments about Witu masks in his

Parkinson (1844–1909), one of the key figures in Oceanic studies and collecting, makes their life history special. The Teels acquired the masks between 1984 and 1994, after the Museum für Völkerkunde, Dresden (Museum of Ethnology, Dresden) had deaccessioned them (nos. 51, 52; fig. 6).

Tracing the masks' history takes us back to their collector, Richard Parkinson — a plantation owner, scholar, and supplier of objects. In 1876 he came to Samoa as plantation manager and surveyor for the Godeffroy Company and married Phoebe Coe, the daughter of an English father and a half-Samoan mother. About 1880–81 Parkinson left Godeffroy, moved with his wife to New Britain, and ultimately established his own plantation in Ralum on the Gazelle Peninsula. He joined the New Guinea Company in 1889 as a collector and surveyor, now focusing his attention on what he liked best: supplying museums around the world with ethnographic and natural history specimens. A gifted writer and keen observer,

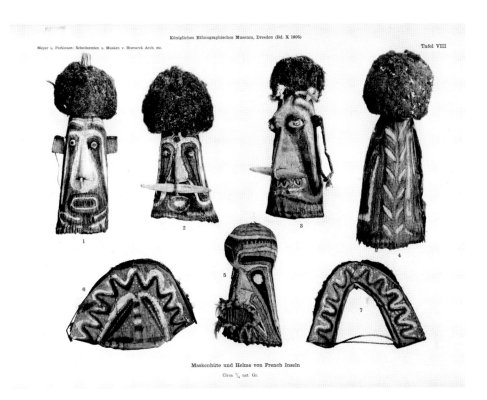

Fig. 7. Masks and headdresses, including no. 52 (lower row, center) and the mask in fig. 6 (upper row, right), from the Witu Islands, Papua New Guinea, illustrated in Meyer and Parkinson 1895, plate VIII

classic 1907 book *Dreissig Jahre in der Südsee* (Thirty Years in the South Seas) do not add much information. There, he simply stated that the helmet masks were associated with circumcision ceremonies, and he presented a photograph of a kneeling masker, a posed image he sent to museums advertising his objects for sale.[19]

The scarcity of information is partly due to the history of the Witu Islands. Garowe, the largest one, was a stop for sailing vessels in the second half of the nineteenth century. The islands became the property of the New Guinea Company, with an agent permanently residing in Garowe, and produced copra for export, which required foreign labor.[20] Parkinson visited the islands for the first time in the 1880s, when he worked for the New Guinea Company.[21] In 1893 a smallpox epidemic decimated the inhabitants of Garowe, and Parkinson remarked in 1907 that only a small remnant of the population remained.[22] It seems that by the time of his visits, the people had already abandoned the institutions with which the masks were originally associated.

When the two bark-cloth masks finally reached Boston, they had traveled a long way from the South Pacific and emerged slightly altered. We may never know whether the one in the form of a helmet (no. 52) had a nose ornament representing the adornments common among men on the islands when it arrived in Dresden. Meyer simply states: "Nose stick lost." Nevertheless, it remains in better shape than the second conical mask, whose nose ornament was still present in 1895 but is now missing (figs. 6, 7).

The wooden helmet mask called *kakaparaga*, which Parkinson donated to the Dresden museum in 1897, seems to be the first of its type to have arrived in a German museum and the first ever to be published (no. 51; fig. 8).[23] The Dresden collection retains a similar mask (number 34608), no doubt the reason for deaccessioning this "duplicate." We know of five other examples in museum and private collections,[24] among them a mask purchased by the Hungarian scholar Lajos Biró on Garowe Island during scientific expeditions sponsored by the Hungarian National Museum in Budapest in 1900 and 1901.[25] Biró associated the mask with funerary celebrations in his notes and called it *Totenmaske* (death mask), an interpretation that scholars repeat to this day.[26]

There has been much speculation about the inspiration for these helmet masks carved out of one piece of wood. Even the earliest writers observed that the Witu Islanders had contact with their neighbors on the Umboi and Siassi islands and with the Kilenge peoples in western New Britain, who have similar mask forms, suggesting that people shared these art traditions. Whatever the connections — and it would be fas-

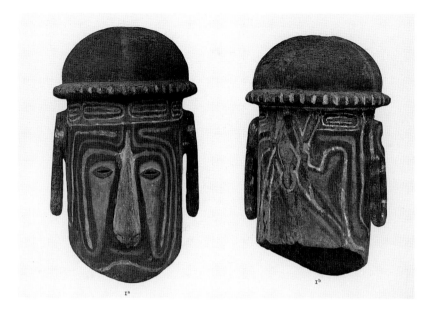

Fig. 8. *Kakaparaga* helmet mask (no. 51) from the Witu Islands, Papua New Guinea, illustrated in Foy 1900, plate I

cinating to look further into the impact of earliest labor migrations here — the homogeneity and historical time frame of this group of seven classic *kakaparaga* masks allow another conclusion. It seems that these masks were collected during a period of five years in Garowe, suggesting that they may well be the work of one artist or workshop. They might have been a variation of an existing mask type or a unique innovation in an area that was given to adopting new mask forms. Although their context remains mysterious, the production of *kakaparaga* masks continues to this day, because Witu artists revitalized this tradition for tourist trade and the international art market.[27]

Finally, it is interesting to note that the Teel Collection includes examples of all three of the mask types scholars associate with the Witu Islands. The first type is the wooden *kakaparaga* helmet (no. 51) and its related bark-cloth version (no. 52). Small bark-cloth conical helmet masks (fig. 6) constitute a second type, and large helmet masks that sit on the shoulders of the maskers form the third group. The Teel Collection contains a mask of this third type as well, although it was made more recently than the others (no. 53).

## A British Gentleman Scholar-Collector and a Mask from the Gulf of Papua, New Guinea

In the early 1970s, many remarkable works from Oceania and Africa appeared on the art market in England. They were part of the collections of the private Pitt-Rivers Museum in Farn-

ham, Dorset, which had closed in 1966 after the death of its then owner George Henry Pitt-Rivers. The story of these objects is intriguing, for it casts light on a fascinating scholar and collector and on the way artifacts moved from the British realm of New Guinea to England through missionary channels and later dispersed around the world as works of art. Several former Pitt-Rivers objects came to the Teel Collection through art dealers, who in turn had purchased them at Sotheby's auctions in London. One such work, a mask from the Elema peoples of the Gulf of Papua region,[28] has been in the Museum of Fine Arts since 1996, when the Teels donated it to the collection (no. 43). It once belonged to Lt. General Augustus Henry Lane Fox Pitt-Rivers (1827–1900).

Born Augustus Henry Lane Fox in 1827, Lane Fox embarked on a military career and amassed archaeological materials and artifacts from around the world. He was an avid collector and was self-educated, becoming an illustrious scholar who based many of his theories about cultural evolution on the evidence drawn from objects. His acquisitions soon outgrew his space in his London residence, and he had to make arrangements for their storage and display elsewhere. He lent a large part of his collection to the Bethnal Green extension of the South Kensington Museum (now the Victoria and Albert Museum) in London. Between 1884 and 1888 he transferred this collection to the Pitt Rivers Museum named for him in Oxford, giving clear directives regarding the manner of display in accordance with his theories about human evolution.[29]

Beginning in 1880 Lane Fox formed a new collection, after inheriting a substantial fortune and land holdings from his cousin Lord Rivers. As stipulated in the testament, he officially added Pitt-Rivers to his name, retired from the military, and was free to indulge in his passions.[30] He immediately established a museum devoted to the display of agricultural and archaeological items in one of the buildings on the grounds of the inherited estate in Farnham. The estate became much more than a museum when he added exotic animals, a "singing" theater, picnic facilities, and a dining room. He hoped to attract the people of the area, because for him the museum first and foremost served educational purposes.

Pitt-Rivers had broad interests. Besides coins, arrowheads, china, and even furniture, he purchased Oceanic and African objects from established artifact dealers, among them William Downing Webster of Bicester, and Fenton and Sons, a trading and auction house in London (see nos. 44, 46, 56). In nine carefully arranged catalogue books, his assistants recorded some ten thousand of his objects, most of them represented in meticulous drawings.[31] Objects from the Pacific were in room nine in his Farnham museum, displayed in wall cases. "ROOM IX contains specimens of the ceremonial objects, weapons, &c., of modern savage tribes. Special attention is directed to the series of fine head-dresses from the Pacific and Benin bronzes [from Nigeria]," stated the general handbook of the museum, edited in 1929.[32] The mask from the Gulf of Papua, an impressive "head-dress," must have been on display somewhere in this room.

From the catalogue entry for this object, we know that Pitt-Rivers acquired a collection of some 220 objects, including this mask, from E. B. Savage of the Square, Ringwood, on October 20, 1894, for the amount of forty-five pounds. An additional comment states that "Mr. Savage made his collection in New Guinea, at the time he was a missionary there."[33] Indeed, Edwin Bentley Savage (born 1854), a missionary with the London Missionary Society (LMS), had arrived in New Guinea in January 1889. James Chalmers, one of the senior LMS missionaries in New Guinea, sent him west to take over the mission on Murray Island, which had fallen on hard times. Later he moved on to Toaripi on the Gulf of Papua coast. When Savage, perceived as a moody and difficult man by his colleagues, failed to live up to the high expectations of his superiors, he resigned and returned to England in 1891.[34] He brought with him this fairly systematic collection and he annotated many objects with comments, now contained in the Pitt-Rivers catalogue books. His extensive notes suggest that he perhaps intended to create a comprehensive survey of Elema material culture. He may have collected the objects as an investment in order to sell them later on, or he may have been among the few missionaries who developed an interest in the ways of life of the indigenous peoples around them.

Here is Savage's report about the mask, accompanying a beautiful drawing of it by A. Peacock, one of Pitt-Rivers's assistants (fig. 9):

> High mask worn by the "Kairakuku" or policeman. From Vailala.[35] The grass appendage meets another which is worn round the loins and touches the ground, so that the man underneath is entirely hid. They trot round about dusk, five or six of them, to strike terror in the hearts of would-be thieves, and to give them to understand that although there are no written laws, there are understood laws which must be obeyed. For instance, certain coconut trees are at times tabooed — no native must pick any nuts from one which has the taboo upon it. That is which is bound round by the leaves of the tree. There as here there are some law-breakers, and he "Kairakuku" is a standing warning (more often running) to such. When not being worn, these masks are hung up in the "dubus" or sacred houses.[36]

Savage's comments raise many questions — did he actually observe the masks' appearance, because he did not live in Vailala; did he buy the mask there or was it brought to him?

*1099*

| DATE. | DESCRIPTION OF OBJECT. | PRICE. | DEPOSITED AT. | REMOVED TO. |
|---|---|---|---|---|

NEW GUINEA COLL: (SAVAGE)

(N° CXIX)
High Mask worn by the "Kaiwakuku" or policeman.
from Vailala.
"The grass appendage meets another which is worn round the loins and touches the ground, so that the man underneath is entirely hid. They trot round about dusk, five or six of them, to strike terror into the hearts of would-be thieves, and to give them to understand that although there are no written laws, there are understood laws which must be obeyed. For instance, certain coconut trees are at times tabooed – no native must pick any nuts from one which has the taboo upon it that is which is bound round by the leaves of the tree. There as here there are some law-breakers and the "Kaiwakuku" is a standing warning (more often running) to such. When not being worn these masks are hung up in the "dubus" or sacred houses.

Room 7.

Fig. 9. Drawing of the *kovave* mask (no. 43) by A. Peacock, illustrated in Pitt-Rivers 1882–99, 3:1039

— but we can assume that he reports about events associated with the *kovave* cycle, a series of ceremonies and performances initiating young men into the *kovave* cult.

We gain another early insight into the use of this type of mask from the comments of Francis Edgar Williams, an Australian government anthropologist in the territory of Papua then under Australian administration, who in the 1930s worked among the Elema in Orokolo, some twenty-five miles east of Vailala.[37] He witnessed the performance of *kovave* masks resembling this work, a tradition in decline then and now abandoned, and took several classic photographs of the stunning displays (p. 94). Williams's poetic description of his encounter with the masks evokes the drama and impact of their performance. He watched the maskers move restlessly along the beach, carrying bows and arrows or sticks. When they spotted a group of young boys, they broke into an ungainly sprint "bent forward, ostrich-like, . . . bast feathers flying in the wind and . . . human arms and legs showing every sign of supreme effort" and scared the children who sought refuge in the village. After their performance they disappeared into the men's house, or *eravo* — the "dubu" in Savage's account.[38]

Anthropologists now know that the life of Elema men and the entire community revolved around these men's meeting houses. *Kovave* was one of three male cults that played important roles in the communities' ritual and economic life; intricate exchanges of goods accompanied all ceremonial oc-

casions. When enough boys had reached the age to be initiated into the cult, the community prepared a large ceremony. The fathers and maternal uncles of the initiates produced masks that embodied forest spirits and gave them the proper names that the fathers and maternal grandfathers had used for the previous material manifestations of the spirit. The mask makers stretched bark cloth over a cane frame and then adorned the structures with shells and feathers. This communal process confirmed the ties within families and encouraged the reproduction of prescribed patterns, which did not change much over time.

During the lengthy initiation cycle, the *kovave* masks and their performers, young male members of the cult, appeared on many occasions. The festival culminated in a race of the maskers to the beach. It also included a lavish exchange of valuables such as pigs and shell ornaments among the relatives of the boys. By the end of the cycle, the *kovave* masks were battered and had lost many of their decorations. The men threw them on a large pile and burned them, only to re-create the masks several years later for the next initiation cycle.[39]

Thus, the nineteenth-century mask that Savage procured — perhaps at the beginning of the cycle — is a rare work and among the oldest from this region in any collection. Moreover, it remains in good condition, only the fiber skirt having been replaced. Like the other works in our case studies, it has undergone transformations in meaning. As a missionary, Savage removed an object related to "pagan rites" (but from his point of view also collectible) from its original context. Pitt-Rivers acquired the artifact for his private museum for educational purposes. As it moved through the auction house and art dealers' hands, it slowly migrated into the realm of art, emerging in an art museum setting.

## | A French Traveler and Lake Sentani Sculptures

The story of two additional works (nos. 11, 12) takes us to different realms: to Lake Sentani in Dutch New Guinea in the 1920s and the impact of the Dutch settlers on native cultures;

and to Paris, magnet for artists and in those years already the exciting hub for collecting objects from Africa and Oceania. This story differs from the previous three, because the objects that arrived in Paris were acquired as art or moved into the realm of art almost immediately. At the beginning of the twentieth century, avant-garde artists had discovered so-called primitive works of art from both Africa and Oceania and felt inspired by their bold, abstract forms, which broke with Western conventions of naturalism.[40]

The name "Lake Sentani" conjured up distant dreamlike realms for Westerners, a sentiment Paul Wirz (1892–1955), a Swiss traveler, scholar, and author, captured in the opening lines of one of his books: "The lake lies in deep slumber, lost below the equator, a dream of days of yore and untouched by the ghost of centuries rushing by. Lost in remote New Guinea, the realm of birds of paradise, impenetrable forests, limitless savannas and mountains reaching the sky. Silently its quaint shape extends at the foot of mighty, wooded mountain ranges, into which the whites set foot only recently."[41]

He visited Teluk Yos Sudarso (formerly Humboldt Bay) on the coast and nearby inland Lake Sentani in 1922 and 1926, conducting several months of research and photographing the peoples and their environment. His publications thus provide an interesting picture of the region and its inhabitants.[42]

The Lake Sentani peoples, who share the same language and many cultural traits, exploited the sago palms in the swamps along the lakeshore, kept gardens, fished, raised pigs, and hunted game in the forests. All early observers describe their villages on pilings that extended above the lake (fig. 1, p. 12).[43] Wooden walkways connected the houses and the *ondoforo*'s, or chief's, residence, which differed in size and elaboration from the dwellings of ordinary people. Depending on the power and influence of the chief, his house ranged from thirty to ninety feet long. Beautifully carved, heavy posts planted into the water supported the ridge poles of the roofs. Human figures such as the ones in the Teel Collection (nos. 11, 12) adorned the top of posts that rose through the walkways in front of the *ondoforo*'s residence.

Recent publications on such sculptures remain remarkably silent about their meaning and function. They merely proclaim that their restrained, conservative forms may echo the tranquil character of Lake Sentani societies.[44] The only extensive discussion appears in a 1923 article by Wirz. When he inquired about the meaning of the human figures, called *to-reri uno* (people from wood), he received few answers. According to his informants, they were neither ancestor figures nor did they protect the houses. However, people mentioned that they were very old and could not be removed, or sickness would strike.[45]

Despite Wirz's assertion about the remoteness and paradisiacal nature of the lake, another theme weaves through many of the early writings, helping to explain the lack of information about figurative sculpture in the area. The peoples of Lake Sentani have always been connected to the nearby coast and Teluk Yos Sudarso and were part of extensive trade networks. They supplied sago and pigs to the coastal peoples and in return received smoked salt-water fish, Chinese beads, bird feathers from other areas, and even a few iron tools after the first whites brought them to Teluk Yos Sudarso. Among the most interesting "imports" was a men's secret cult adopted from their neighbors, along with its related art traditions. Chiefs who owned the cults constructed imposing ceremonial houses, high pyramidal structures with figurative carvings and painted panels that resembled similar buildings in the Teluk Yos Sudarso area (no. 10).[46]

With the arrival of the Dutch, outside influences became more intense. In 1901 the Dutch established the administrative headquarters Hollandia (now Jayapura) at Teluk Yos Sudarso; in 1918 they opened a military post in Dojo on the northwest shore of the lake; and a few years later they opened another in nearby Ifar. In 1921 they imposed taxes, and men had to participate as laborers in the wage economy to afford the payments. The people of Lake Sentani enjoyed modern imports, soon adopting clothing such as small frontal aprons for men and experimenting with new hairdos. Chiefs' houses, and with them the wooden sculptures, fell into disrepair be-

cause the men in the labor force no longer maintained them. The ceremonial houses for the secret societies disappeared, too — some collapsed, others were burned about 1924 by policemen and soldiers of the Dutch colonial government on the instigation of missionaries, who saw them as bastions of paganism.[47]

Sculptures and works of art from Lake Sentani were not only victims of neglect and of colonial and missionary intervention. So-called cargo cults, a variety of phenomena that swept through Melanesia and other parts of the Pacific, led to their destruction and abandonment as well. These cults revolved around native peoples' beliefs that Westerners had unfairly gained access to goods ("cargo") that the ancestral spirits had intended for them. They thought that certain activities and rituals similar to those of the Westerners were efficacious and would impel the cargo that was rightfully theirs to come back; as a result, they discarded figurative sculptures as they had witnessed the missionaries do.[48] Thus, by the end of the 1920s, works from Lake Sentani had been swept up in currents of local and colonial history, and few seem to have remained.

Enter Jacques Viot (1898–1955), a French eccentric and writer. He came to Paris in 1925 and developed ties to the Surrealists, a group of artists and intellectuals who created an aesthetic philosophy emphasizing the critical and imaginative powers of the unconscious. Viot encountered the painter Juan Mirò and began to represent him, dabbling in the paintings trade and participating in the Paris gallery scene. One of his acquaintances was the gallery owner Pierre Loeb, who sold the paintings of Surrealist artists but at the same time maintained a collection and traded in Oceanic art. Probably broke, Viot suggested to Loeb that he might go to Australia and purchase Oceanic works for the gallery in order to pay off a debt he owed Loeb. The gallery owner agreed to the proposal, gave him a monthly salary for a year, and hoped for the best.[49]

In 1929 Viot showed up at Teluk Yos Sudarso and Lake Sentani, mainly in pursuit of *maro*, the intricately painted bark cloths that had by then garnered Parisians' attention (no. 13). Although Viot saw a few sculptures decorating posts outside

the chiefs' residences, many works had disappeared or were decaying.[50] In a stroke of business genius, Viot decided to search the lake at the sites of the destroyed ceremonial and chiefs' houses and succeeded in rescuing some sixty submerged sculptures. He documented his finds in a series of photographs showing two young men, possibly his assistants, with the sculptures. Holding two or three works at a time, they pose in what looks like a fenced backyard of a missionary or government rest house. Viot may have taken the images for future buyers and as documents of his activities. One of the photographs shows the two sculptures now in the Teel Collection, which may have come from the site of Dojo.[51] Viot kept his promise to Loeb and by the end of 1929 sent a large collection from the region back to Paris, including these two figures.

Philippe Peltier, who has written extensively about Viot, provides a glimpse of the many figures' paths after they arrived at Loeb's gallery in Paris in late 1929. Besides the sculptures, Viot's shipment contained *maro* that he had commissioned in Tobati on Teluk Yos Sudarso, along with beautifully decorated everyday Lake Sentani objects such as wooden bowls. When Loeb began to show part of the collection to the public and the cognoscenti in gallery settings, the reaction was mixed and was certainly less than enthusiastic when it came to the sculptures. In the eyes of the public, they still seemed awkward; they had not quite made the transition from artifact to work of art.

The Lake Sentani figures slowly entered the art market and private collections as Loeb began to sell them to his customers. It would take almost thirty years for them to emerge on a larger stage. In the fall of 1959, when the Museum of Primitive Art in New York organized the exhibition *The Art of Lake Sentani*, which included many of the sculptures, they had finally metamorphosed into unique works of art attesting to the skill and creativity of artists in a far-away place.[52] Tracing the journeys of the two figures now in the Teel Collection after they left the Loeb gallery, we find that one of them arrived in the collection of René Rasmussen, a renowned Paris art dealer and collector (no. 12). By 1988 it had made its way to a New York gallery, where the Teels purchased it because they admired its elegant form. The route of the second figure led to New York and San Francisco, before Mr. Teel acquired it there in 1999 (no. 11). By then, he knew the Sentani figures' history, had seen the Viot photograph showing his earlier acquisition together with this sculpture, and determined to reunite the two works in his collection.

## A Diaspora of Objects

These four stories about the life histories of several works in the Teel Collection exemplify the complex travels of Oceanic objects from the Pacific to collections around the world. During their journeys, the objects transitioned from items that were efficacious and active in their communities of origin to curiosities, ethnographic artifacts, and, finally, works of art. The people and institutions associated with them influenced their movements and shifts in meanings. Tracing such objects' histories often resembles detective work, because much of the documentation about their travels has disappeared. Most significantly, we may perhaps never fully grasp their meanings in their places of origin, where the peoples, too, have been caught up in dramatic changes over time. Removed from their original context, many of the works have become fragments of larger ensembles: isolated masks once were only a small, perhaps not even the most significant, part of an entire costume; figures now displayed as freestanding sculptures on mounts once adorned posts surrounding houses in Lake Sentani villages.

In museum galleries or in the homes of private collectors, displayed next to each other and far from their places of origin, the objects from the South Seas seem to form a diaspora. Like people in diasporas all over the globe, they have assumed new lives and identities. Now seen as works of art, they open small windows on distant worlds and help the viewer understand the many ways in which humans aspire to beauty and efficacy in their material world.

1. In the past two decades, social scientists and art historians have explored the notion that objects have life histories or biographies. This idea is based on the observation that things exist in time and space and that at any given moment they are part of processes of production, exchange, and consumption. For a discussion of this approach to objects see Kopytoff 1986, Gosden and Marshall 1999, Gosden and Knowles 2004, and O'Hanlon and Welsch 2000.

2. See Corbey 2000 for an interesting overview of the circulation of objects from regions of the world such as Oceania and Africa.

3. See Scheps 2005. I am grateful to Birgit Scheps and Marion Melk-Koch for generously sharing with me information about Godeffroy and other collectors when I was in Leipzig in May 2005.

4. After World War I, Australia also administered the former German protectorate until the country of Papua New Guinea, which comprises the former British and German parts, gained independence in 1975.

5. Museums of ethnology opened their doors in Leipzig in 1869 and in nearby Dresden in 1875. Hamburg followed suit in 1879. The Royal Museum of Ethnography in Berlin, now the Ethnologisches Museum, finally followed in 1883.

6. See Köpke and Schmelz 2003.

7. According to Gunn 1997, 142, both terms refer to the same type of mask. *Kepong* seems to be the older designation frequently found in early literature, while people in the region today tend to refer to these masks as *ges*.

8. Stevenson 1892, 10.

9. Hiery 2001, 137; personal communication by Birgit Scheps, May 2005.

10. In a recent catalogue Michael Gunn, a specialist for the arts of New Ireland, explained *malagan* as a "means by which a northern New Irelander can adequately honour his or her affines, i.e. the people one marries"(Gunn 1997, 18–19).

11. Gunn 1997, 57–58, 142.

12. Gunn 1997, 42.

13. The other mask was number 1499.

14. An earlier name for the archipelago was French Islands. Garowe, the largest island in the group, was formerly known as Deslacs.

15. For a full account of Parkinson's activities see Specht 1999.

16. Meyer 1889.

17. Meyer and Parkinson 1895, 1.

18. Meyer and Parkinson 1895, 4, 11 (translated from the German by the author).

19. Parkinson 1907, 638–40.

20. According to Philip J. C. Dark, even in the 1960s plantation laborers were mostly of foreign origin (Dark 1979, 134).

21. Parkinson 1907, 35.

22. Parkinson erroneously gives the date of the epidemic as 1897 (Parkinson 1907, 35); see Hiery 2001, 427.

23. Foy 1900, 4–6, Pl. I.

24. Two *kakaparaga* masks came to the Linden-Museum Stuttgart at the beginning of the twentieth century, only a few years after Parkinson's mask arrived in Dresden (Heermann 2001, 105–7); two more are in a private collection and in the Musée Barbier-Mueller (Newton and Waterfield 1995, 300; Sotheby's 2004).

25. Bodrogi 1959, 39–40; Guiart 1963, pl. 273.

26. Bodrogi 1971, 50, 59; see also Heermann 2001, 167.

27. See Dark 1979, 132–35.

28. The term *Elema* refers to a group of culturally and linguistically related peoples along the shores of the Gulf of Papua (see Williams 1940, 24).

29. The display he developed remains in the museum to this day and is a testimony to Victorian aesthetics and scholarly approach to material culture.

30. See Waterfield 2002.

31. Thompson and Renfrew 1999. The catalogue books are now in the Cambridge University Library (Pitt-Rivers 1882–99).

32. Buxton 1929, 28–29.

33. Pitt-Rivers 1882–99, 3:1039.

34. Langmore 1989, 287.

35. Francis Edgar Williams reports that the term *kovave* was the Elema designation for these masks, although *kairakuku*, the term in Savage's account, also occurred. Apparently *kairakuku* was the word that Motu peoples, who live in the region of Port Moresby, used for all Elema masks (Williams 1940, 140).

36. Pitt-Rivers 1882–99, 3:1099.

37. Williams 1940, 139–52.

38. Williams 1940, 139–40.

39. Williams 1940, 140–52.

40. Peltier 1984.

41. Wirz 1929, 1 (translated from the German by the author).

42. Kaufmann 1992, 142.

43. See, for example, Sande 1907.

44. Kooijman and Hoogerbrugge 1992, 95.

45. Wirz 1923, 32–38.

46. Wirz 1928, 323. Wirz was the original source for this information, which has then been repeated by Kooijman and others.

47. Wirz 1928, 327; Wirz 1929, 12, 63.

48. The designation "cargo cult" for these movements is problematic, yet it still has currency. See Worsley 1957, 98–99; Peltier 1992, 161.

49. Peltier 1992, 159.

50. Simon Kooijman apparently talked to Viot about his collecting; see Kooijman 1959, 18, for more details.

51. This image has been published in Kooijman and Hoogerbrugge 1992, 95, ill. 62.

52. Kooijman 1959, 2.

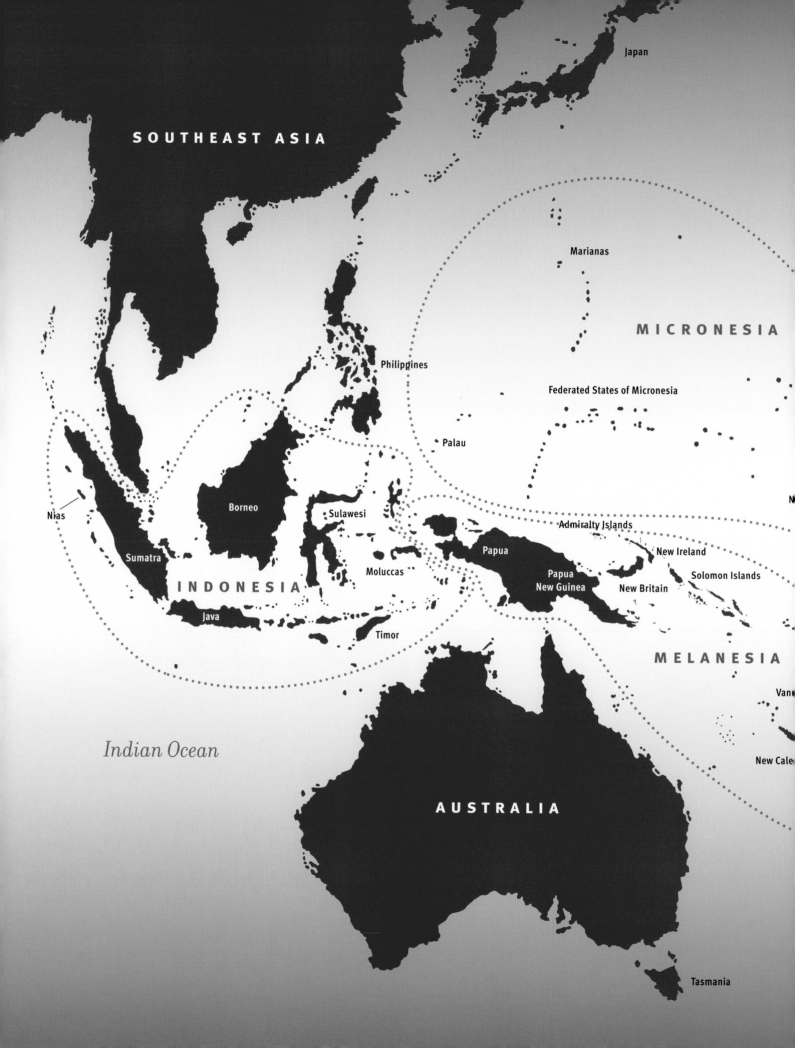

Hawai'ian Islands

hall Islands

Line Islands

Kiribati

**POLYNESIA**

Phoenix Islands

Tuvalu

Marquesas Islands

*Pacific Ocean*

Samoa

Society Islands    Tahiti

Fiji

Cook Islands

Tonga

Austral Islands

Easter Island

New Zealand

## THE SOUTH SEAS

As reflected in this map, this catalogue of objects from the South Seas, a term coined in the sixteenth century to identify the region of the Pacific containing the islands of Oceania, maintains the division of the region into four sections — Indonesia, Melanesia, Polynesia, and Micronesia — first suggested by J. S. C. Dumont d'Urville, a nineteenth-century French explorer and geographer. Although scholars today increasingly abandon these classifications (especially in the case of Melanesia) and emphasize the interconnectedness of the peoples and their arts, this conceptual frame-work inspired the way many collectors in the second half of the twentieth century, including William and Bertha Teel, organized their collections.

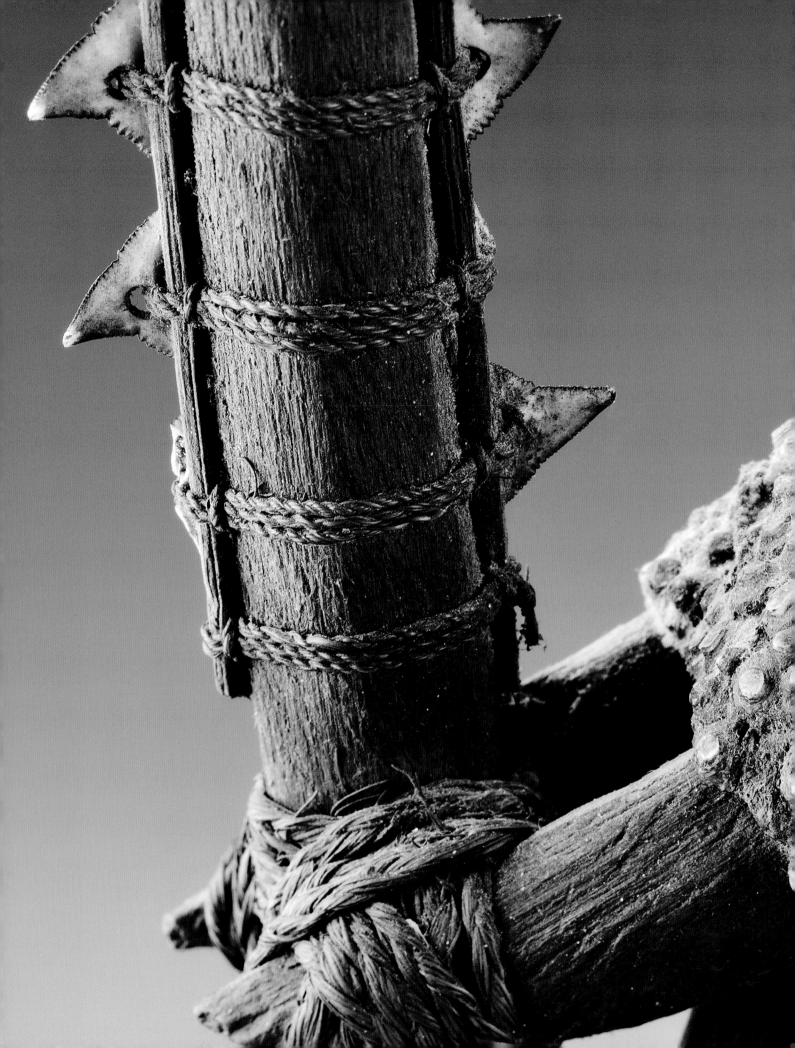

From the South Seas

# 1 | Indonesia

Until the end of the last Ice Age some eleven thousand years ago, the Sunda continental shelf extended from Southeast Asia to encompass Sumatra,

Java, and Borneo, while the Sahul shelf linked New Guinea and Australia. Rising waters created more than twenty thousand islands southeast of the Asian mainland that are collectively known as Indonesia (alternatively called Island Southeast Asia). The name Indonesia refers here not to the present nation but to a geographic sphere of indigenous peoples who share languages and cultural characteristics and whose religious identity remains distinct in the presence of Buddhist, Hindu, and Islamic influences. Many of their beliefs focus on the spirit world, on controlling supernatural powers to grant protection and fertility, and on the ancestral realm. This section presents objects relating to these beliefs and associated practices — works that in Western art museums have become unique art objects. Several of them come from Nias, Sumatra, and Sulawesi, islands that are now part of the modern nation of Indonesia. Others derive from the large island of Borneo and the island of Timor, both of which are politically divided.

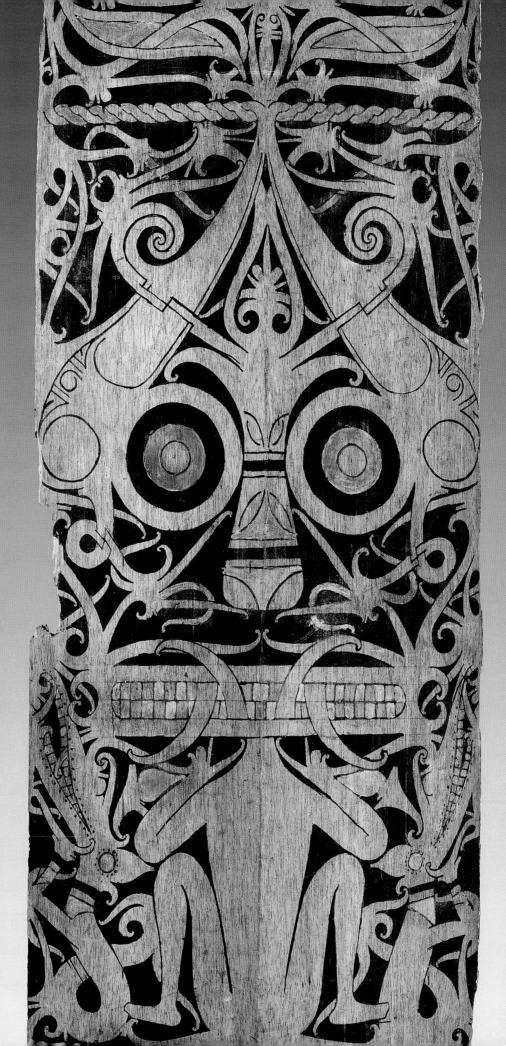

# 1  Ceremonial seat (*osa osa*)

Nias, Indonesia
Mid-20th century
Stone, pigments
Height 18 inches, length 21½ inches
Formerly in the collection of Hadju Datuk, Indonesia
Acquired from Thomas Murray, California, in 2001
Bibliography: Barbier and Newton 1988

The inhabitants of Nias, a small island off the northwest coast of Sumatra, were traditionally divided into two classes: commoners and nobles. Individuals of both groups staged lavish feasts, generously supplying pigs (which they accumulated as wealth) and food. In different, culturally distinct parts of the island, these events served various purposes. In some instances they helped the sponsor achieve recognition and high rank in society; in others they marked the founding of a new village or the installation of a new headman. On the occasion of the feast, stone monuments — ranging from plain megaliths to figures — and stone mounts or seats of honor were placed in village plazas and in front of nobles' houses. Designed to elevate the occupant, these seats were sometimes circular, sometimes square. Some displayed the head of a hornbill, an animal, or a mythical creature called a *lasara* that is associated with the lower world. This seat, a relatively small example of a four-legged animal, has the head of a dragonlike *lasara* with horns, ears, and raised bridle and an elevated, birdlike tail symbolizing the upper world. A *kalabubu*, an emblem recalling a brass and coconut-shell necklace worn by brave hunters or warriors, encircles the neck. Sharp edges on one rear leg suggest restoration, and traces of red pigment remain in the open mouth.

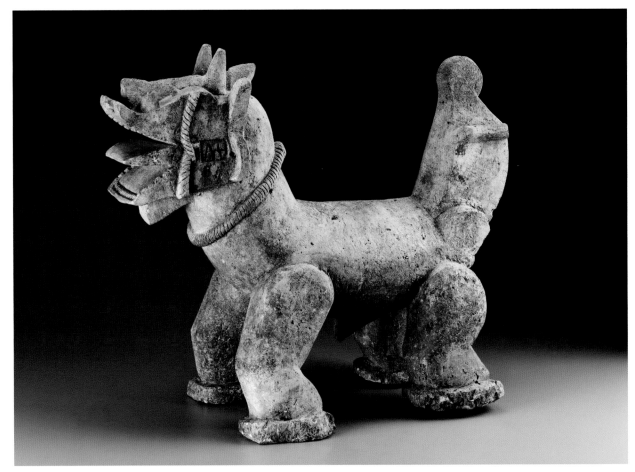

1

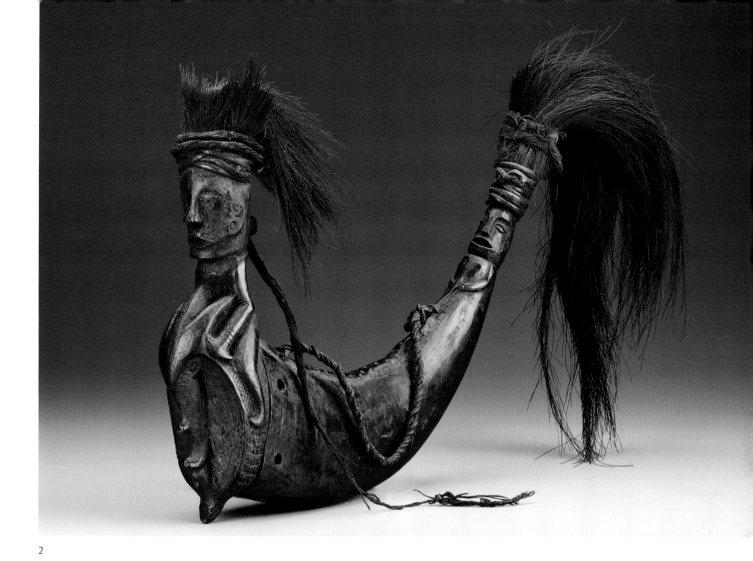

2

## 2  Ritual container (*naga morsarang*)

Batak peoples, Sumatra, Indonesia
Late 19th–early 20th century
Horn, wood, hair, fiber
Length 12 inches
Formerly in the collections of the Museum of Delft and Loed
  van Bussel, Amsterdam
Acquired from Michael Oliver, New York, in 1985
Bibliography: Sibeth 1991

The Batak peoples, who inhabit the mountainous plateau of northern Sumatra, include six closely related groups, among them the Toba and the Dairi-Pakpak Batak. All live in autonomous villages ruled by a *raja*, or chief. In the past the status of a Toba Batak *raja* was equaled only by that of the *datu*, a magician-priest who might also serve as chief. As guardian of ritual knowledge and medicines, the *datu* stored his substances in a container such as this for use during rituals. The water-buffalo horn bears an incised serpent on its upper side and terminates at the small end in a stylized human head with a long tuft of hair. At the large end, a detachable wood stopper consists of a plumed, large-headed rider mounted on a protective *singa*. This iconic Batak being combines elements of the water buffalo, the horse, and a snake of the underworld and is associated with fecundity, wealth, and protection.

## 3 Figure (*gana-gana*)

Batak peoples, Sumatra, Indonesia
20th century
Wood, fiber, metal
Height 22 inches
Collected about 1930 by a German missionary doctor
Acquired from Steven Alpert, Dallas, in 1990
Bibliography: Capistrano-Baker 1994

High-ranking Batak families occupy large three-level houses with soaring roofs and elaborate facades adorned by carved *singa* heads. Just as those mythical beings protect the outside of the house, this grim, compressed figure called *gana-gana* served as an interior guardian to ward off illness and evil spirits. Rising from a broken staff, the figure clasps its ankles and pulls its legs to its torso. One of its hands has six fingers, an allusion to supernatural powers. Protruding eyes, whose metal pupils may suggest supernatural vision, call attention to the large head with well-defined features. Two beads and wooden amulets are suspended from the neck by a fiber cord.

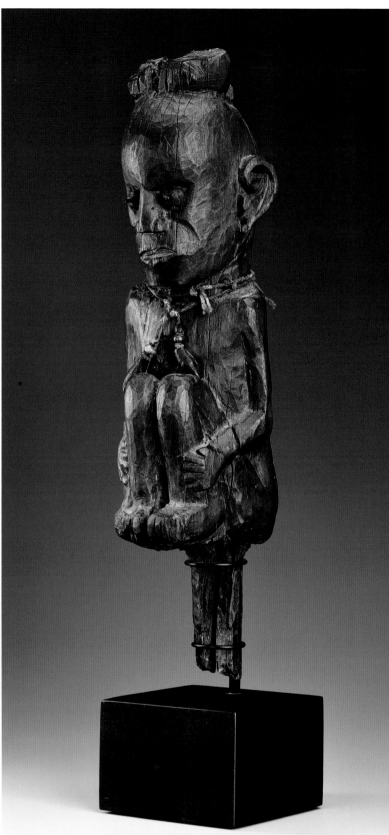

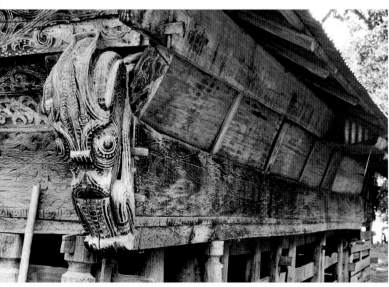

*Singa* image on a headman's house, 1980

3

## 4  Figure (*hampatong*)

Dayak peoples, Borneo, Indonesia
Late 19th–early 20th century
Wood, shells
Height 36 inches
Gift of William E. and Bertha L. Teel  1994.411
Acquired from Tambaran Gallery, New York, in 1988
Bibliography: Newton 1999

The Dayak peoples, a generic designation for dis-
tinct indigenous groups such as the Kenyah, Kayan,
and Bahau, inhabit the dense rainforest of the
region of interior Kalimantan on the large island of
Borneo. Most live in villages that consist of multi-
family communal longhouses called *uma*. Large
carved images, usually called *hampatong*, meaning
"figure" or "effigy," guard the village entrances and
houses, protecting inhabitants against illness and
misfortune borne by evil spirits and against enemy
raiders. This monumental sculpture in gray ironwood
probably comes from the Bahau peoples. Its aggres-
sive posture, flexed legs, and massive shoulders are
intended to be menacing. Ear ornaments, shell eyes,
and the protruding tongue make the huge head,
with its convex-concave contrasts, even more intimi-
dating. Such figures were carved on coffins and bur-
ial posts that were featured in elaborate funerary
ceremonies.

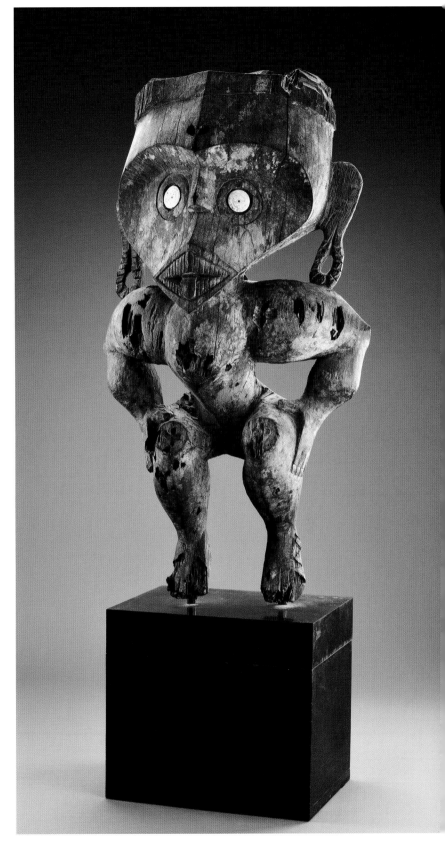

4

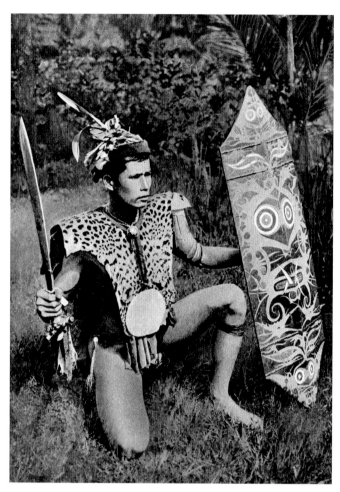

Dayak man with a shield, late nineteenth century

## 5 Shield (*kelembit* or *klebit*)

Dayak peoples, Borneo, Indonesia
20th century
Wood, pigments
Height 32 inches
Acquired from Alain Schoffel, Paris, in 1991
Bibliography: Greub 1988; Newton 1999

In the past, warriors of the Kenyah, Kayan, and neighboring peoples of Borneo used shields such as this one for protection and intimidation in warfare. Their bold designs were intended to ward off human enemies and ever-present evil spirits. This example shows the typical shape: a bowed rectangle with pointed ends. The undecorated back bears a raised handle, while the front exhibits a painted curvilinear design representing otherworldly creatures. A frog-like human figure crouches in the center, displaying a monstrous goggle-eyed face with a toothed mouth. Dragonlike supernatural beings called *aso*, which literally means "dog," appear elsewhere. The sinuous *aso* is a common motif in Dayak art and seems to resemble Chinese dragon designs. Many shields originally incorporated layers of attached human or horse hair. Today, men display the shields during ceremonies such as a wedding or the naming of a child.

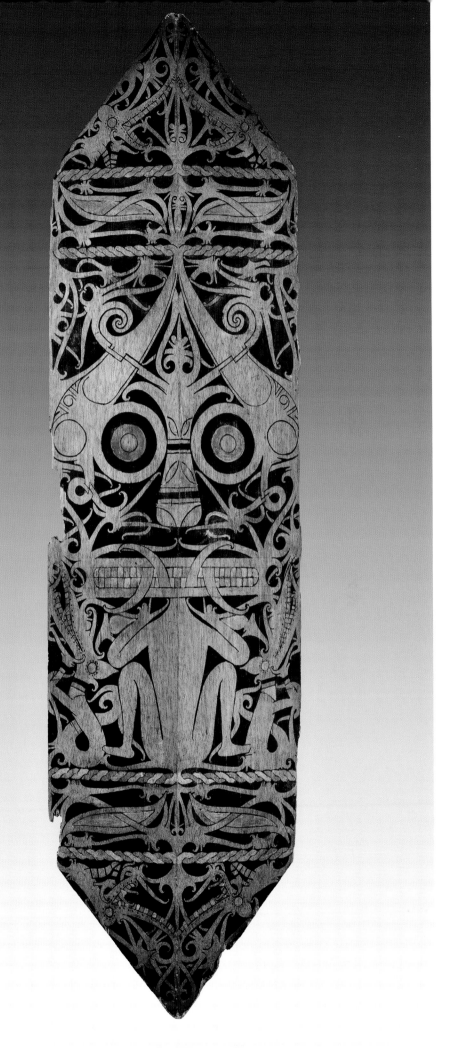

5

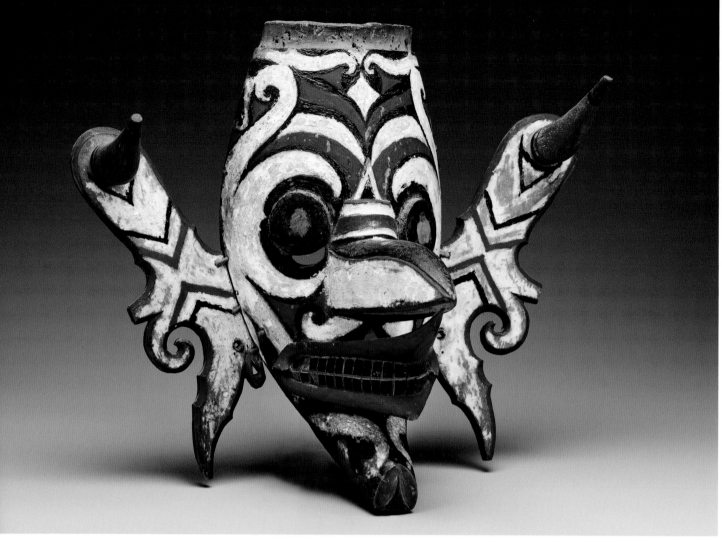

6

## 6  Mask (*hudoq*)

Dayak peoples, Borneo, Indonesia
20th century
Wood, pigments, fiber
Height 17 inches
Acquired from Alain Schoffel, Paris, in 1987
Bibliography: Barbier and Newton 1988

This bold mask appeared at agricultural festivals in the villages of the Kayan and Kenyah peoples. During sowing and harvest festivals, young men traditionally performed *hudoq* masquerades, impersonating beings from the forest — spirits who had come down to earth to secure prosperity, bountiful harvests, and the fertility of women. During dances the maskers were cloaked in banana-leaf costumes, and bright feathers were attached to the top of the mask. Some masks display human faces, others incorporate stylized animal traits. This example suggests a composite dragon-hornbill creature whose beaklike nose extends to a projecting mouth with menacing teeth. The flange-like ears or wings bear detachable hornlike projections. Brilliant colors accentuate the exaggerated facial features. When not in use, such masks were carefully stored and then repainted with red, white, and black curvilinear designs for the next performance.

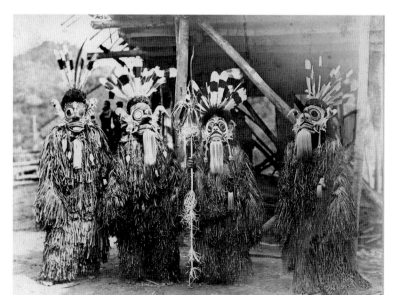

Kenyah shamans wearing *hudoq* masks, about 1900

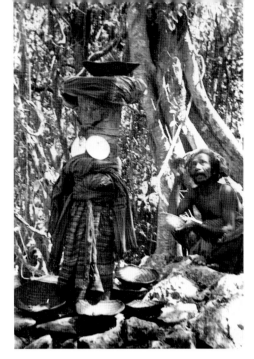

Man next to an offering post, 1953

## 7 Offering post (*ai tos*)

Tetum peoples, West Timor, Indonesia
Late 19th–early 20th century
Wood
Height 39 inches
Formerly in the collection of Carimi, Italy
Acquired from Bruce Frank, New York, in 2003
Bibliography: Barbier and Newton 1988; Feldman 1994

The inhabitants of Timor are linguistically diverse
and now politically divided. At least fifteen language
groups exist on the island, including the Tetum, who
live in the center and on the southeastern coast.
Historically, the Tetum cultivated rice, and most of
their rituals focused on maintaining proper relation-
ships with nature spirits and the ancestral world.
The Tetum and their neighbors memorialized progen-
itors by placing post figures on stone mounds and
adorning them with textiles and jewelry. Carved from
either stone or wood, these sculptures collectively
are called *ai tos*, which literally means "hard wood."
This weathered wooden example from western Timor
consists of a relatively realistic head, which once
bore shell eyes, and an abstract pole-like body with
intricate bands of geometric ornamentation. A slab
on which offerings to the ancestors were placed origi-
nally sat on top of its head.

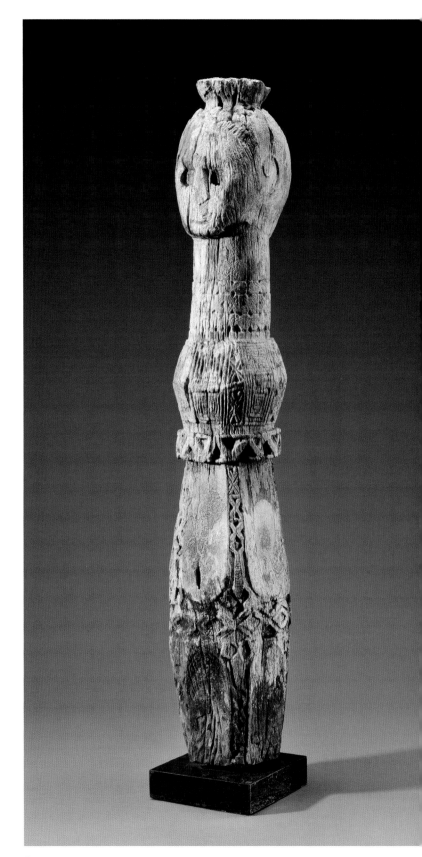

7

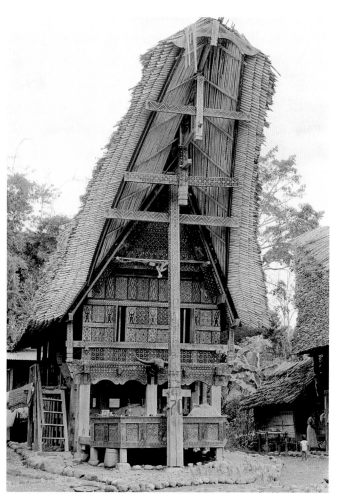

Toraja family house (*Tongkonan, nonongan*), 1983

## 8 Door

Sa'dan Toraja peoples, Sulawesi, Indonesia
Late 19th–early 20th century
Wood
Height 41 inches
Acquired from Steven Alpert, Dallas, in 2002
Bibliography: Feldman 1994; Kis-Jovak, Nooy-Palm,
  Schefold, and Schulz-Dornburg 1988

The Sa'dan Toraja live in the mountains of south
central Sulawesi (formerly the Célèbes). Chiefs or
nobles reside in houses called *tongkonan*, pile
structures with saddle roofs and extensive decora-
tion. The interiors consist of a series of rooms that
refer conceptually to the human body, the cardinal
directions, and the division between the living
and the dead, who are honored with elaborate
funerary rituals. This interior door from a chief's
house depicts the stylized head of a water buffalo,
a pervasive emblem of prestige and wealth as well
as strength and courage. Gracefully curving horns
encircle the central spine that perhaps alludes to
the tree of life. The rich spiral designs in the back-
ground are associated with ancestral energy. Similar
doors also grace rice barns, important symbols of
the owner's status that stand opposite the houses.

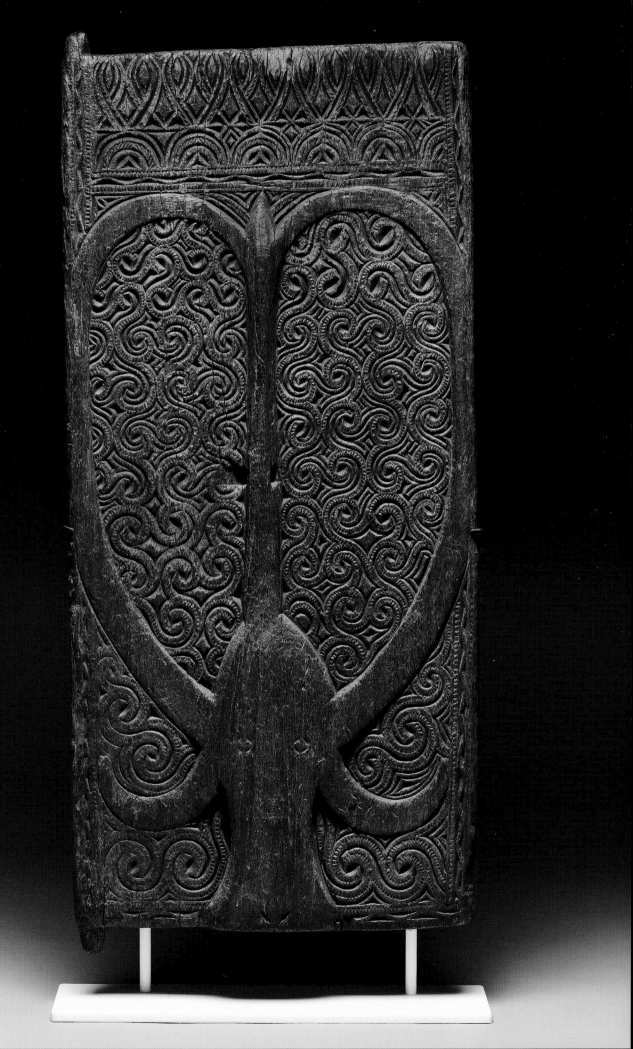

8

Melanesia, a vast region of islands and archipelagos, extends some twenty-five hundred miles from the easternmost Indonesian isles into the South Pacific.

The largest island, New Guinea, is about fifteen hundred miles long with rugged mountains, dense forests, and hazardous rivers and swamps. The peoples of Melanesia are culturally diverse. The spectacular variety and quantity of their arts preclude any single characterization. Most art forms derive from complex beliefs in the power of ancestors and protective spirit beings and in the value of communal ceremonies and ritual objects. Paul Wingert, an early Oceanic art scholar, distinguished two generalized artistic tendencies in Melanesian art: expansive polychrome forms, more common in the Sepik River, Gulf of Papua, New Ireland, New Britain, and Vanuatu; and contained sculptural forms, more prevalent in northwest New Guinea and the Admiralty, Solomon, and New Caledonia islands.

In New Guinea, now politically divided, the peoples in the northwest — which includes Teluk Cenderawasih (formerly Geelvink Bay), Teluk Yos Sudarso (formerly Humboldt Bay), and Lake Sentani — have created some of the island's most distinguished works of art. The bold sculptures of the Asmat in the southwestern part are equally famous. The Dutch ruled western New Guinea until it became part of the nation of Indonesia in 1949. It was known previously as Irian Jaya, but in 2002 the Indonesian government renamed it Papua Province.

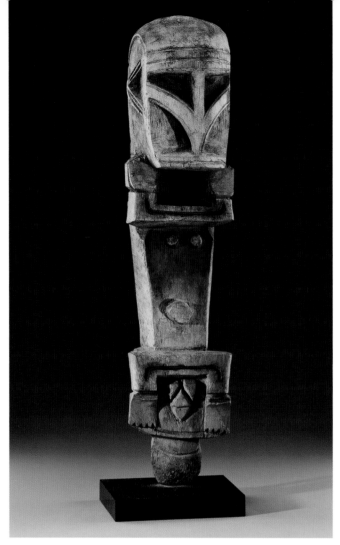

9

Carved by specialists, they served as an abode for the spiritual power of ancestors, some even incorporating the ancestral skull. *Korvar*-type imagery appeared in other contexts as well, in the handles of drums and at the top of shields. This enigmatic, compact figure seems to be a variant on the *korvar* motif. It may have been part of a canoe prow ornament providing protection and success in fishing. Among the female figure's characteristics are schematic downthrust legs and angular upraised arms, which touch the massive rectangular head with an anchor-shaped nose. Red pigment covers the entire work.

## 10   Roof panel

Lake Sentani, Papua Province, Indonesia
Early 20th century
Wood, pigment
Height 41½ inches
Collected in 1924 by H. F. Tillema. Formerly in the
    Dutch collections of Huysman, Loed van Bussel,
    and Bert da Silva
Acquired from Steven Alpert, Dallas, in 1994
Bibliography: Greub 1992

The peoples who live on the north coast of New Guinea around Teluk Yos Sudarso and nearby Lake Sentani historically shared many art forms. Accomplished wood carvings and bark paintings brought them international attention in the 1920s. Carved and painted plaques such as this one once adorned the roofs of ceremonial men's houses, where initiation rituals were held. The Dutch medical doctor H. F. Tillema collected this panel in 1924 on Lake Sentani. One of his photographs shows similar boards on a Lake Sentani house, but such plaques also occur in the Teluk Yos Sudarso area. The raised design, associated with a specific clan, depicts opposing marine spirits with large-eyed, barbed heads. Their serpentine legs terminate in fish forms, and other bird and fish shapes surround the sinuous figures. A similar motif called *karau*, which means both "human figure" and "frog," is common in Teluk Yos Sudarso tattoo patterns.

## 9   *Korvar*-style figure

Teluk Cenderawasih region, Papua Province, Indonesia
Early 20th century
Wood, pigments
Height 23 inches
Formerly in the collection of Pierre Verité, Paris
Collection of the Muséum d'Histoire Naturelle, La Rochelle,
    France, in 1940
Acquired from Wayne Heathcote, New York, in 1986
Bibliography: Baaren 1968; Newton 1999

The Austronesian-speaking inhabitants of the Teluk Cenderawasih region in northwestern New Guinea were active traders and seafarers with close cultural ties to peoples in Indonesia. Their carvings echo some of the stylistic characteristics of those of their neighbors. Among the best-known works of art from this region are rigid, large-headed figures called *korvar*, which can be translated as "soul of the dead."

Roof adorned with panels, 1924

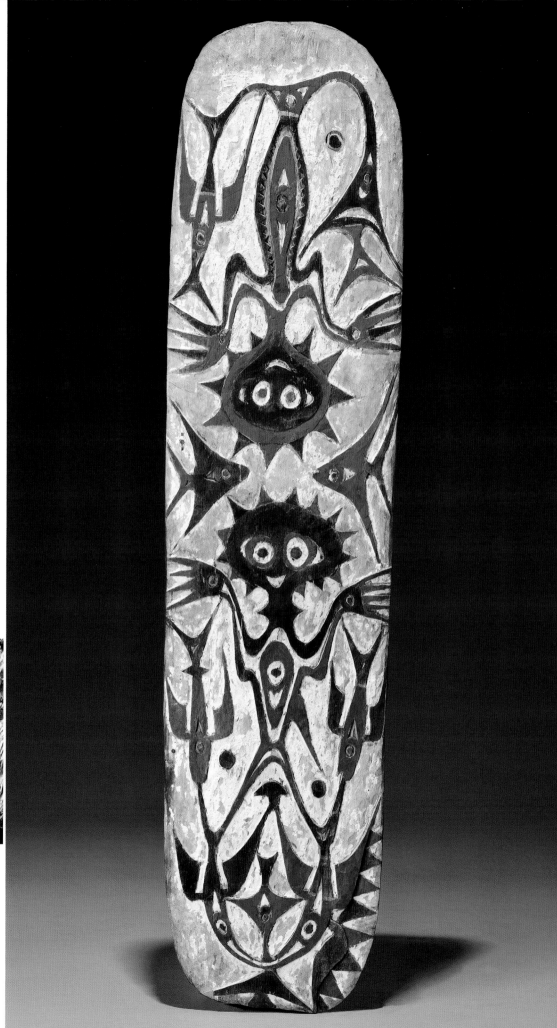

10

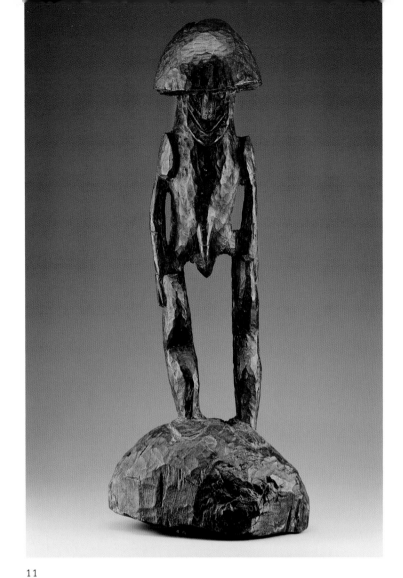

11

In the Lake Sentani region, figurative art adorned chiefs' houses, which were built on piles sunk into the water with walkways connecting them to other houses. Sculptures once crowned posts carved from tree trunks that rose through the floors and supported these structures. Figural works such as these two carvings embellished the outermost posts surrounding the base of the buildings. Both figures, now removed from the actual posts, stand on conical bases with their legs divided and their hands clasped to their torsos. Stylistic distinctions between them point to different carvers. One is compact, with the poise and serenity typical of most Sentani figures. It shares another characteristic with many of these works — its nose is missing. The other, a long-legged figure, shows an uncommon vitality of broken form and rough surface. Said to represent male and female ancestors associated with the chiefs, they reflected the chiefs' and the communities' special relationship with the ancestral world.

When the French traveler Jacques Viot arrived at Lake Sentani in 1929, he collected more than sixty post sculptures, retrieving these two near the village of Dojo, where the government had burned down one of the ceremonial houses (see the essay "From the South Seas" in this catalogue).

## 11, 12 **Male figures**

Lake Sentani, Papua Province, Indonesia
Early 20th century
Wood
Height 29 ½ inches and 27 inches
Collected and photographed in 1929 by Jacques Viot
No. 11: Formerly in the collections of Pierre Loeb, Paris,
    and Sam Kootz, New York
Acquired from David Rosenthal, San Francisco, in 1999
No. 12: Formerly in the collections of Pierre Loeb, Paris,
    and René Rasmussen, Paris
Acquired from Tambaran Gallery, New York, in 1988
Bibliography: Greub 1992; Kooijman 1959; Wirz 1923

Young man holding a carved figure, 1921 or 1926

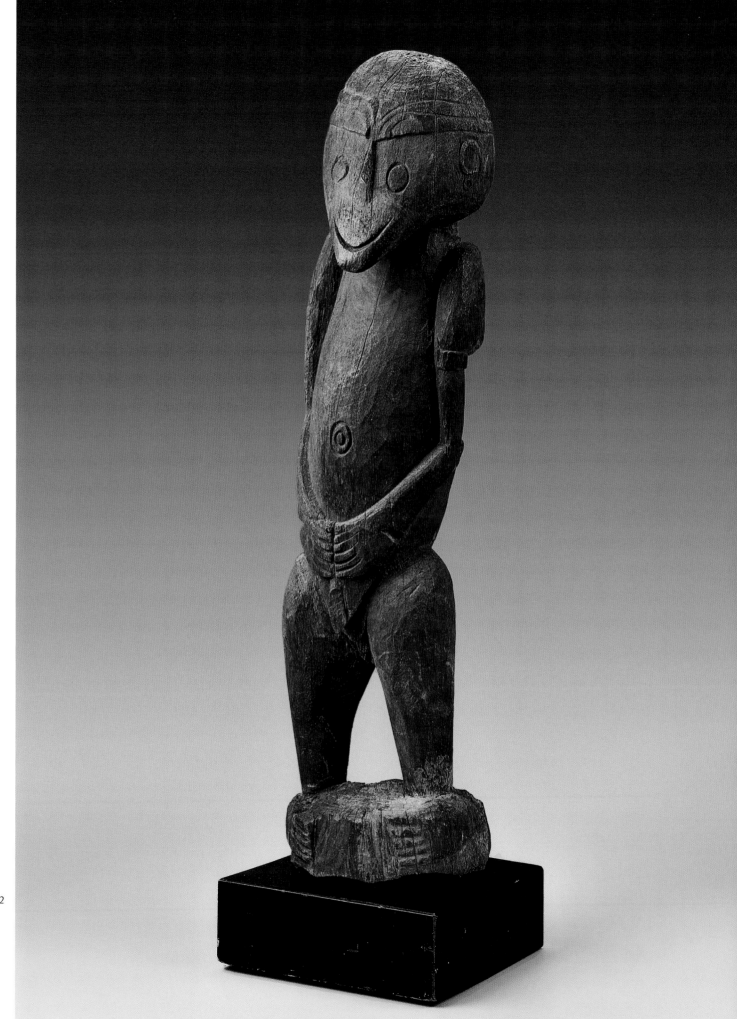

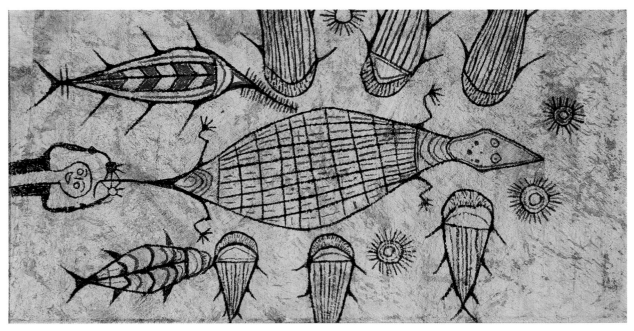

13

### 13  Bark cloth (*maro*)

Tobati, Teluk Yos Sudarso, Papua Province, Indonesia
Early 20th century
Bark cloth, pigment
Length 51 inches, width 25 inches
Gift of William E. and Bertha L. Teel   1991.1076
Possibly collected by Jacques Viot, 1929. Formerly in the
　　collection of André Lefèvre, Paris
Acquired from Wayne Heathcote, New York, in 1983
Bibliography: Greub 1992

Women in the Lake Sentani and Teluk Yos Sudarso areas traditionally produced *maro*, or cloths, from different kinds of bark, to which men applied earth pigment designs. Married women wore them as loin cloths, and *maro* were also displayed on mortuary structures. Additionally, Teluk Yos Sudarso area clans owned such cloths and draped them on the walls of men's houses. Their designs, some containing rows of nonfigural spirals, others incorporating fish, birds, and fauna, early attracted the admiration of Western visitors. Bark cloths are fragile, and few from this region in Euro-American collections predate the 1920s. In this freestyle painting of marine motifs on a tan background, which was probably part of a larger *maro*, the perspective seems to be from above, as though looking down into the water. A human figure grasps the tail of a central turtle-lizard creature, surrounded by a barbed sawfish and other fish. The circular forms with radiating lines suggest jellyfish. This cloth possibly was commissioned by Jacques Viot in 1929 from artists in the village of Tobati on Teluk Yos Sudarso.

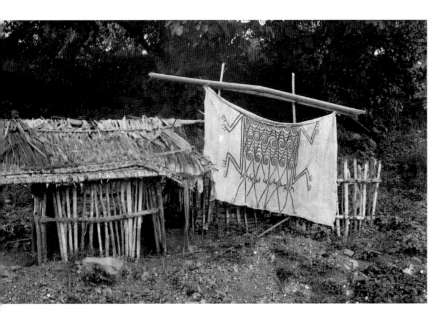

Woman's grave with a *maro* on display, about 1926

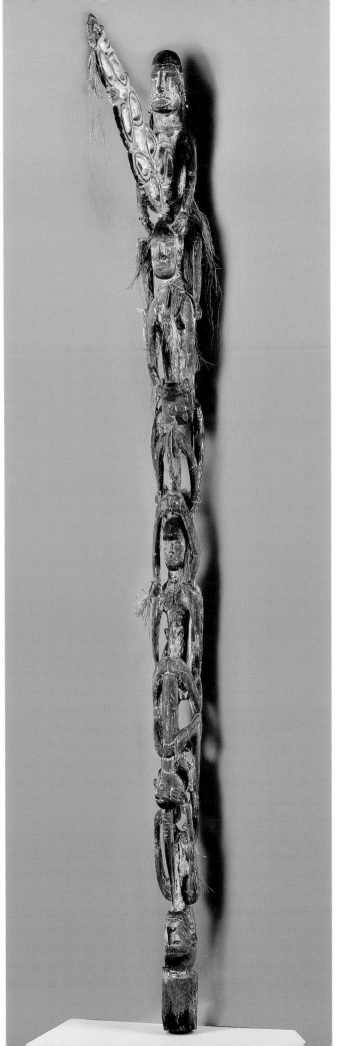

## 14  Memorial pole (*bisj*)

Asmat peoples, Papua Province, Indonesia
Second half of the 20th century
Wood, pigments, fiber, beads, and feathers
Height 124 inches
Gift of William E. and Bertha L. Teel  1994.417
Acquired from Tambaran Gallery, New York, in 1990
Bibliography: Konrad and Konrad 1996; Schneebaum 1990;
    Smidt 1993

The Asmat live near the streams and alluvial
swamps of the southwest coast of New Guinea.
Renowned in the past as warriors and headhunters,
they were among the last New Guinea peoples to
come under colonial rule when Dutch authorities
established a government post on Asmat territory in
1939. Asmat artists are known today for the bold-
ness and scale of their wood carvings, exemplified
by *bisj* (or *mbis*) poles, which can be up to thirty feet
high. Artists fashioned each pole from a single, ritu-
ally felled mangrove tree, carving the inverted trunk
into human figures and the main root into a pierced
triangular projection. The figures commemorated
ancestors whose deaths during warfare had to be
avenged to assuage their ever-present spirits. In
preparation for counterattacks, poles were carved
and erected in front of the ceremonial men's house,
or *yeu*. Upon return from a successful campaign,
the celebrants discarded the sculptures.

This pole incorporates six superposed human
figures with elongated, interlocking limbs. The life-
size heads display aggressive expressions, pierced
septums, and bared teeth. Curvilinear incising, red,
black, and white pigments, and fiber appendages
adorn the bodies, faces, and a rudimentary bird
form. The sculpture could be interpreted as a canoe
that carried the spirits of clan members to the realm
of the dead. The openwork projection at the top may
represent the canoe's exaggerated prow but also
can be interpreted as a phallus, alluding to male
prowess. In contrast to most *bisj* poles, this one is
carved from hardwood.

14

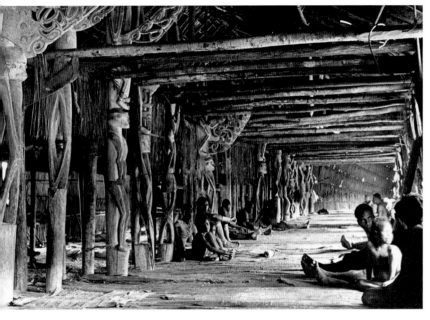

Interior of an Asmat men's house, 1961

## 15 Male figure

Asmat peoples, Papua Province, Indonesia
20th century
Wood, pigment
Height 57 ½ inches
Gift of William E. and Bertha L. Teel  1996.369
Collected before 1940. Formerly in a Dutch collection
Acquired from Wayne Heathcote, New York, in 1984
Bibliography: Gathercole, Kaeppler, and Newton 1979;
    Smidt 1993

According to Asmat mythology, the deity Fumeripitsj
was a sculptor who created the first humans by
bringing carved figures to life with his chanting and
drumming. Human figures remain a prominent
subject for Asmat carvers. Figural sculptures are
considered to be personifications of ancestors,
whose death must be avenged by warfare or ritual
actions to restore social balance. This male image,
carved from a cylindrical tree trunk as a fully three-
dimensional figure, is a remarkable example of
reductive sculpture. It rises from pointed, three-toed
feet to a knee-to-elbow posture typical for such
figures. In the myth of creation, this is the position
of the first people, animated by Fumeripitsj. The
squatting position is also reminiscent of the praying
mantis, an insect that in Asmat thought alludes to
head-hunting. The attenuated torso and small head
are marked by linear, pigmented incisions. A bird
with an open beak rises from the top of the head,
adding to the elevating effect of the open form.

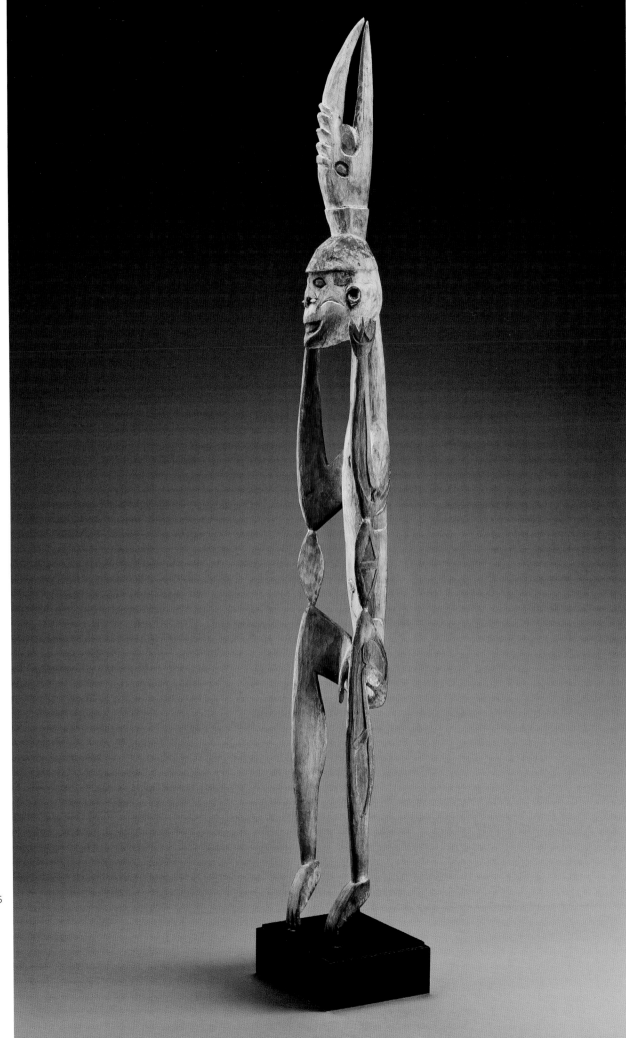

15

# 3 | Melanesia: The Sepik River Region

## One of the most prolific artistic regions of Oceania surrounds the Sepik River,

some seven hundred miles long with numerous tributaries, in present-day Papua New Guinea. The river allows for trade and communication, and the peoples in its vast watershed share certain cultural traits and objects. Men's societies historically dominated the spiritual life of the communities, staging elaborate ceremonies such as initiations, funerals, and harvest festivals. Objects played an important role in these events. At times the objects were secret, used in men's ceremonial houses and shown only to initiates; others could be seen and enjoyed by the entire community. Much of the art now in museums and private collections was created for use in these contexts.

A history of endemic warfare and the trading of objects and rituals make ethnic attributions of works often difficult. Fluid transformations of human and animal forms, colorful polychroming, and appended materials such as shells and fibers characterize artistic styles from the Sepik estuary to the interior highlands. The region has undergone tremendous changes in the last three decades. Some peoples abandoned certain rituals and art forms when they converted to Christianity. Other groups — since at least the 1930s — began producing objects for tourists and the Western art trade. Finally, some peoples revived, reclaimed, and resurrected art forms of their past, creating distinct identities for themselves in the modern state of Papua New Guinea.

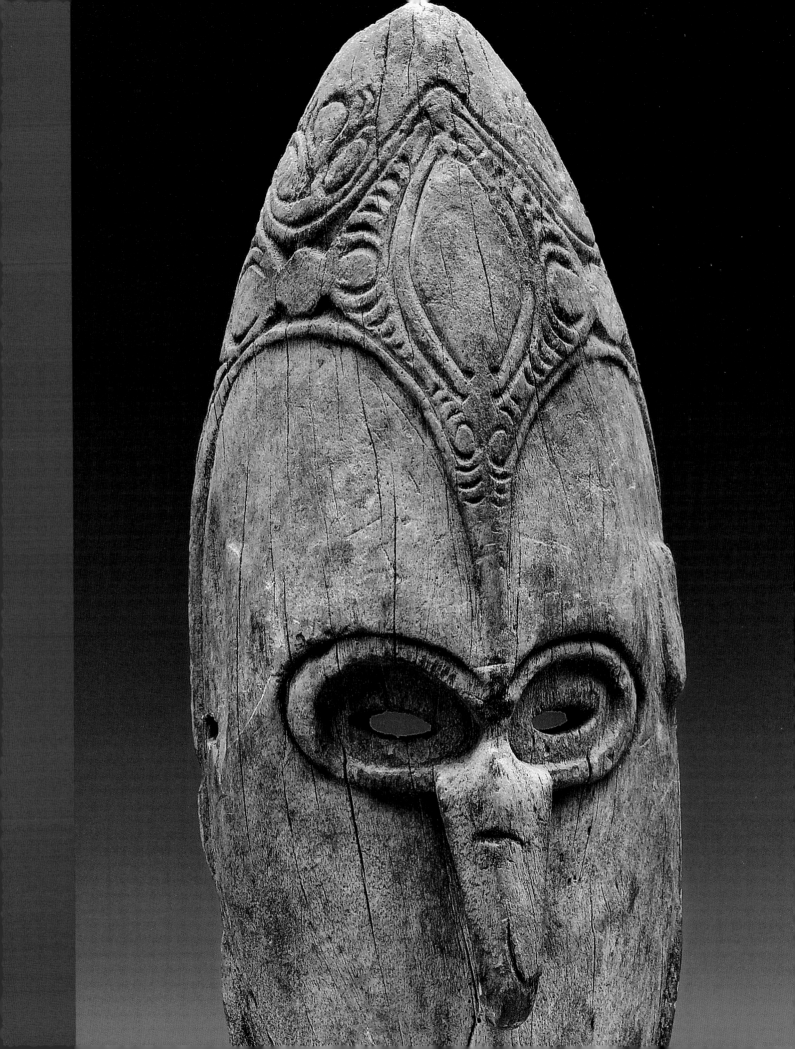

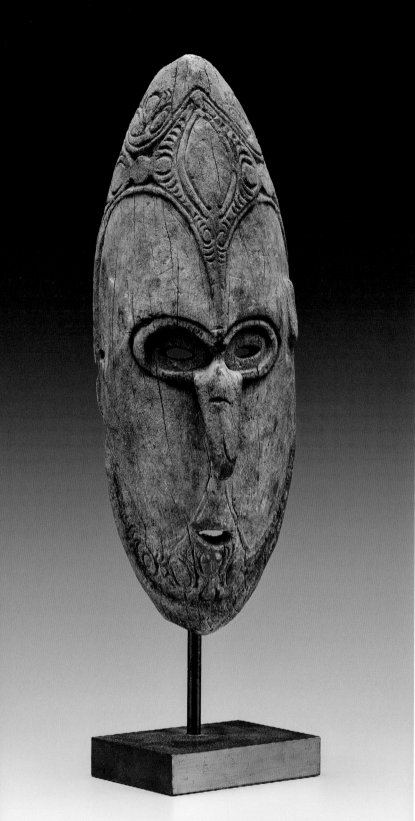

## 16 Mask

Lower Sepik, Papua New Guinea
Early 20th century
Wood
Height 15 inches
Acquired from Alain Schoffel, Paris, in 1991
Bibliography: Kelm 1966–68; Schmitz 1971;
    Smidt and Eoe 1999

During the German colonial period in northeast New Guinea (1884 to 1914), collectors brought hundreds of masks from the lower Sepik and the nearby Ramu River and the surrounding regions to German museums. This weathered and elegantly carved mask with its elongated oval shape and raised edges shares the stylistic characteristics of many such works. The delicate, curvilinear design of the upper part seems to represent a headdress or a coiffure that extends to a point between the eyes. The lower design curves upward to the pursed, open mouth and the hooked beaklike nose, which merges with the rimmed oval eye sockets. This combination of human and avian features is common to most Lower Sepik masks. We know little about the objects' context, because early observers seldom documented them and the festivals in which they performed have long been abandoned (although some instances are now revitalized). Some wooden masks were part of the costume of a gigantic masked being that appeared at the initiation of young men, during the inauguration of a new ceremonial house, at funerals, and in other ritual contexts. Traditionally, these masks functioned as representations of spirit beings or ancestral spirits.

Religious procession with feather masks, about 1910

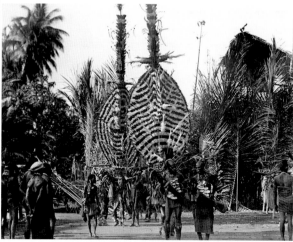

16

## 17  Male figure

Breri or Kominimung peoples, Goam and Upper Ramu
    rivers, Papua New Guinea
Mid-20th century
Wood
Height 24 inches
Gift of William E. and Bertha L. Teel  1991.1080
Collected in the 1950s. Formerly in the collection of Walter
    Randel
Acquired from Wayne Heathcote, New York, in 1985
Bibliography: Kelm 1966–68; Smidt 1975; Smidt 1990

The Breri and Kominimung peoples live on the upper
reaches of the Ramu and its tributary, the Goam
River south of the Sepik. We know little about the
functions and spiritual contexts of most arts in this
area, partly because many ritual objects were so
sacred that the people did not readily show or part
with them. Moreover, between the 1950s and the
1970s, collectors and dealers who ventured into the
area rarely documented their finds. Masks and
figures such as this one may possibly refer to protec-
tive mythical or historical ancestors. Some may have
been attached to bamboo flutes. This figure's power
is not in its long legs, swollen abdomen, and spindly
arms, but in the large masklike head. Its maker
pierced the oval perimeter to hold attachments and
rendered the facial plane with concentric ridges at
the mouth, eyes, and brow. The eye sockets melding
into the triangular nose form a heart-shaped face.

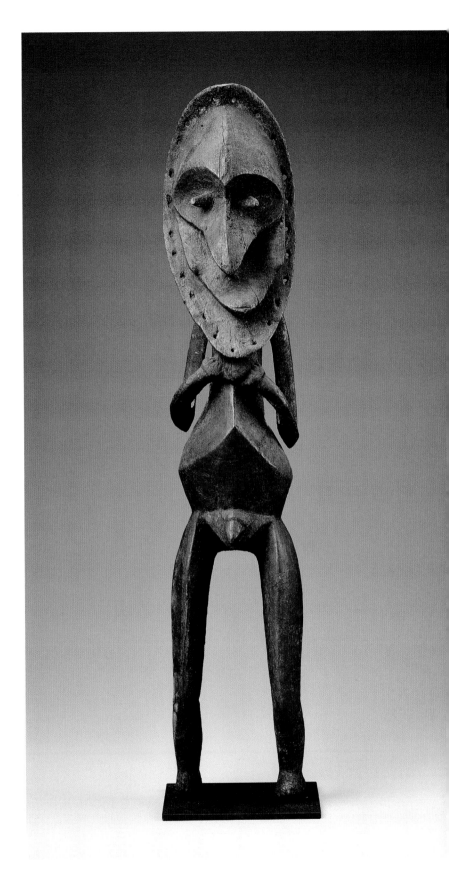

17

## 18  Mask

Kambot peoples, Yuat and Keram rivers, Papua New Guinea
19th–early 20th century
Wood, pigments
Height 11½ inches
Gift of William E. and Bertha L. Teel  1994.400
Collected in New Guinea by members of a German
    expedition. Formerly in a private German collection
Acquired from Tambaran Gallery, New York, in 1982
Bibliography: Bühler, Barrow, and Mountford 1962;
    Kelm 1966–68; Stöhr 1987

The Kambot peoples and the neighboring
Mundugumor (also known as Biwat) live on the Yuat
and Keram rivers. They traditionally stored masks
such as this one in ceremonial or dwelling houses
and brought them out for initiations and other ritual
activities. Kambot masks tend to be elongated and
oval, whereas related masks of the Mundugumor are
rounded. Like its Mundugumor counterparts, this
narrow mask has a short, bulbous nose with a
pierced septum above a protruding open mouth.
Beneath the topknot, the high forehead melds into
arching brows over the ringed circular eyes. Raised
knobs on the cheeks and forehead add to the sculp-
tural vigor, and white pigment on the recessed areas
and yellow and red on the protrusions lend color.

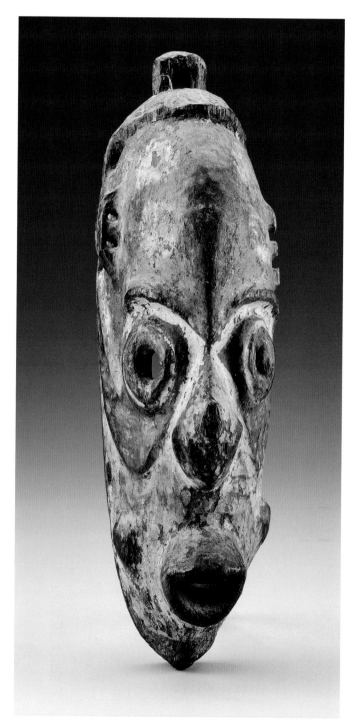

18

## 19  Sago palm spathe painting

Kambot peoples, Yuat and Keram rivers, Papua New Guinea
Mid-20th century
Sago palm spathe, fiber, pigment
Height 50 inches, width 34 ½ inches
Formerly in a New York State collection
Acquired from Tambaran Gallery, New York, in 1994
Bibliography: Huppertz 1992

In the Keram River region, the Kambot and Kam-
brambo peoples, known collectively as Tin-Dama,
hang both feather boards and paintings created on
sago palm spathe (the leaflike material that sur-
rounds a tree's stem) on the inside and outside of
men's houses. The panels depict birds, crocodiles,
and mythical characters such as Mobul, the primo-
genitor of the Kambot. Mobul is the powerful, frontal
figure on this two-part palm spathe panel lashed at
the middle. The artist painted his swelling, muscular
body in ochre pigment and used white and ochre for
the large, round eyes and hook nose on the oversize
circular head. Geometric designs in the same colors
fill the areas surrounding the imposing image.

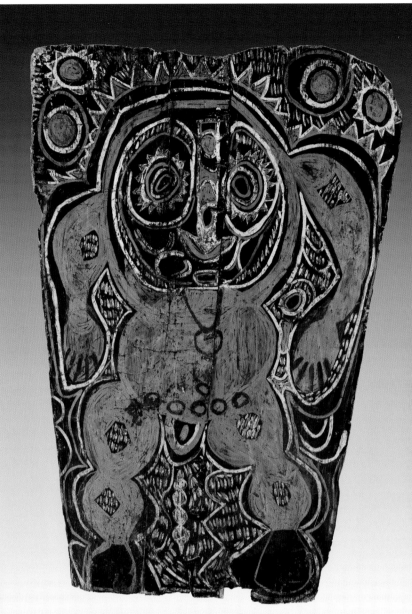

19

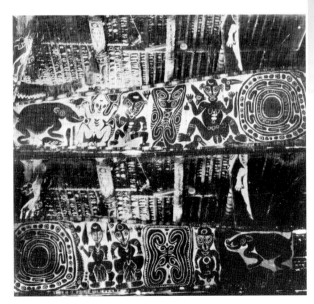

Painted panels in a Kambot men's house, 1930

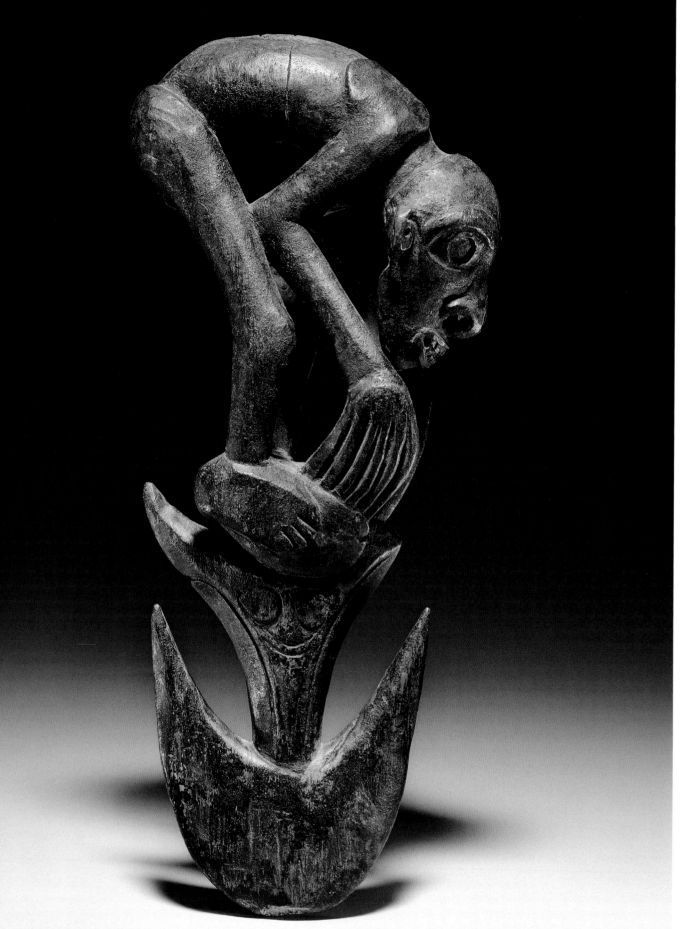

## 20  Suspension hook

Mundugumor (Biwat) peoples, Yuarma, likely a Yuat River
    tributary, Papua New Guinea
20th century
Wood
Height 13 inches
Gift of William E. and Bertha L. Teel  1994.403
Collected by E. J. Wauchope, Sydney, Australia, in 1938
Acquired from Wayne Heathcote, New York, in 1984
Bibliography: Bühler, Barrow, and Mountford 1962;
    Moore 1968

Wooden hooks varying in size and elaboration are
among the most common objects from the Sepik
region. Fastened by rope to the rafters of ceremonial
men's houses or family dwellings, they suspend net
bags or baskets filled with ritual paraphernalia, valu-
ables, and food, thus protecting these items from
insects and moisture. Typically, standing figures in
frontal poses surmount such hooks, especially the
more elaborate ones from the men's houses. This
hook is unusual in representing a crouching figure in
profile. It is similar to another hook with two profile
figures now in the Australian Museum in Sydney that
was also collected by E. J. Wauchope during one of
his collecting expeditions to the Sepik for that
museum. The bowed torso of this figure mirrors the
lower curve of the hook. Flexed legs and arms,
grasping feet, and large six-fingered hands support
the figure. The heavy brows, pierced nose, and
round eyes (which were once inlaid) are characteris-
tic features favored by Mundugumor artists. The
sculptor delicately incised triangular, large-eyed
faces in low relief on both sides of the upper hook.

## 21  Female figure

Mundugumor (Biwat) or neighboring peoples, Yuat River,
    Papua New Guinea
20th century
Wood, traces of pigment
Height 19 inches
Gift of William E. and Bertha L. Teel  1991.1079
Formerly in private collections in Germany, then France
Acquired from Wayne Heathcote, New York, in 1979
Bibliography: Kaeppler, Kaufmann, and Newton 1997

The artists of the Mundugumor and their neighbors
carved especially bold sculptures. Although this
figure has been attributed to the Mundugumor,
rather unusual stylistic features such as the protu-
berant belly indicate that it may come from a nearby
area. Like other anthropomorphic works from the
Sepik region, it is thought to represent a powerful
legendary or recently deceased ancestress.
Communities traditionally kept large figures of this
type in ceremonial houses. Families owned smaller
sculptures, such as this one, which had proper
names and were recognized as spirits that could
benefit the family and the community. This female
figure — with its forward-thrusting head and
hunched shoulders — assumes a dynamic, almost
threatening pose. Its tension and its broken form
suggest imminent movement and belie its relatively
small size. With feet clutching a mound base, it
stands with flexed, widespread legs, bulging stom-
ach and breasts, and a face with prominent ridged
eyes and pierced septum. The weathered, heavy
wood retains faint traces of red and white pigments.

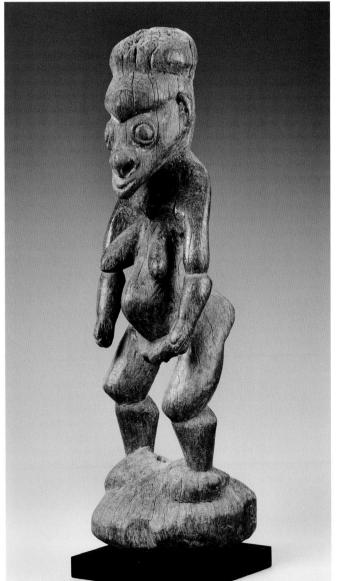

21

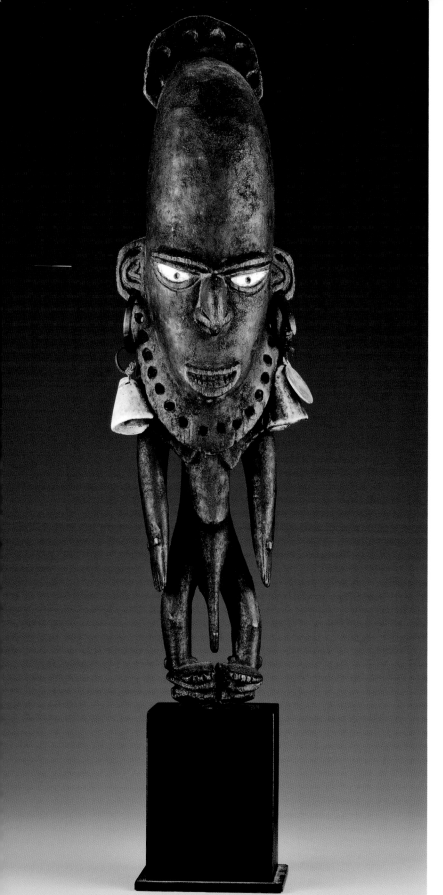

22

## 22  Flute figure

Mundugumor (Biwat) and neighboring peoples, Yuat River,
    Papua New Guinea
Early 20th century
Wood, conus shell, metal coin
Height 21 inches
Gift of William E. and Bertha L. Teel  1991.1078
Collected by an expedition in 1932. Formerly in a
    German collection
Acquired from Wayne Heathcote, New York, in 1985
Bibliography: McDowell 1991; Pelrine 1996

Men of the Mundugumor and their neighbors cus-
tomarily owned sacred bamboo flutes of up to eight
feet in length, precious heirlooms preserved by fam-
ilies. During feasts and ceremonial occasions such
as initiations of young men into the *ashin*, or croco-
dile, cult (one of the few cults anthropologists
observed among the Mundugumor), men played the
flutes sideways. When not using the instruments,
owners wrapped them in mats and inserted wooden
stopper figures to protect the upper end of the bam-
boo tube close to the mouth hole. Many such figures
reside in museums and private collections, and this
one closely resembles the others. The dwarfed body
with dangling arms is overpowered by the prominent
head, which the Mundugumor consider the most
sacred part of the body. A carver created the
wooden part of the stopper, and members of the
community attached prestigious materials such as
feathers, hair, and shells to the holes around the
high-domed, bearded head. All of the attachments
have disappeared except the ear ornaments of shell
and a metal 1928/29 head-tax token of the territory
of New Guinea. The dark overall coloring, which may
have been applied after the work arrived in Europe,
emphasizes the white shell eyes.

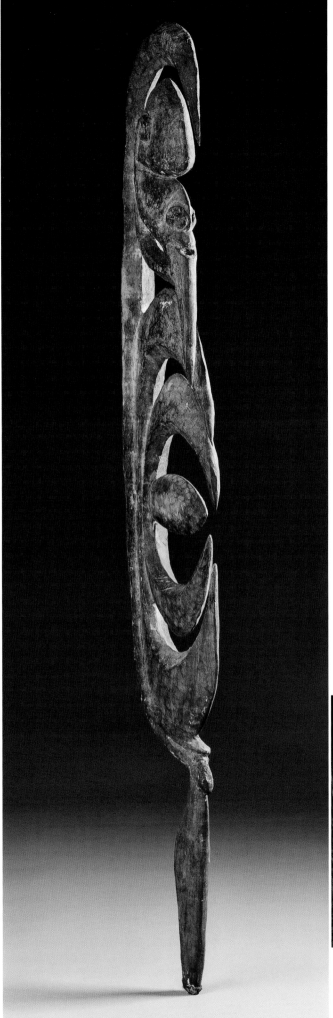

## 23   Hook figure (*yipwon*)

Yimar peoples, Korewori River, Papua New Guinea
Early 20th century
Wood, shells
Height 38 ¼ inches
Formerly in the collection of Stephen Kellner,
    Sydney, Australia
Acquired from Maurice Bonnefoy, New York, in 1987
Bibliography: Haberland 1964; Haberland and Seyfarth
    1974; Kaufmann 2003

Among the Yimar peoples, who live on the Korewori
River, *yipwon* figures were the traditional focus of
religious life. People believed that these sculptures
were beings imbued with souls, and they ensured
men's good fortune during hunting and warfare.
Men carried small hook figures in their net bags,
and communities kept larger ones — images of the
patron spirits of the clan — in ceremonial houses,
propitiating them and passing them down through
the generations. This thin, planklike carving sug-
gests a profile figure, whose body consists of oppos-
ing hooks, standing on a single leg. The figure's
backbone extends upward into a beaklike hook that
overhangs the large head's bulging forehead,
pointed beard, and shell eyes. The central hooks
suggest curving ribs surrounding the heart.

This work closely resembles other figures that Eike
Haberland and Siegfried Seyfarth, two German
ethnologists, collected in the Sepik for the Museum
der Weltkulturen, Frankfurt, in 1961. Social condi-
tions were changing dramatically in the region at
that time. As people increasingly converted to
Christianity, many figures became obsolete and
their owners sold them to foreign collectors.

23

*Yipwon* hook figures
in a house, 1973

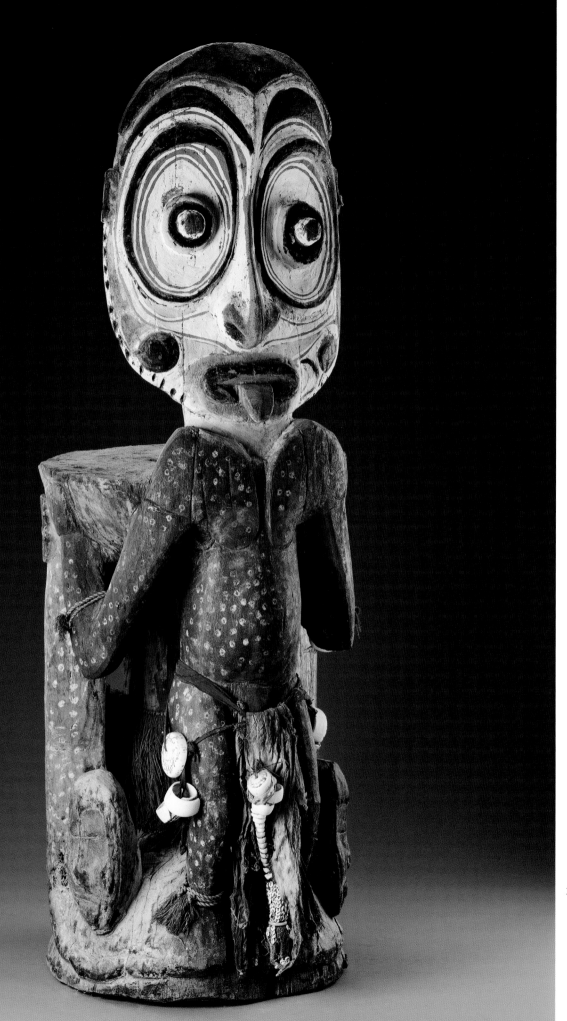

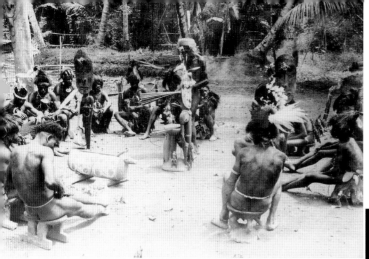

Iatmul men assembled around an orator's stool, 1953

## 24 Ceremonial stool (*teket*)

Iatmul peoples, Middle Sepik region, Papua New Guinea
Mid-20th century
Wood, shells, cloth, raffia, pigments
Height 55 inches
Collected in the western Iatmul village of Korogo
Acquired from Gallery Lemaire, Amsterdam, in 1975
Bibliography: Greub 1985; Stöhr 1972

The Iatmul live in the Middle Sepik region, their villages dominated by the distinct men's ceremonial houses. Stools known as "orator chairs" customarily stood at the center of these houses. These unusual objects functioned similarly to a pulpit in Western cultures: men used them during speeches as a stand or podium. Standing beside the stool to discuss political matters or tell details of clan history and mythology, speakers emphasized their point by holding a bundle of sacred leaves and placing a leaf on the seat after each pronouncement. The frontal figure on each stool embodies an important ancestral spirit of the community that could be summoned by ritual means. On this large example, the principal figure's proportions are relatively realistic, apart from the reverse bend of the arms and the oversize polychrome face that commands attention with its prominent eyes and protruding tongue. The mound-like base bears two life-size heads and two supporting posts, one shaped as a crocodile, the other as a serpent. The artist carved the back support as a half-size female figure standing hands-to-hips in a raffia skirt.

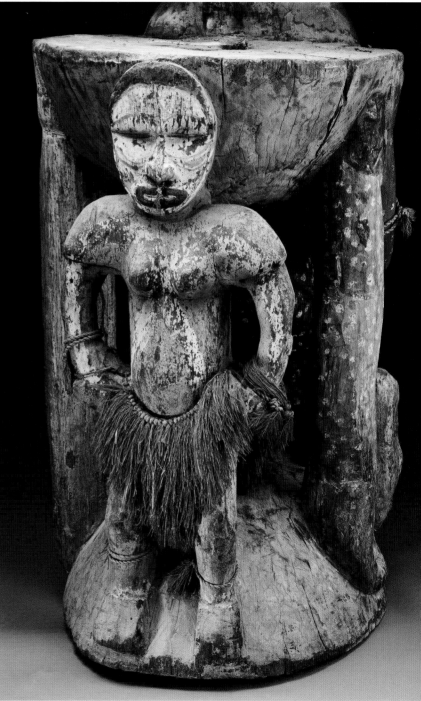

24 (back support)

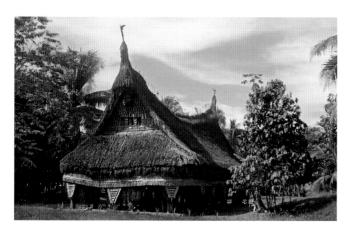

Sawos men's house with a decorated gable, 1959

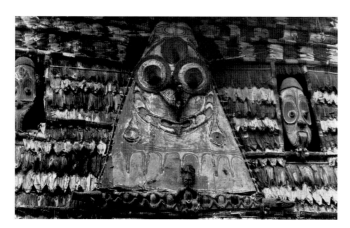

No. 25 in situ, attached to the gable of a men's house, 1964

## 25 House panel

Sawos peoples, Torembi, Middle Sepik region,
    Papua New Guinea
20th century
Wood, pigments, fiber
Length 48 ½ inches
Gift of William E. and Bertha L. Teel  1992.406
Photographed in situ by Alfred Bühler, a well-known Swiss
    scholar, in 1959 and by Douglas Newton in 1964
Acquired from Wayne Heathcote, New York, in 1986
Bibliography: Kelm 1966–68; Wardwell 1971

The Sawos peoples of the Middle Sepik region are
divided into a number of clans associated with speci-
fic ancestors and totemic species. Wooden figures
stored in the men's ceremonial house often repre-
sented such beings. This openwork panel once was
attached to the thatched roof of a Sawos men's cere-
monial house in the village of Torembi. The horizon-
tal plank consists of a central male figure flanked by
conjoined human figures without heads, which may
allude to the ritual practice of headhunting. One end
terminates in a carved crocodile head, the other in
a boar head. The squat central figure stands with his
hands on his thighs. Men may have carried the
detachable, finely featured head as a charm during
hunting expeditions. Fiber attachments still adhere
to the figure's ear, nose, and arms, and red and
white pigments remain on the dark-brown surface.

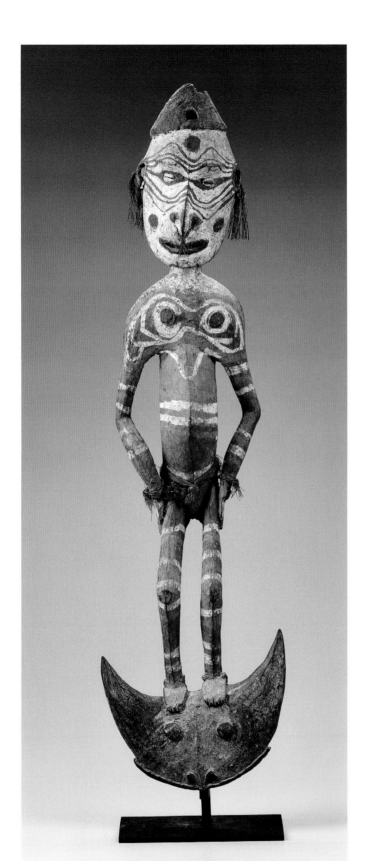

26

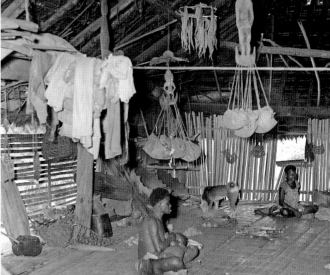

Suspension hooks in a house, 1956

## 26 **Suspension hook**

Iatmul peoples, Chambri Lake, Middle Sepik region,
    Papua New Guinea
20th century
Wood, fiber, shell, pigments
Height 36 inches
Gift of William E. and Bertha L. Teel  1991.1077
Collected from the Iatmul/Chambri village of Aibom
    by Wayne Heathcote in 1963
Acquired from Wayne Heathcote, New York, in 1979
Bibliography: Schefold 1966

Although most figurative suspension hooks found
throughout the Middle Sepik region have a flat lower
element resembling an anchor or half moon, their
style varies greatly. They range in size from twelve to
eighty inches. Very large hooks with elaborately
carved figures may have hung in men's ceremonial
houses as sculptures rather than as utilitarian
objects. Like freestanding figures, which resemble
them in style and size, they may have ritual signifi-
cance, representing protective clan spirits. This
hook from the ceremonial men's house in the Iatmul
village of Aibom was collected during a 1963 census.
The hook proper is a pointed half-moon shape with
a raised relief of a schematic face. It supports a
slender, round-shouldered female figure standing
hands-to-hips with flexed legs and arms. The artist
emphasized the large face with its long nose,
pierced septum, and shell eyes by painting curvilin-
ear lines and circles on the white surface, thus
echoing the face painting of Iatmul women. White
accents enhance the dark body and limbs, and raffia
attachments adorn the ears, septum, and wrists.

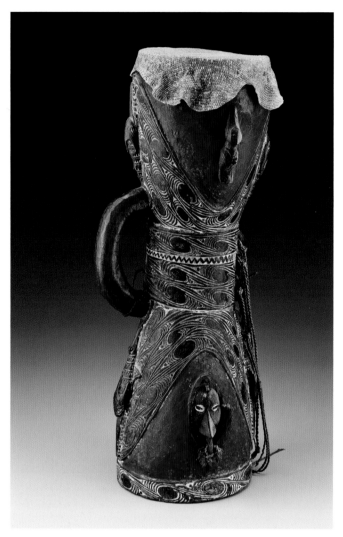

27

The many peoples of the Sepik region accompany their singing and dancing during ceremonies and rituals with various musical instruments, heightening the dramatic effect of the performances. Although slit gongs and sacred flutes were often kept from public view, men played hand drums during funerals, at the dedication of new clan houses, and when new canoes were launched. A stretched lizard-skin membrane covers this hourglass-shaped drum (the rim that held down the skin is missing), which tapers toward the middle and has a single handle. Curvilinear bands carved in low relief provide a rich decoration, from which six bird-fish forms and two human faces with shell eyes protrude. Fiber attachments and red, green, and white pigments enhance the instrument's graceful form.

## 28   Ritual money (*talipun*)

Boiken peoples, Maprik region, Papua New Guinea
20th century
Shell, plaited fiber, clay, feathers, pigments
Height 21 inches
Acquired from Maurice Bonnefoy, New York, in 1987
Bibliography: Greub 1985; May 1990

Artists among the Boiken, who live in the foothills of northern Sepik tributaries, fabricated an unusual type of object called *talipun* that circulated as ceremonial currency throughout the region. Collectors refer to the *talipun* as "bride's price," because they were exchanged during marriage transactions and on occasions such as birth, initiation, death, and the settlement of disputes. The most valuable part of a *talipun* is the large curved shell of a sea snail (*Turbo marmoratus*) that was traded inland from the coast. After cutting the shell, an artist would decorate it with a plaited fiber mask, outlining the mask's lime-paste surface with red, white, and black pigments and rimming it with cassowary feathers. Without nose or ears, the arresting face centers on pierced, telescope-like eyes. By the 1960s these works had become very rare, as the numbers of snails in shallow waters had declined. With the arrival of net fishing, the shell supply increased and Boiken artists revived the production of *talipun*, this time mainly for export. Collectors and museum specialists value the juxtaposing of materials and colors in works like this dating from the revival period.

## 27   Hand drum

Iatmul peoples, Chambri Lake, Middle Sepik region,
    Papua New Guinea
20th century
Wood, lizard skin, shells, fiber, pigments
Height 18 inches
Collected in the Iatmul/Chambri village of Indigai
    by Wayne Heathcote in 1963
Acquired from Wayne Heathcote, New York, in 1985
Bibliography: Kelm 1966–68; Wardwell 1994

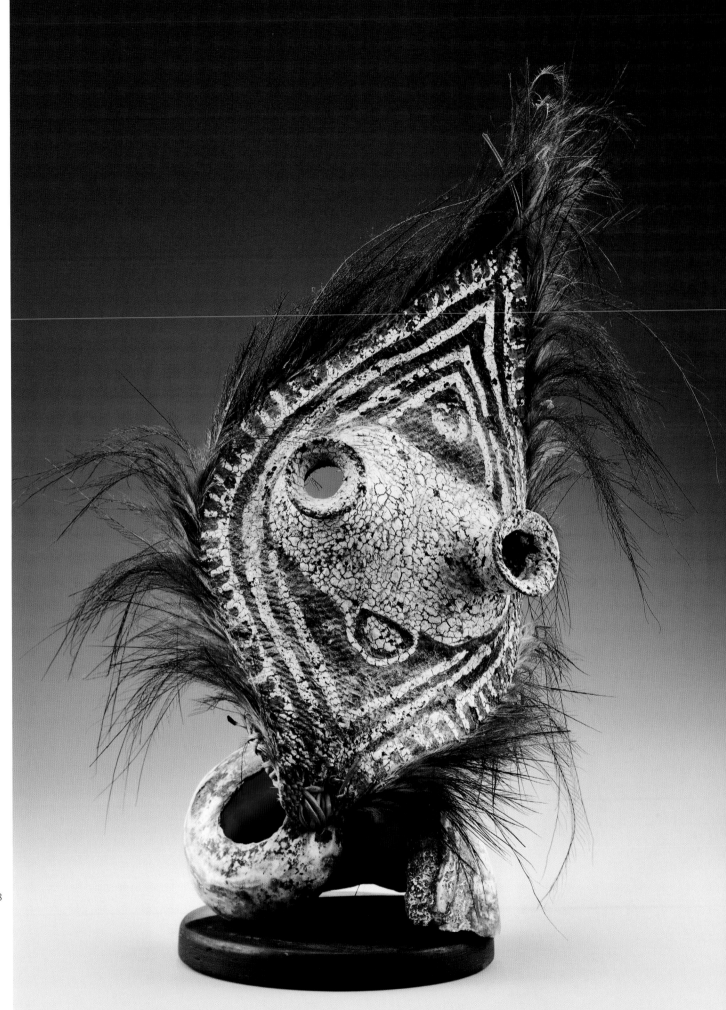

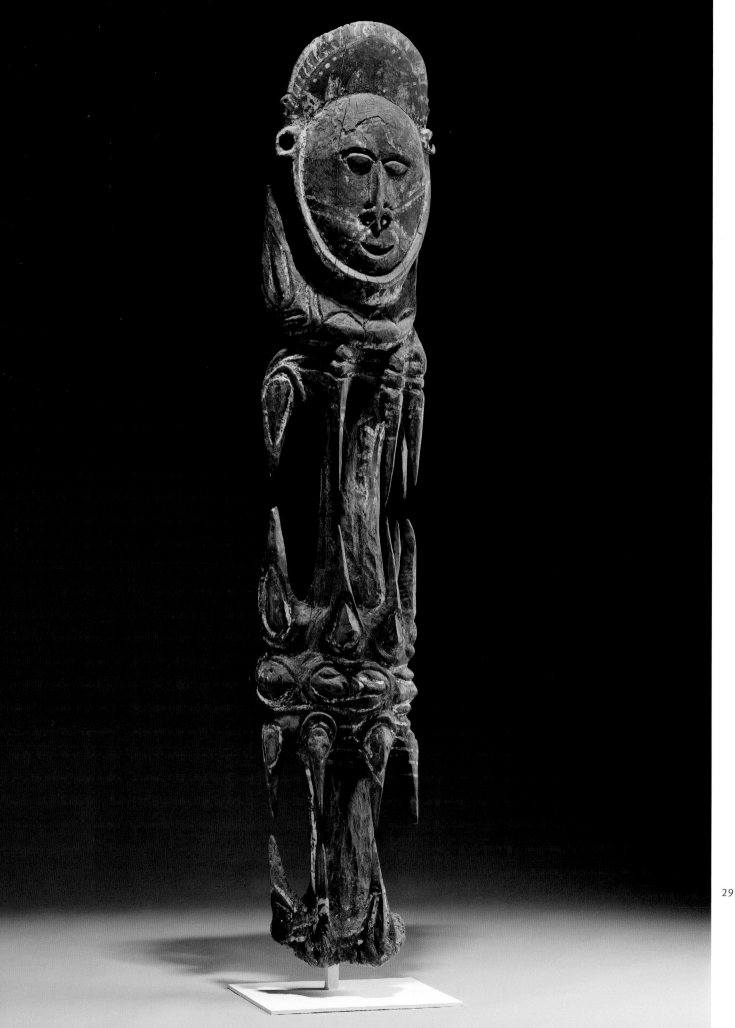

## 29 Hook figure (*nggwalndu*)

Abelam peoples, Maprik region, Papua New Guinea
20th century
Wood, pigments
Height 60 inches
Collected by Father Heinemann of the Catholic Mission
  at Wewak, probably in the late 1950s. Formerly in
  the collections of Ronald Clyne and Wayne Mones,
  New York
Acquired from David Rosenthal, San Francisco, in 2002
Bibliography: Haberland 1964; Hauser-Schäublin 1989

The Abelam constitute one of the largest linguistic
groups in the Maprik region. Many of their wooden
sculptures are semirounded, panel-like forms with
only their frontal side carved. The figures visually
embody spirit beings called *nggwal* and are among
the most secret and sacred of Abelam objects. Kept
in ceremonial houses, they play an important role
during men's initiations. This figure has registers of
hooklike appendages suggestive of the hornbill, an
important totemic bird. The crestlike shape on top of
the head, which responds to the opposing crest at
the neck, represents the oval basketry headdress
and ornaments that men wear during rituals.
Angular painted motifs in flaking red, blue, white,
and yellow pigments enliven the surface and echo
men's ritual face painting. This tall figure derives
from the ceremonial house of a southeastern
Abelam village, probably Roma. A photograph from
the late 1950s taken in New Guinea shows it beside
a similar work now in the Ethnologisches Museum,
Berlin, Germany.

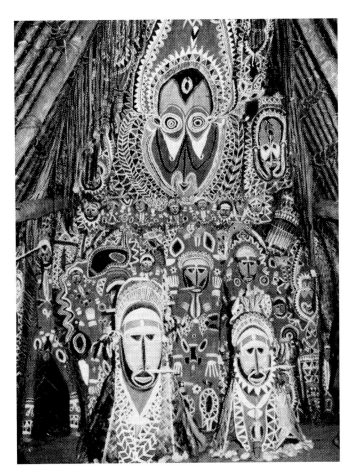

*Nggwal* figures in an Abelam men's ceremonial house

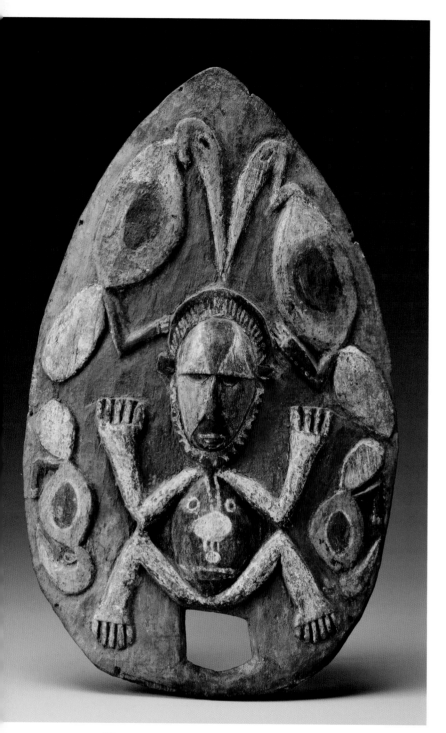

30

## 30 Headddress (*wagnen*)

Abelam peoples, Roma, Maprik region, Papua New Guinea
20th century
Wood, pigments
Height 22 ½ inches
Acquired from Wayne Heathcote, New York, in 1986
Bibliography: Hauser-Schäublin 1989

Abelam artists create surprising spatial configurations enlivened by vivid coloring. Many carved objects, such as architectural elements, human figures, and masks, have multiple meanings, transmitted through oral tradition. This low-relief oval board was made to be attached to the head of a male dancer during performances in Roma. The headdress depicts four hornbills, emblematic of certain clans and associated with fertility, surrounding a squatting figure called *ngwgwaldu-puti*, which has four- and five-fingered hands and five- and six-toed feet. An aureole framing the figure's convex head may represent a man's basketry headdress. The once brilliant polychroming has faded to soft hues over time.

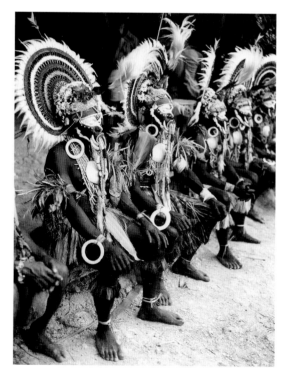

Ceremonial dancers wearing headdresses, 1980

## 31   Male figure

Arapesh peoples, Sassuia, Maprik region,
    Papua New Guinea
20th century
Wood, pigments
Height 36 ½ inches
Collected by Lynda Cunningham in the early 1970s
Acquired from Oceanic Primitive Arts, New York, in 1977
Bibliography: Kaeppler, Kaufmann, and Newton 1997

The art forms of the Arapesh peoples bear many
similarities to those of the Abelam. This stylized,
anthropomorphic figure, which may be the embodi-
ment of a male ancestor spirit, generates a remark-
able effect of tension. The open, frontally convex
form has a vertical median ridge. Its shoulders and
legs (one of which has broken off) angle sharply
upward, and its torso bears a saw-toothed design.
The large, neckless head of diamond shape displays
a long-nosed, triangular face of vivid yellow framed
by a projecting brow and beard. As with Abelam
figures, the back is not developed and the painting,
which could be reapplied for later ceremonies,
assumes an importance equal to or greater than
the sculptural form.                                    31

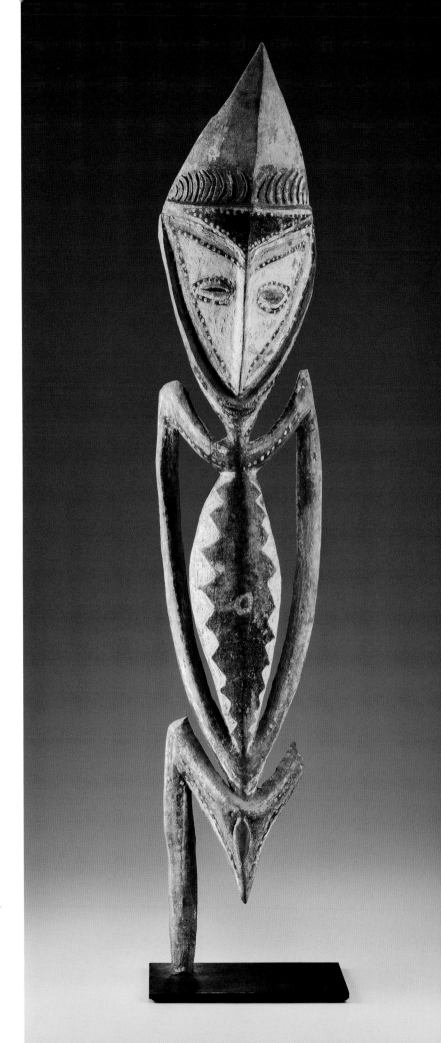

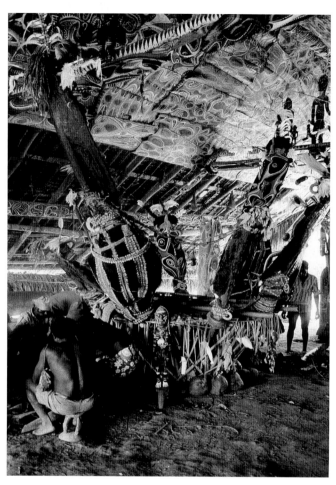

Kwoma *yina* figures in a men's house, 1973

## 32  Yam cult head (*yina*)

Kwoma peoples, Washkuk Hills, Papua New Guinea
20th century
Wood, pigments, feathers
Height 60 inches
Gift of William E. and Bertha L. Teel  1992.404
Collected by Douglas Newton in 1970, along with others
    now in the Metropolitan Museum of Art, New York
Acquired from Staempfli Gallery, New York, in 1972
Bibliography: Bowden 1983; Kaufmann 1968; Newton 1971

In the Washkuk Hills bordering the upper Sepik, the Kwoma peoples and their closely related neighbors the Nukuma and Manambu share a unique tradition revolving around the cultivation of yams. An annual series of rituals associated with the yam harvest ensures the tuber's continuing abundance and renders it suitable for human consumption. Clans sponsor the events, which are staged in a sequence of three rituals each involving different types of figures. Men carve elongated wooden heads such as this one for the first two ceremonies of the series and arrange them on a large mound of recently harvested yams. Each ritual lasts two days, during which the men perform songs and dances to purify the yams. At the conclusion of the ceremonies they store the *yina* heads, later repainting them to reinvigorate their power prior to the next series of events.

Douglas Newton, then at the Museum of Primitive Art in New York, collected this repainted head in 1970. Its long, hooklike nose descends over a facial plane dominated by bulging, ringed eyes. A serpentine tongue loops downward to touch the planklike extension of the chin or neck.

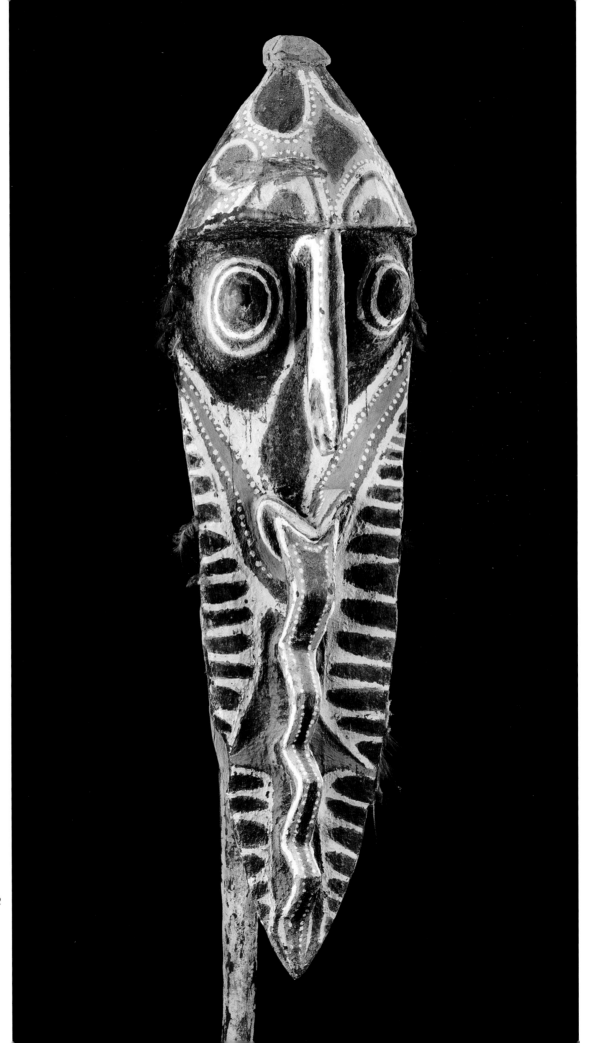

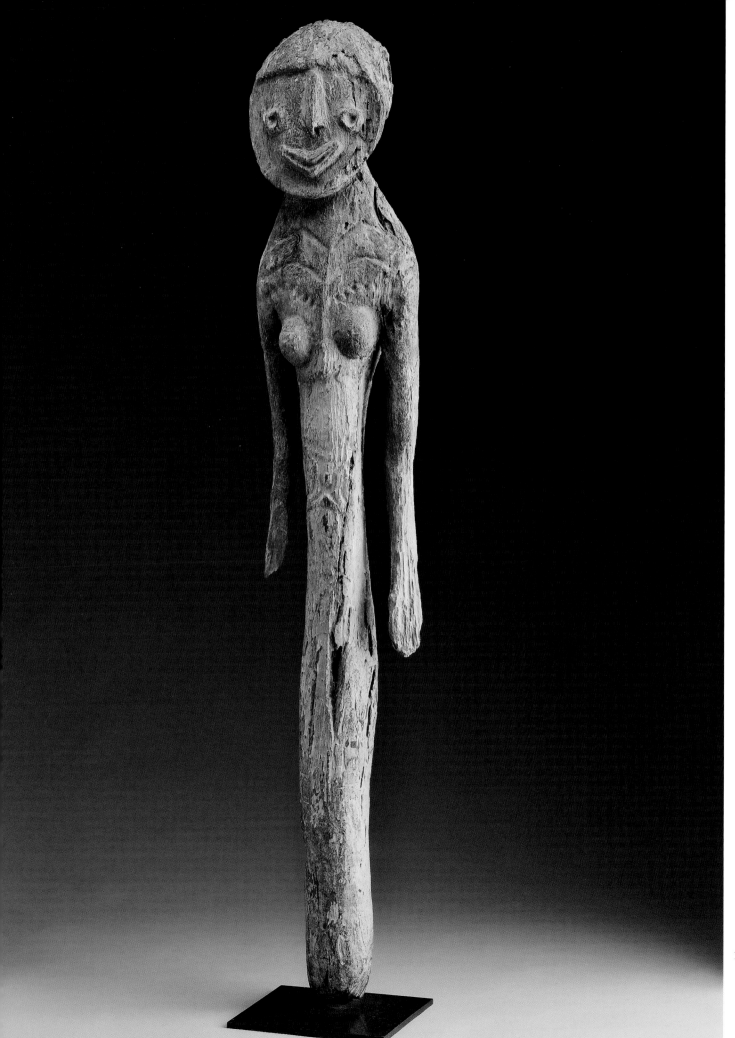

## 33  Female figure (*nokwi*)

Nukuma peoples, Maprik region, Papua New Guinea
20th century
Wood, pigments, shells, fiber
Height 39 inches
Collected by Roger Craig, 1962–63. Formerly in the
    collection of Bruce Seaman
Acquired from Kevin Conru, London, in 1994
Bibliography: Bowden 1983; Kaufmann 1968; Newton 1971

The Nukuma and Kwoma peoples restrict the third
ritual (called *nokwi*) in the annual harvest sequence
to senior male initiates only. The clan sponsoring
the ceremony displays figural sculptures embodying
female spirits, few of which have found their way
into museums and private collections. This weath-
ered piece, typical of Nukuma *nokwi* figures, has an
elongated, postlike body and a small head with min-
imal remaining features. When the annual festival
cycle ends, the men cover the sculptures with a layer
of gray clay to protect them from insects. Before the
next festival, they repaint them with white, red, and
yellow pigments over the clay. This practice accounts
for the somewhat muted quality or lack of color in
many of these statues.

## 34  Female figure (*nokwi*)

Manambu peoples, Washkuk Hills, Papua New Guinea
20th century
Wood, pigments, shells, fiber
Height 39 inches
Gift of William E. and Bertha L. Teel  1992.411
Collected in Yambun
Acquired from Wayne Heathcote, New York, in 1986
Bibliography: Newton 1971; Wardwell 1994

Art traditions associated with the cultivation of yams
also are important among the Manambu peoples, a
river-dwelling group who trade and compete with
the Kwoma to their north. Similar to Kwoma and
Nukuma practices during the third stage of the yam
ritual (*nokwi*), senior male initiates — to the sound
of drums — erect a huge platform and bring forth
carved personifications of female ancestors. This
relatively naturalistic figure stands with divided legs
and arms, hands to its hips. Rings of color empha-
size the navel and breasts, and shell eyes animate
the face. The extensive chevron pattern on the torso
echoes the designs frequently found on pottery.
This figure is said to have come from the Manambu
village of Yambun.

34

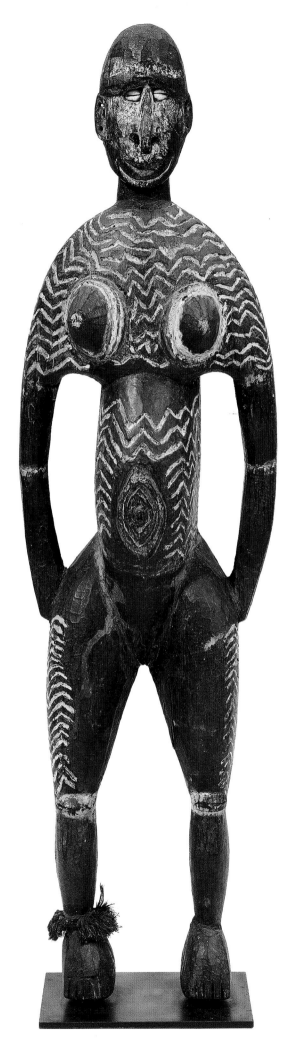

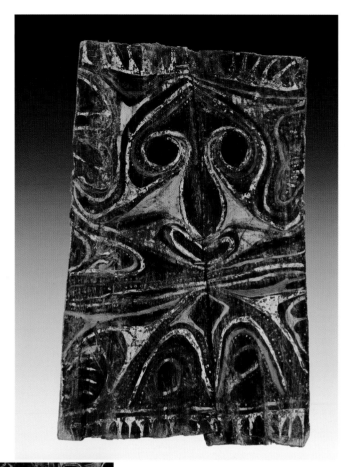

one. Outsiders sometimes received permission to acquire carvings and painted panels before this destruction. Thus, in 1970 Douglas Newton was able to purchase some 150 sago palm panels that once lined the ceiling of a Kwoma ceremonial house. This painting from the group consists of two panels lashed together and treated as a single composition. At the top is a large ghostly face with a prominent nose and ringed eyes. A line divides that face from a smaller triangular one below that is reversed like a reflection in water. The artist rendered the design in white and tan on a dark-brown ground, surrounding the faces with dots, chevrons, and curvilinear lines. This image, called *nawaa*, belonged to the Kalaba crocodile clan and was associated originally with an ancestor named Bugwiyo. In recent times, according to Newton, it also has appeared on a conical headdress used in village dance performances.

## 36 Pottery jar

Kwoma peoples, Middle Sepik region, Papua New Guinea
20th century
Clay, pigments
Height 18 inches
Acquired from Wayne Heathcote, New York, in 1986
Bibliography: Kaufmann 1972; Kelm 1966–68

Kwoma, Nukuma, and Manambu men and women made fired pottery vessels that were traded extensively throughout the middle Sepik region. They often worked collaboratively, the women shaping the pot and the men adding the figurative elements. When Swiss scholar Christian Kaufmann studied pottery making among the Kwoma in the 1960s, the craft had almost died out. His interest soon led to a revival, and many more pots became available. This cylindrical pot with its sculptured heads belongs to the context of yam harvest festivals. The upper third displays two broadly modeled janiform faces, looking in opposite directions and framed by a prominent rim. On each face, circular eyes and a protruding nose appear above a broad, crescent-shaped mouth that the Kwoma say signifies a male. The jar's upper knob has no opening, but the pierced mouths and eyes offer access to the interior. Red and white pigments emphasize the faces, and repeated linear incising marks the body of the pot.

35

## 35 Sago palm spathe painting

Kwoma peoples, Washkuk Hills, Papua New Guinea
20th century
Sago palm spathe, fiber, pigments
Height 42 inches
Collected by Douglas Newton in 1970
Acquired from Staempfli Gallery, New York, in 1972
Bibliography: Bowden 1983; Newton 1971

Painted panels and carvings on both the upper walls and the ceilings adorn the ceremonial houses of the Kwoma peoples. The designs and carved forms are the property of specific clans. Male members build and embellish the houses to last for approximately twenty years. At the end of this period, they burn each house and its contents, later erecting a new

Kwoma paintings in a men's house, 1973

Since the mid-nineteenth century, Western visitors have taken note of and gathered objects from the southeastern reaches of New Guinea, which contains

three major areas: the Gulf of Papua; the Massim region, including the Trobriand and other islands; and the area of the Huon Gulf and Tami Islands. The peoples of the coastal areas and the islands were in contact with foreign navigators even before they came under British and German colonial rule in the 1880s. In 1905 British New Guinea became part of Australia, itself newly independent from Great Britain. After World War I, Australia administered the entire region, and since 1975 the area has been part of the independent nation of Papua New Guinea.

Arts from the Gulf of Papua are some of the most varied and also well-researched in all of New Guinea, thanks to the work of Swiss ethnographer and traveler Paul Wirz in the first half of the twentieth century. Thousands of objects have been retrieved from the region called Massim (a name perhaps derived from Misima Island). To this day, these various groups' languages and material culture are surprisingly similar. A ceremonial trading system called *kula* linked them in complex individual exchange relationships and probably contributed to this homogeneity. People in the Huon Gulf and the Tami Islands also maintained extensive trading relationships, which fostered exchanges of works created by specialized artists via long-range sailing canoes.

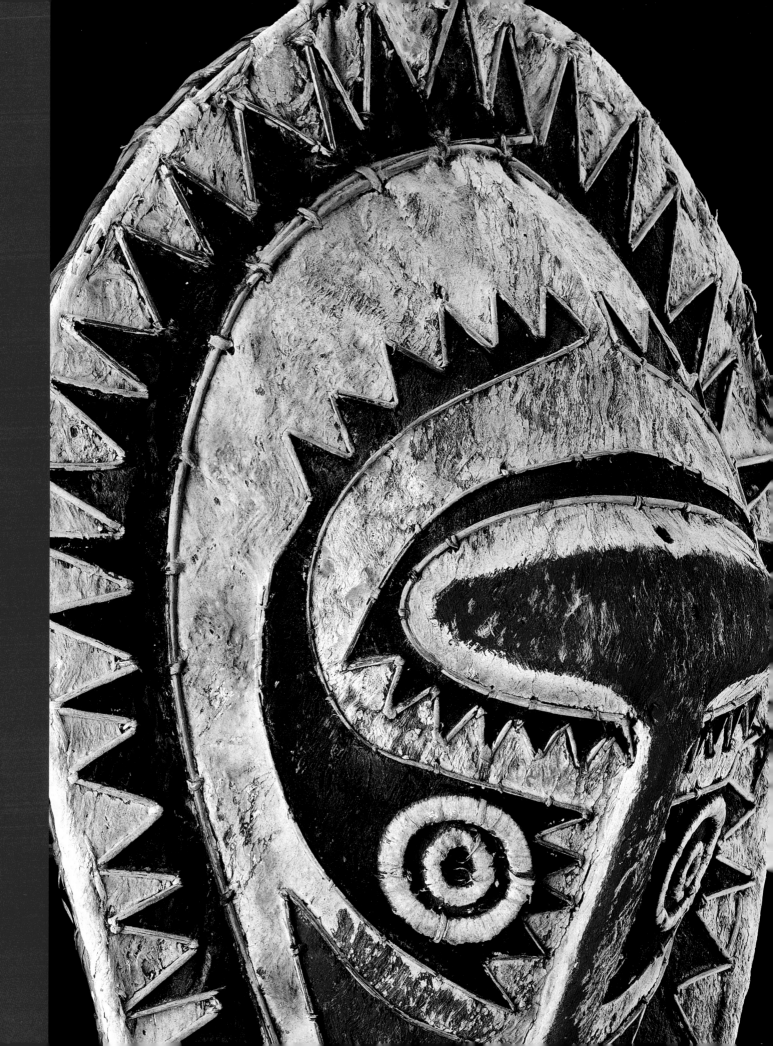

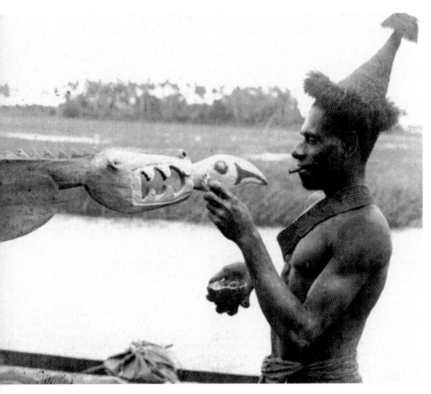

Gogodala man painting a canoe prow, 1930

## 37 Male figure (*udaga wawa*)

Attributed to Kebali of Kini
Gogodala peoples, Aramia River, Gulf of Papua region,
    Papua New Guinea
Second half of the 20th century
Wood, pigments, seeds, shells, feathers
Height 114 inches
Purchased at auction in Melbourne, Australia, by John
    Edelen in 1980
Acquired from Kevin Conru, London, in 1992
Bibliography: Crawford 1981; Newton 1961

Artists of the Gogodala, who live inland around the Aramia River, have created some of the largest, most extravagant arts in the region of the Gulf of Papua. In the past, they fashioned enormous canoes and figural images for spectacular ceremonies associated with a complex cycle of initiations for young men, which culminated with induction into the secret *aida* cult. By the 1930s, when the Gogodala converted to Christianity, they had abandoned these traditions and their artists no longer made such works. In the 1970s, however, sculptors revived many of the carving traditions to assert their Gogodala identity and to satisfy the foreign collectors' demand for Gogodala art.

Attributed to Kebali of Kini, who was active in the 1970s, this image represents a clan ancestor and was displayed during initiation rites. The central focus of the polychromed, nine-and-a-half-foot figure is the emblem, or *gawa tao*, of the Tabama clan, in the form of a jungle fowl painted on the torso and on the feathered, detachable headdress. The arms, which spread seventy-eight inches, and the feet are removable. Shells and seeds on the face and navel, a fiber skirt, and flamboyant coloring in red, white, black, and ocher add to the work's startling impact.

## 38  Figure

Turamarubi peoples, Turama River area, Gulf of Papua
    region, Papua New Guinea
Late 19th–early 20th century
Wood, pigments
Height 48 inches
Gift of William E. and Bertha L. Teel  1992.415
Collected at Goaribari by Thomas Schultze-Westrum
    in 1966. Formerly in a private Dutch collection
Acquired from Wayne Heathcote, New York, in 1980
Bibliography: Newton 1961

The human figure, a common motif throughout the
Gulf of Papua region, is seldom rendered natural-
istically and usually occurs in relief carvings. An
exception are rare three-dimensional human forms
such as this one, which artists of the Turamarubi
peoples fashioned from the fork of a tree into a
shape that precluded arms. The long, flexed legs
support a sloped-shouldered torso and a small
head with carved features. Pigment emphasizes the
triangular eyes and defines the mouth and necklace.
This figure was probably associated with the yearly
*moguru* ceremonies that ushered youths into
adulthood.

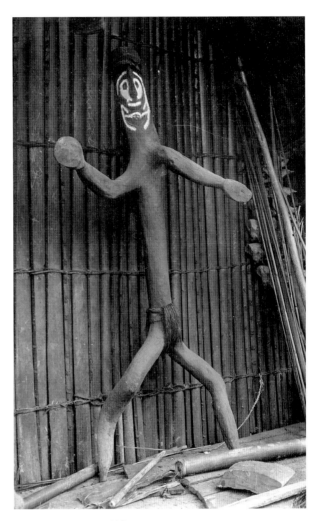

Anthropomorphic Turamarubi figure, 1930

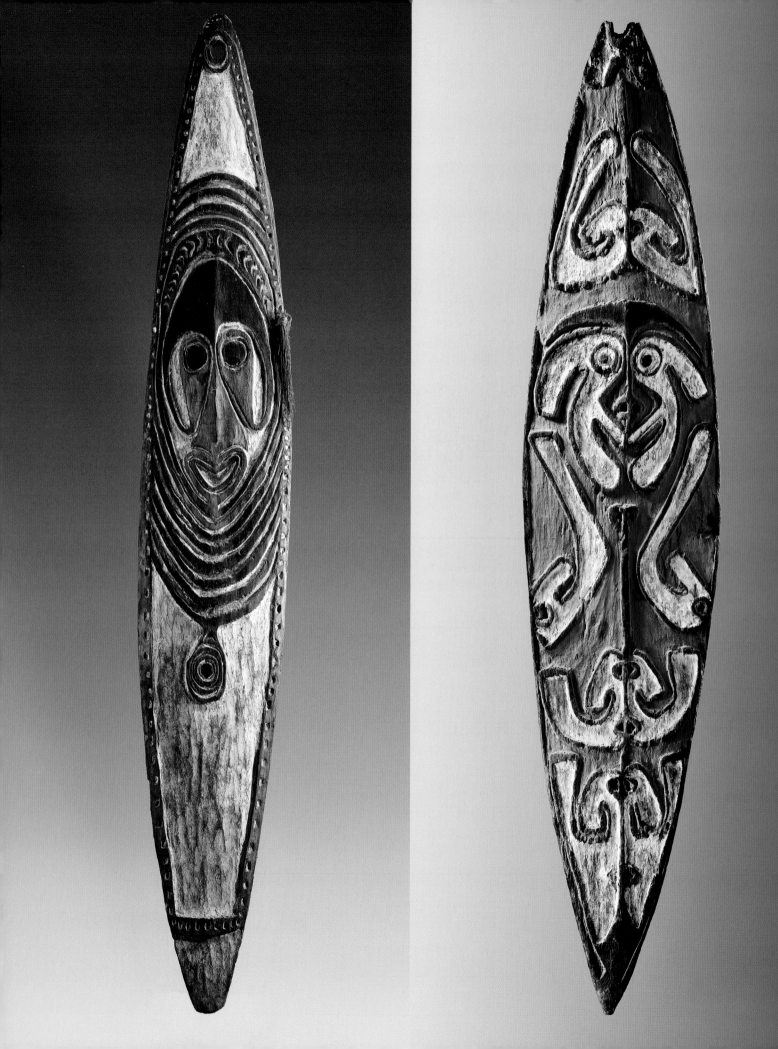

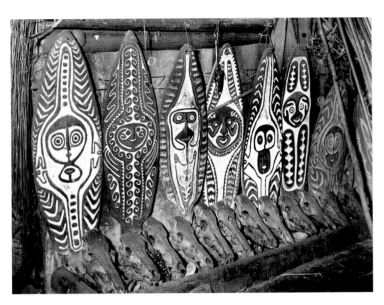

Rack with *gope* boards and crocodile skulls, about 1923

Dopina village created a raised-relief design painted in red and black on the white ground. A firm border encloses an oversize face surrounded by a number of rings. From the pointed brow, loops descend to encircle the prominent round eyes. A ringed navel is the only body part depicted. The vibrant colors indicate that this board has been repainted.

## 39  Board (*gope*)

Kerewa peoples, Dopina, Goaribari Island, Gulf of Papua
  region, Papua New Guinea
20th century
Wood, pigments
Height 78 inches
Collected by Thomas Schultze-Westrum in 1966. Formerly
  in the collection of Morton May, St. Louis
Acquired from Wayne Heathcote, New York, in 1983
Bibliography: Newton 1961; Newton 1999

So many narrow oval boards called *gope* were fashioned by the Kerewa peoples or collected from Goaribari that the name of the island became synonymous with the object. Referred to as "crocodile spirits," the boards differed in size, style, and importance. Large boards honoring clan ancestor spirits played a prominent role in ceremonies that involved initiations and hunting raids. These were stored in the ceremonial men's house, whereas small *gope* owned by uninitiated youths were kept at home. The maker of this tall, pointed oval board from

## 40  Board (*gope*)

Era River, Gulf of Papua region, Papua New Guinea
Late 19th–early 20th century
Wood, pigments
Height 40 ½ inches
Collected by Paul Wirz in the Gulf of Papua region in 1930
Acquired from Gallery Lemaire, Amsterdam, in 1970
Bibliography: Newton 1961; Newton 1999; Wirz 1934

*Gope* boards perfectly illustrate the two-dimensional, symmetrical character of much of the art of the Gulf of Papua. Their designs center on human images subject to remarkable transformations. Some depict schematic figures with large heads and prominent eyes, whereas others, such as this one, are virtually abstract. White hooklike shapes are balanced here on each side of a central vertical axis. Some of these seemingly animal-like elements have small eyelike indentations, and a face is approximated at the center by rings suggesting eyes and opposing curves indicating a mouth. A hole at the top, which is broken due to use, permitted this *gope* to be hung. According to the information received from the Gallery Lemaire, Paul Wirz collected it in 1930.

39, 40

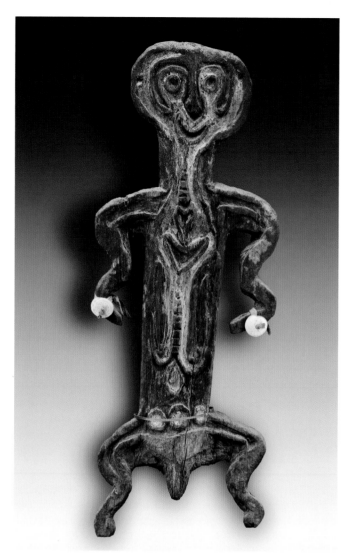

41

hunter-warrior spirits. One type of board called *bioma* is a flat, silhouetted figure. This remarkable, roughly fashioned example apparently was carved with stone tools. The curves of the dangling limbs lend it a degree of animation, and the raised contours of the torso reveal the internal organs, as in an x-ray. Traces of white pigments remain in recessed areas, and cloth bindings attach shells to the wrists.

## 42  Mask (*eharo*)

Elema peoples, Orokolo, Gulf of Papua region,
 Papua New Guinea
Late 19th–early 20th century
Cane, bark cloth, fiber, pigments
Height 24 inches
Formerly in the collection of Julius Konietzko, Hamburg
Acquired from Robert Burawoy, Paris, in 1977
Bibliography: Mamiya and Sumnik 1982; Williams 1940

Among the Elema, a designation referring to several groups that speak dialects of the same language, many art forms traditionally were connected with large festivals. They marked events in people's lives and often served as occasions for exchanging valuable goods. *Hevehe*, one such festival cycle addressing spirits of the sea, required the efforts of the entire community for up to fifteen years. Different masks with elaborate costumes appeared at certain stages of the festival. Some were sacred, while others, such as the *eharo* masks, entertained. Referred to as "things of gladness," *eharo* were fashioned by festival guests from neighboring villages. The young men who wore these masks reenacted stories through dance and song. In this example, a sturdy cane frame supports an oval bark-cloth face with pointed chin and projecting snout. Blue chevrons surround the convex facial plane, and upswept blue elements emphasize the ringed eyes. Small stitched canes outline the colored areas. The men destroyed sacred *hevehe* masks at the end of the cycle, but their makers often kept the *eharo* masks.

This mask came from Julius Konietzko, an early twentieth-century Hamburg collector and dealer who supplied objects to many important German ethnographic museums.

## 41  Figure (*bioma*)

Era River, Gulf of Papua region, Papua New Guinea
Late 19th–early 20th century
Wood, pigments, shells
Height 35 ¼ inches
Collected by Paul Wirz in the Gulf of Papua region in 1930
Acquired from Alain Schoffel Gallery, Paris, in 1970
Bibliography: Newton 1961; Newton 1999; Wirz 1934

In the Era River area of the central Gulf of Papua region, communal longhouses were divided by an aisle into niches belonging to particular clans. Partitions and racks supported trophy skulls and a variety of ancestor boards that commemorated

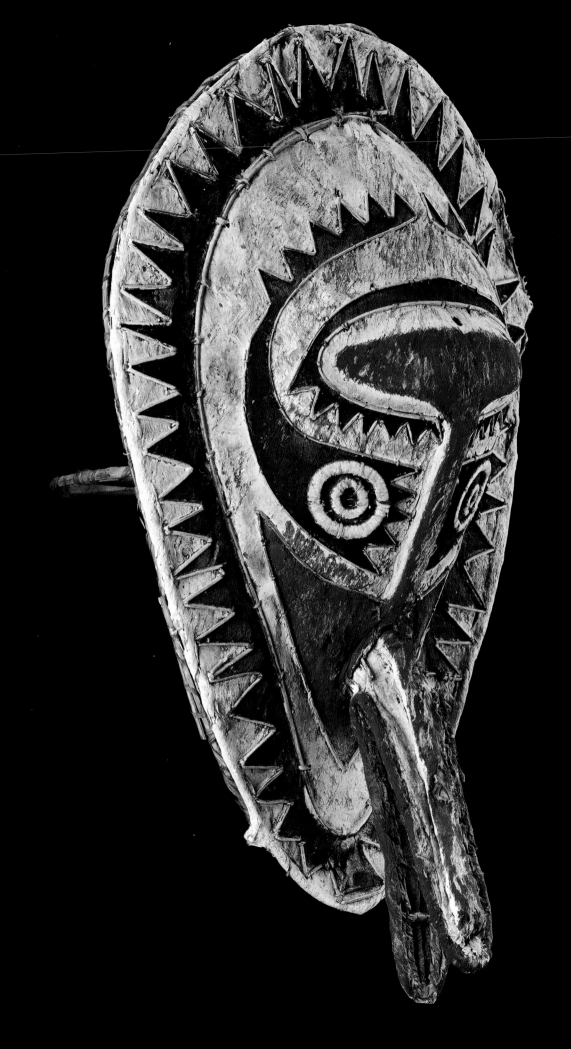

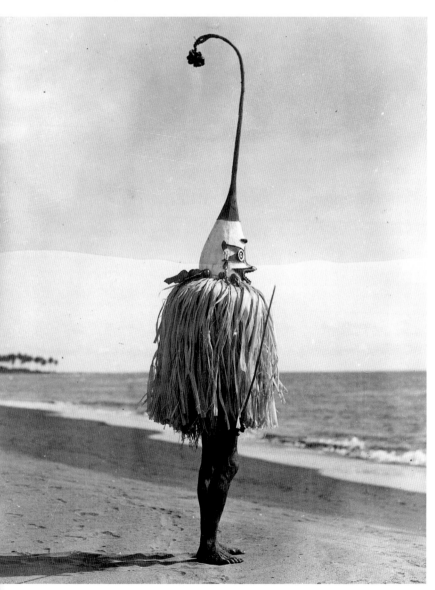

Masker wearing a *kovave* on a beach, 1937

## 43   Mask (*kovave*)

Elema peoples, Vailala, Gulf of Papua region,
    Papua New Guinea
Late 19th century
Cane, bark cloth, fiber, raffia, pigments. Fringe replaced
Height 31 inches
Gift of William E. and Bertha L. Teel   1996.400
Collected by Edwin Bentley Savage in Vailala, 1889–91
    Formerly in the collection of the Pitt-Rivers Museum,
    Farnham, Dorset, England
Acquired from Kevin Conru, London, in 1994
Bibliography: Mamiya and Sumnik 1982; Thompson and
    Renfrew 1999; Williams 1940

This mask is among the oldest illustrated in this
book. Similar masks or conical headpieces
appeared in considerable numbers during various
stages of the *kovave* festival, which celebrated the
initiation of young men into the cult of the same
name. Many are of enormous size and have a long
extension above the bark-cloth face. This *kovave*
mask has a colorful face framed by small cane out-
lines on a white ground. Black pigment defines the
protruding brow, nose, mouth, and pupils; red
chevrons circle the forehead and emphasize the
eyes. The masker's costume consisted of two fiber
fringes — one (seen here) covering the upper part of
the body, the other wrapped around the waist like a
skirt. The fascinating history and context of this
mask is one of the topics in the essay "From the
South Seas" in this catalogue.

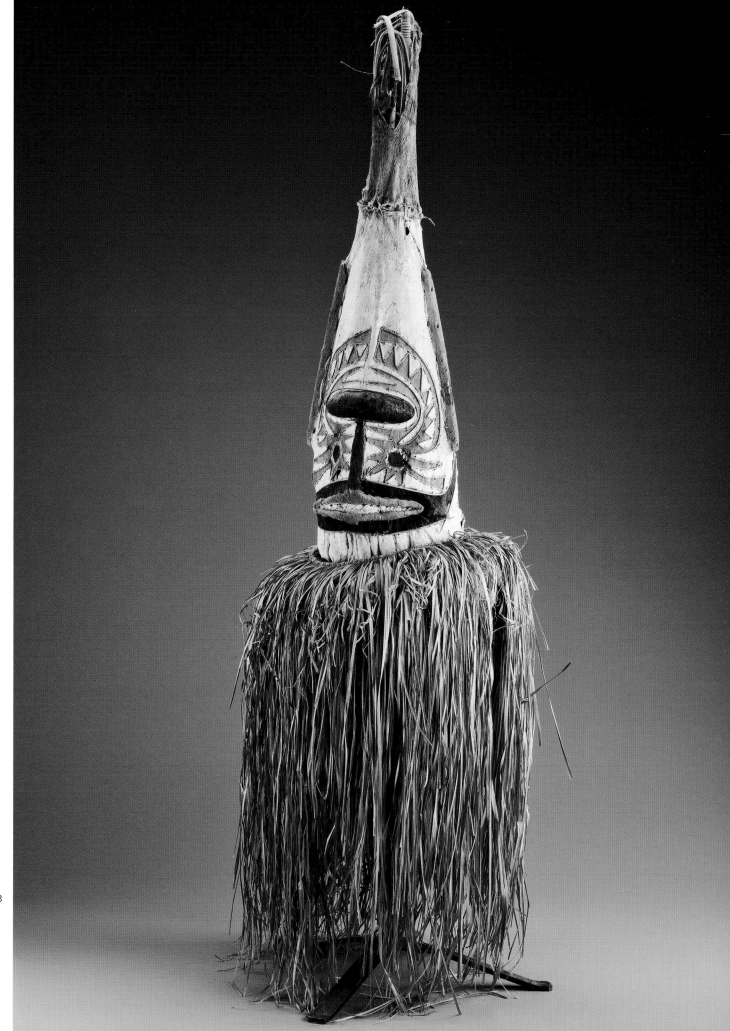

## 44  Shield (*kaikatakera*)

Trobriand Islands, Massim region, Papua New Guinea
Late 19th century
Wood, cane, pigments
Height 17 inches
Gift of William E. and Bertha L. Teel  1992.414
Sold at Fenton and Sons, a trading and auction house
    in London, in 1895. Formerly in the collection of the
    Pitt-Rivers Museum, Farnham, Dorset, England
Acquired from Sotheby's, New York, in 1985
Bibliography: Benitez-Johannot 2000; Beran 2005

Among the most valued objects of the Massim
region are war shields from the Trobriand Islands,
which Westerners collected as early as the 1890s.
The foreigners were particularly entranced by the
delicate, carefully organized designs painted on
their flat surfaces. The composition of this shield
is remarkably similar to other known examples.
A large oval medallion appears beneath vertical
hooklike shapes at the top. At each side is a trio
of paddle-like forms, the remaining surface covered
by tiny letterlike dots. Scholars have proposed
multiple interpretations of the intricate designs.
Recent research suggests that many of the complex
motifs represent insects, fish, or serpent shapes,
which symbolically allude to prowess in war.
The white ground has faded, but red and black
pigments remain. The slightly convex back bears
cane handles and an inscription: "Bt. of Fenton
[Bought of Fenton], May, 1895."

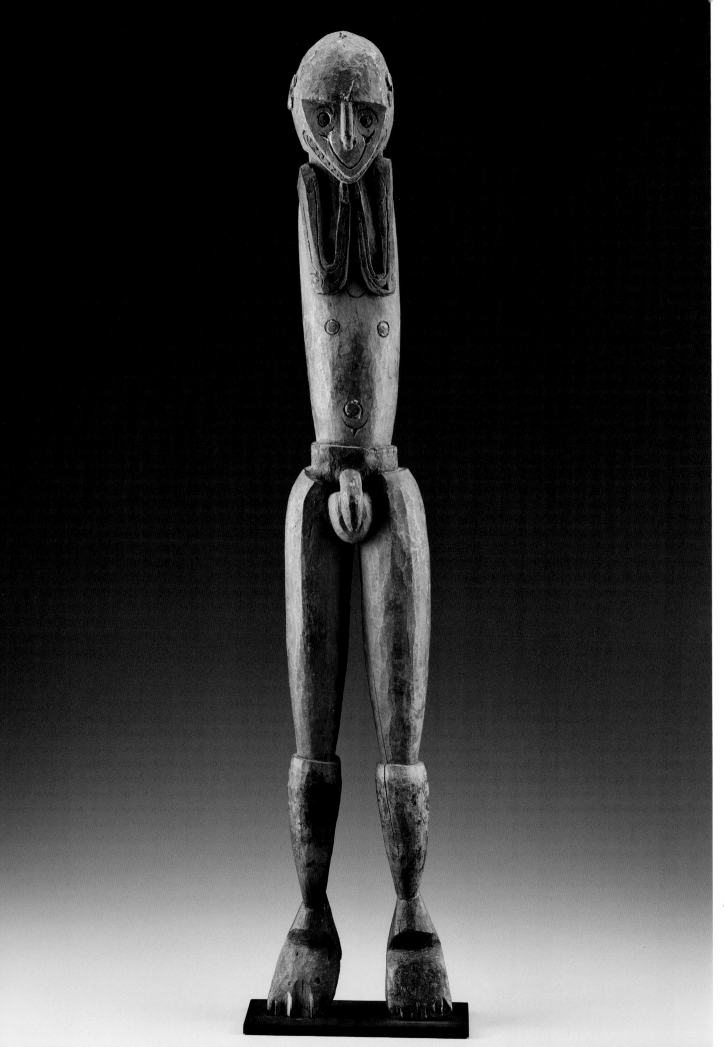

## 45 Figure

Trobriand Islands, Massim region, Papua New Guinea
Late 19th century
Wood, pigments
Height 25 ½ inches
Formerly in the collection of Herman Lissauer,
    Melbourne, Australia
Acquired from Maurice Bonnefoy, New York, in 1988
Bibliography: Dwyer and Dwyer 1973; Musées de Marseille
    2000; Museo di Antropologia e Etnologia di Firenze
    1992; Newton 1975

The meaning of rare freestanding human figures
from the Trobriand Islands remains a mystery. Some
writers suggest they protected homes from sorcery,
others claim they represent spirits or ancestors. This
elongated male figure is poised on seven-toed feet
with bootlike enclosures on the lower legs. Above
the ridged waistband, thin arms extend to the chin
of a small triangular face with a heavy brow and an
incised, upturned mouth. The smooth red surface
alternates with black on the lower legs, waistband,
arms, and crown, with touches of white at the mouth
and navel. This work closely resembles a male figure
purchased in 1895 for the the Pitt-Rivers Museum, in
Farnham, England, which later dispersed its objects.
Other standing figures acquired before 1900 are in
the collections of the M. H. de Young Memorial
Museum, in San Francisco, and the Museo Nationale
di Antropologia e Etnologia, in Florence, Italy.

## 46 Figure

Trobriand Islands, Massim region, Papua New Guinea
Late 19th century
Wood, pigments
Height 12 inches
Formerly in the collection of William Downing Webster,
    England
Acquired from Wayne Heathcote, New York, in 1986
Bibliography: Musées de Marseille 2000; Museo di
    Antropologia e Etnologia di Firenze 1992

The great sailing canoes of the Trobriand Islands
were sturdy constructions with richly embellished
functional components. This unusual figure may
have been a canoe ornament similar to a work in the
collection of the Peabody Essex Museum, in Salem,
Massachusetts. According to other sources it could

have been a decorative element from a house. Its
elongated legs are divided and end not with feet but
with hooklike reverse curves. The figure's thin arms
with clasped hands descend from a thick chest
marked with a chevron design. On the block-shaped
head, the white face displays triangular cheek inci-
sions and a toothed mouth. The overall color is
bright red, and the left hip bears the inscription:
"#1348, New Guinea, Bt. Webster, Aug. 1897." It was
thus bought ("Bt.") from William Downing Webster,
an artifact dealer in Bicester, England, who auc-
tioned off most of his stock in 1904. The number
"1348" is a Webster number.

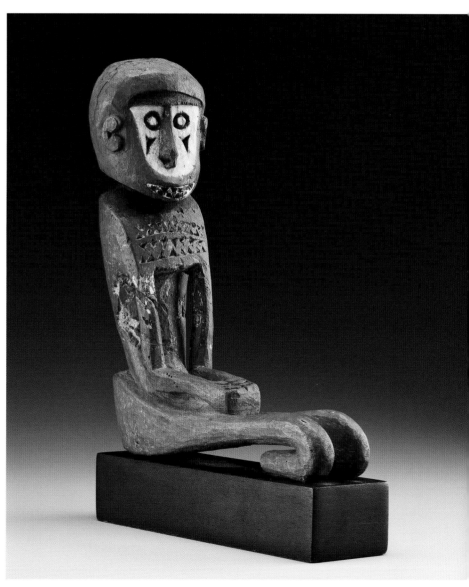

46

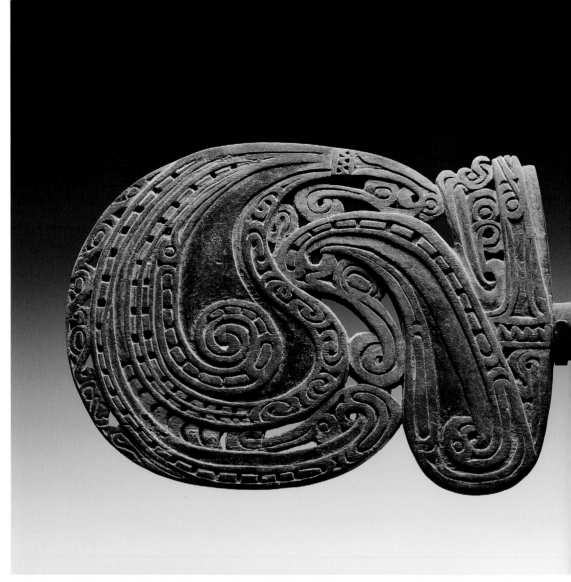

47

## 47  Dance shield (*kai diba*)

Trobriand Islands, Massim region, Papua New Guinea
20th century
Wood, pigments
Height 29 ½ inches
Formerly in a Los Angeles collection in the 1930s
Acquired from Hurst Gallery, Cambridge, Mass., in 1990
Bibliography: Newton 1975

Trobriand master carvers are esteemed for their transformation of totemic imagery into complex swirling compositions. This artistry is evident in the curvilinear designs of distinctive dance shields (also referred to as wands or paddles) that men used in ceremonies such as the annual harvest festival. Projecting from a central handle, two large lunettes combine openwork with fluid low-relief carving on both sides of this shield. Frigate birds and aquatic shapes meld into curves; beaks and tails metamorphose into interlocking spirals. Black pigment in recessed areas contrasts with the overall red color. During performances, the fluttering of fiber attachments heightened the visual impact of the shields.

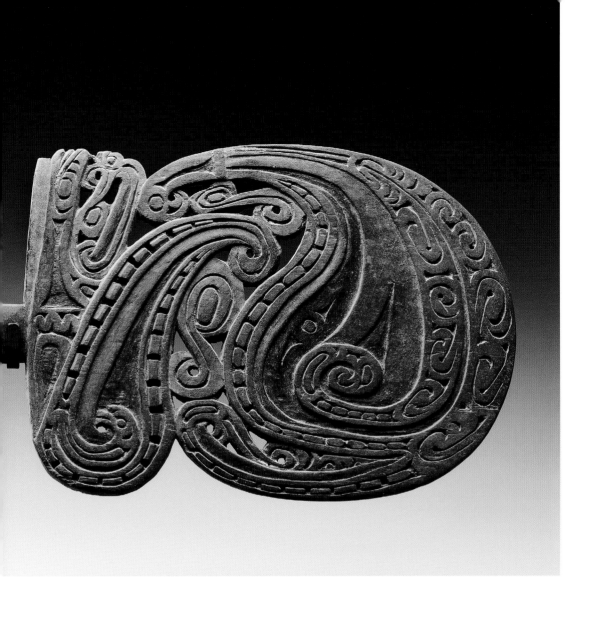

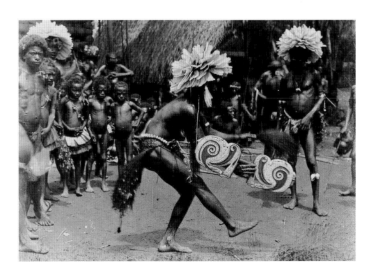

Men performing with a dance shield, 1915–18

## 48  Headpiece

Tami Islands, Papua New Guinea
Late 19th–early 20th century
Wood, bark, fiber, feathers, pigments
Height 16 inches
Formerly in the collection of a Viennese family whose
    grandfather was in New Guinea in 1909
Acquired from Steven Alpert, Dallas, in 1992
Bibliography: Dark 1979; Heermann 2001

The inhabitants of the Tami Islands in the Huon Gulf
region of New Guinea were renowned for their out-
rigger canoes and navigational skills. They con-
ducted extensive expeditions and maintained
trading relationships with other islands as far afield
as New Britain. Tami artists specialized in the pro-
duction of wooden bowls (their main trade article),
suspension hooks, headrests, and similar carvings.
This unique conical headpiece apparently originated
from these islands as well, although bark masks and
headdresses are much more common in New
Britain. It consists of two diamond-shaped panels of
bark framed by lightweight wood and lashed to a
supporting top. Feathers, now lost, once decorated
the wooden frame. The artist adorned the bark pan-
els with a black design of projections and lines emit-
ted from concentric circles that resemble eyes. A
similar motif appears around the eyes of *nausung*
masks, which perform at circumcision ceremonies of
the Kilenge peoples in New Britain (who called it the
"tears of *nausung*"), and on Tami wooden bowls.
Men wore headpieces such as this one while per-
forming a vigorous dance that may have resembled
the *sia* of the Kilenge.

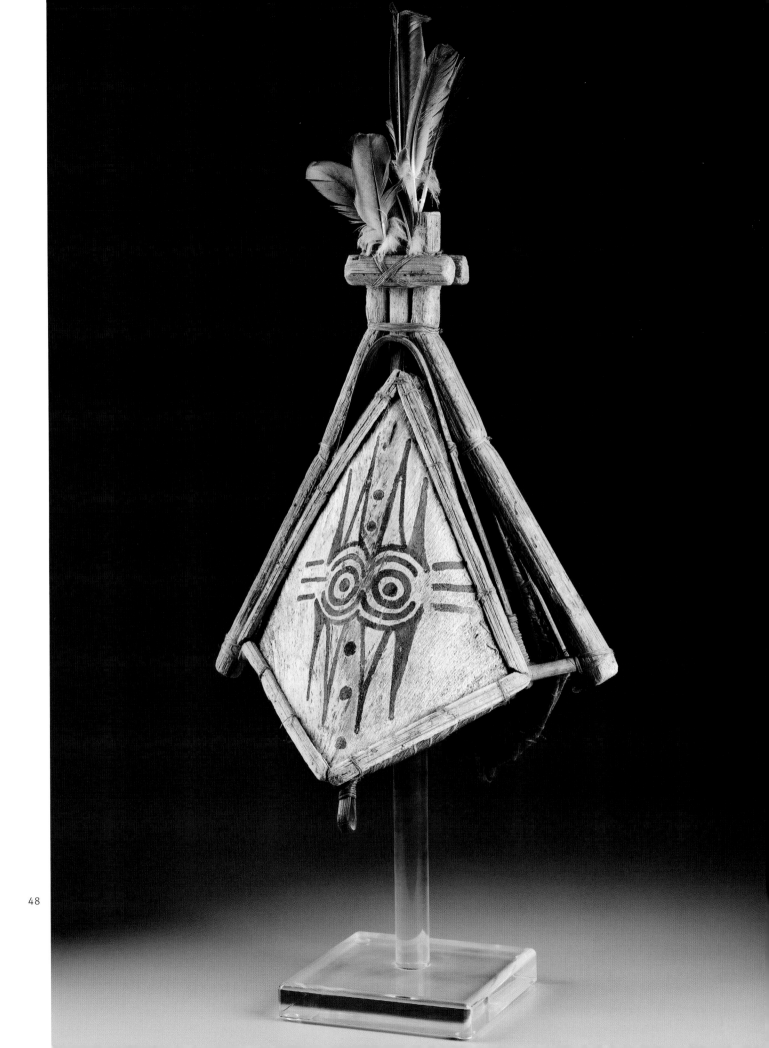

48

# The peoples of the Melanesian Islands, a term that applies to island groups east of New Guinea that share similar cultural and artistic characteristics,

have been in touch with each other for centuries. If contact did not occur directly through seafaring then it happened indirectly through a process not unlike "chaining." This linguistic term describes the differentiation of dialects among populations, in which each dialect is closest to that of the immediate neighbors. Even if no direct contact occurred between peoples on the ends of such chains, we can still follow the chain and discover commonalities, not only in the languages but in other aspects of culture. In the sphere of the visual arts, particular styles can be identified in different island groups and sometimes within a single island. A disposition toward contained sculptural forms is more prevalent in the Admiralty, Solomon, and New Caledonia islands, while expansive forms are more characteristic of New Britain, New Ireland, and Vanuatu.

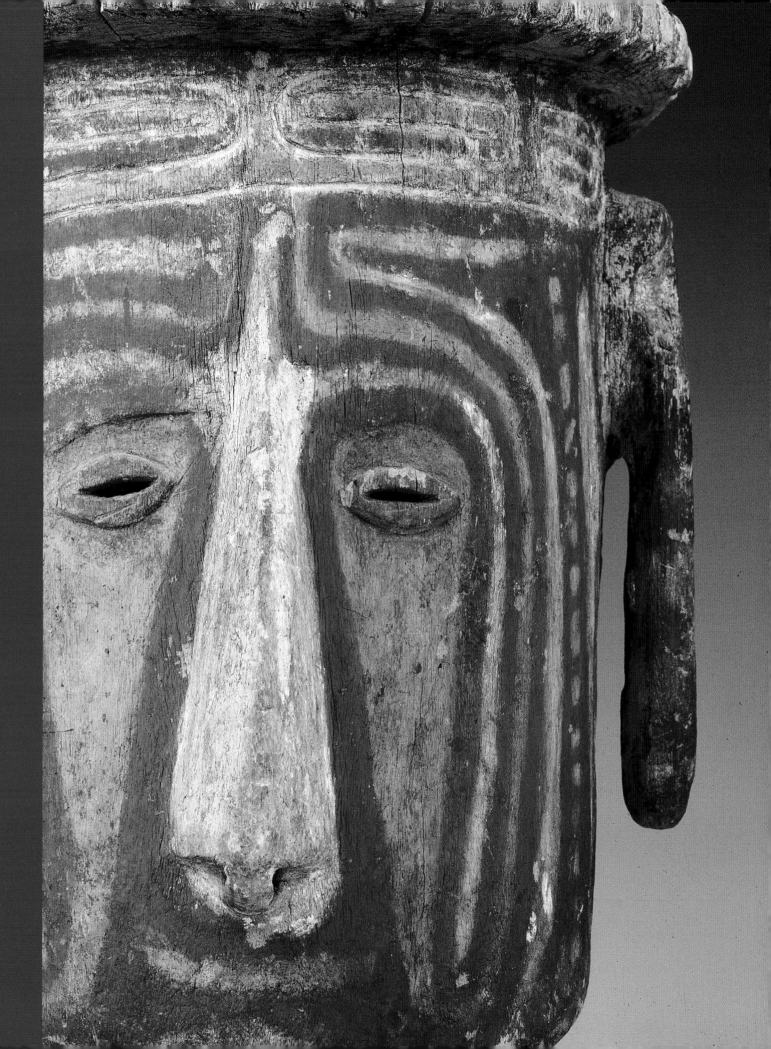

## 49  Figure

Admiralty Islands, Papua New Guinea
20th century
Wood, pigments
Height 16½ inches
Formerly in collections in England and Hamburg, Germany
Acquired form Wayne Heathcote, New York, in 1985
Bibliography: Kaufmann, Kocher Schmid, and Ohnemus
    2002; Ohnemus 1998

The Admiralty Islands, including the main island of
Manus, lie off the northern coast of New Guinea.
Their inhabitants use a rich array of wooden objects
in daily life, among them food bowls, slit gongs,
canoe prows, and anthropomorphic figures that
adorn ceremonial men's houses. This object is prob-
ably an ornamental element of a ceremonial plat-
form, also referred to as a bed, in a chief's house. It
displays the common motif of a human half-figure in
a hands-to-hip pose emerging from the gaping jaws
of a stylized crocodile head. Ear pendants and a
spherical topknot emphasize the figure's large pro-
jecting head. Delicate patterns of incised diamond
shapes are scattered over both creatures, and traces
of white pigment contrast with the overall red color-
ing. The sulpture resembles the large freestanding
figures that commonly were placed in ceremonial
men's houses.

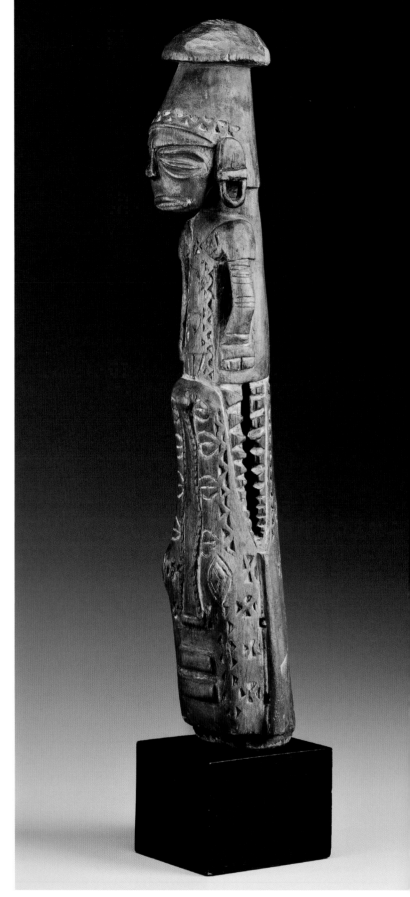

49

50

## 50 Spirit figure (*pokopoko ingiat*)

Tolai peoples, New Britain, Papua New Guinea
Late 19th century
Limestone, pigment
Length 11½ inches
Formerly in a German collection
Acquired from Wayne Heathcote, New York, in 1982
Bibliography: Heermann 2001; Meier 1911

Artists of the Tolai (also called Gunantuna), who live on the Gazelle Peninsula, are renowned for masks associated with the *dukduk* men's secret society and works made for the *iniet* secret society. Initiates of the *iniet* society received small stone images, ritual objects of animal and human configuration that reportedly represent various ancestor and spirit entities. The form of this doglike animal probably follows the natural shape of the stone from which it was hewn. Rough indentions define the thick legs, tail, and torso, and blue coloring marks the features on the upraised head. Joseph Meier, a Catholic missionary, depicted this particular work in a photographic plate in his 1911 article about the *iniet* society.

## 51  Mask (*kakaparaga*)

Witu Islands, Papua New Guinea
Late 19th century
Wood, pigments
Height 19 inches
Gift of William E. and Bertha L. Teel  1991.1075
Collected by Richard Parkinson, 1893–95. Formerly in the
    collections of the Museum für Völkerkunde, Dresden,
    Germany (no. 12116); Everett Rassiga; Walter Randel;
    and John Friede, New York
Acquired from Wayne Heathcote, New York, in 1982
Bibliography: Bodrogi 1971; Dark 1979; Heermann 2001

Art forms of southern New Britain and offshore
islands have affinities to those of New Guinea's
Huon Gulf and the Tami Islands due to extensive
trading networks. On the Witu Islands to the north-
west of New Britain, artists make masks from a
variety of materials, such as bark cloth, fibers, cane,
feathers, and leaves. Three types have been
identified, among them this *kakaparaga* form. It is
the only type of helmet mask in the region carved
entirely from wood, although it resembles wooden
masks called *nausung* made by the Kilenge on New
Britain. The lone protrusions on this cylindrical
helmet are the notched ridges of the bulbous head-
piece, the long pierced nose, and the pendant ears.
Triangular areas of turquoise enhance the shape of
the nose and eyes, and only paint indicates the
mouth; alternating bands of red, turquoise, and
white pigment surround the face. The back of the
head bears a slightly raised relief of an animal,
perhaps a crocodile. Early European observers
referred to the *kakaparaga* and other mask types on
the Witu Islands as death masks, indicating that
they may have been used in funerary rites. For more
on this mask, see the essay "From the South Seas."

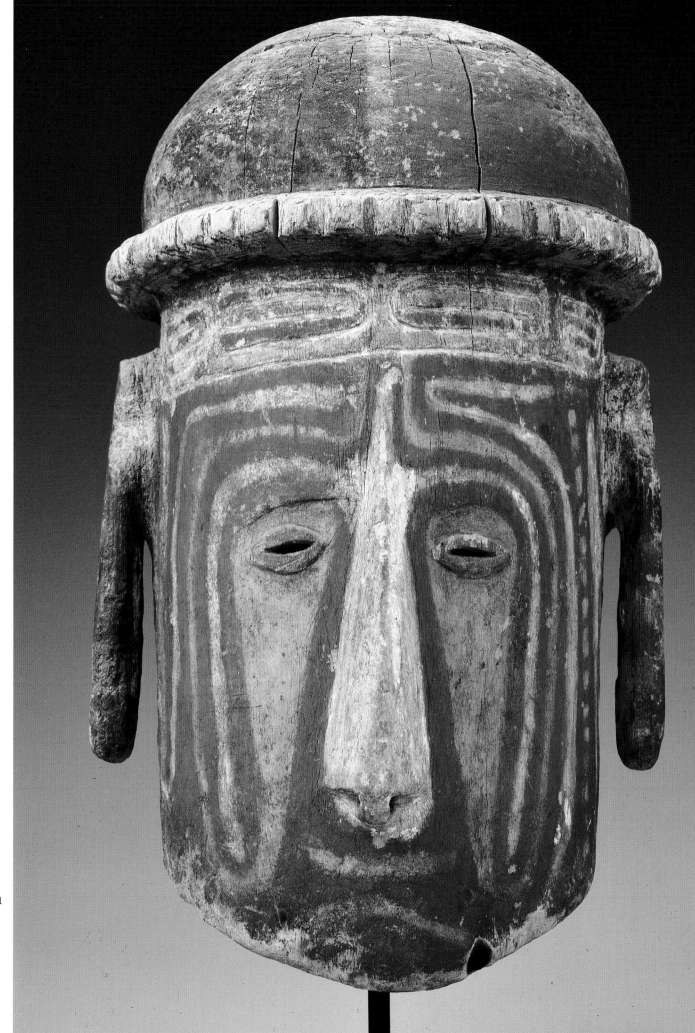

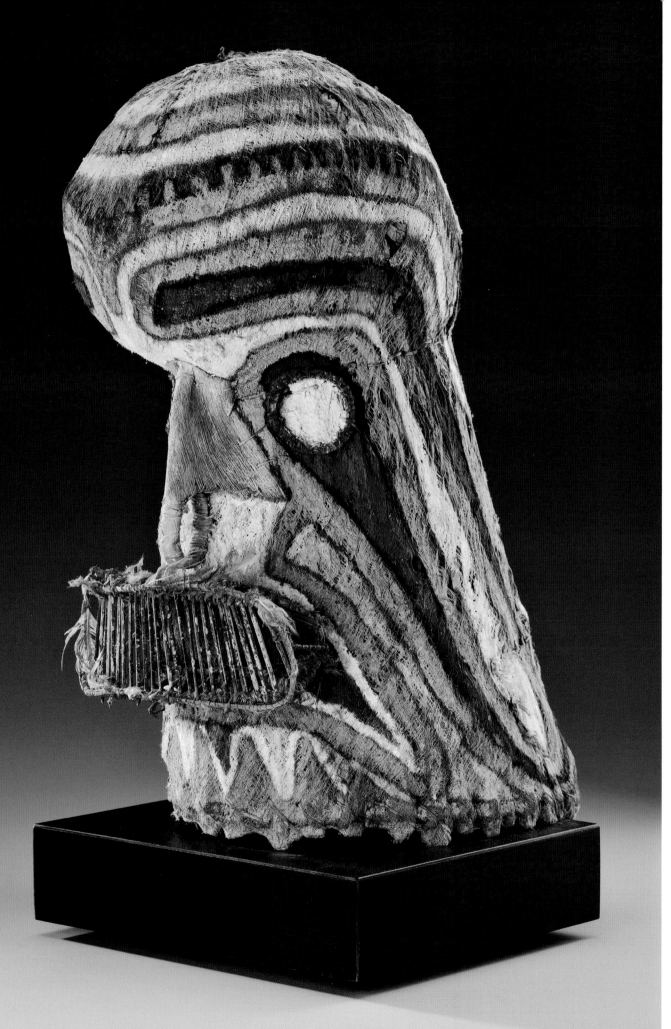

## 52  Helmet mask

Witu Islands, Papua New Guinea
Late 19th century
Bark cloth, cane, pigments, feathers
Height 17½ inches
Collected by Richard Parkinson, 1893–95. Formerly in
    the collection of the Museum für Völkerkunde,
    Dresden, Germany (no. 8042)
Acquired from Horvath, Berne, Switzerland, in 1994
Bibliography: Meyer and Parkinson 1895

This colorful mask of bark cloth and feathers over a cane framework is a sophisticated variant of the wooden helmet mask, or *kakaparaga*. Its gracefully swelling forehead echoes the "hat" of the wooden counterpart. The nose ends in a loop of light-colored fiber that once held a wooden ornament — long lost during the object's travels from the South Pacific to European and American collections (see the essay "From the South Seas"). A prominent cagelike appendage with vertical toothlike elements disguises the wide red mouth. Only a few feathers remain on the mouth guard. Subtle coloring of grays, red, and white extends across the face to the back of the head, where the lines become a curvilinear design.

## 53  Mask

Witu Islands, Papua New Guinea
Second half of the 20th century
Coconut fiber, cane, wood, shell, dog's teeth, cloth,
    feathers, pigments
Height 58¼ inches
Gift of William E. and Bertha L. Teel  1991.1074
Formerly in the collection of Thomas Schultze-Westrum,
    Munich, Germany
Acquired from Maurice Bonnefoy, New York, in 1987
Bibliography: Bodrogi 1971; Brake, McNeish, and Simmons
    1979; Heermann 2001

In addition to smaller masks of wood and bark cloth, Witu Islanders fashion another type: tall conical helmets that combine coconut bast and a variety of other materials. On this example, tab ears of bark with dangling fiber pendants frame a face, notable for painted eyes accentuated by a tapering triangular design (which also occurs in other masks from this region). The elongated nose is wood, and the open mouth displays stick teeth. The back bears a branching treelike design in red, yellow, and blue. The head swells into a tuft of lightweight tan fiber embellished with trimmed and painted feathers. A cloth binding wrapped with a ring of wild pig teeth, an unusual element in such masks, comprises the headdress element, supported by a bamboo pole. Masks such as this covered the wearer's head during circumcision ceremonies; a skirt of palm fronds veiled his body.

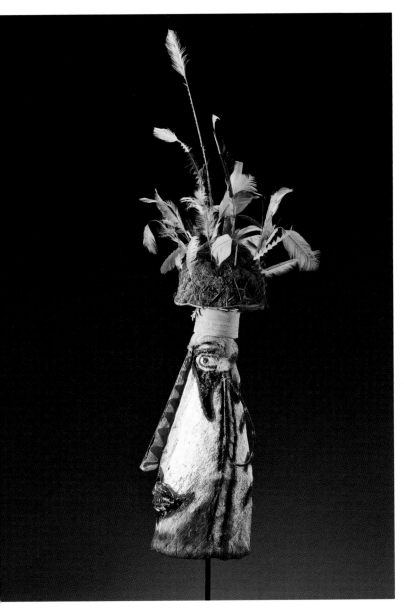

53

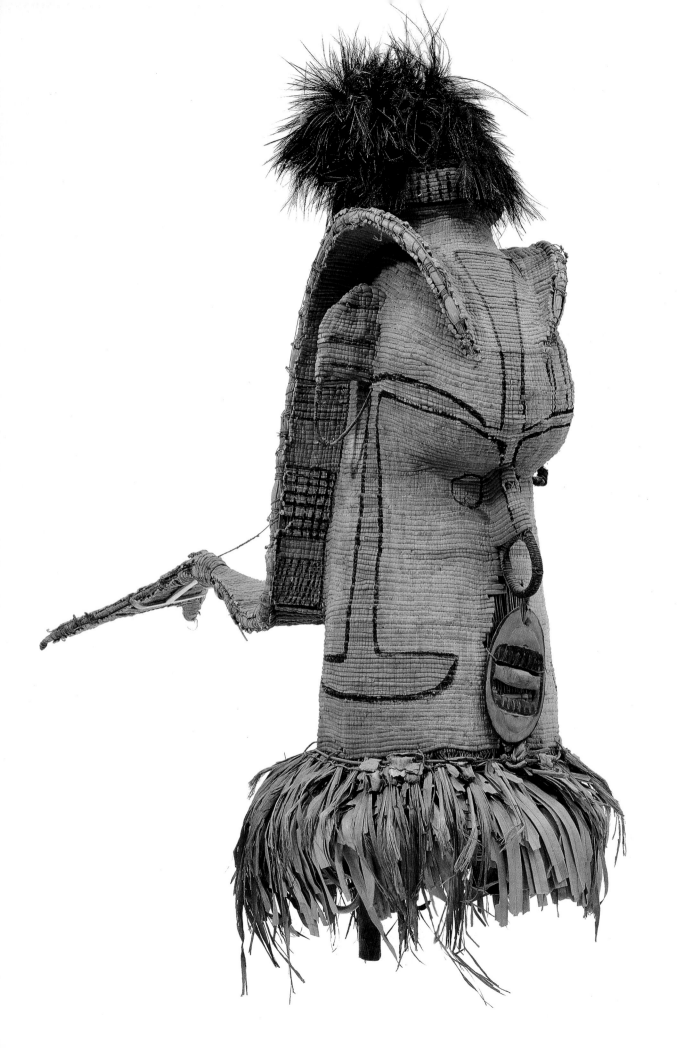

54

## 54  Headddress (*susiu*)

Sulka peoples, New Britain, Papua New Guinea
Late 19th century
Vegetable pith, rattan, fiber, pigments, feathers
Height 31 ½ inches
Gift of William E. Teel and Bertha L. Teel  1994.410
Gift of Consul Max Thiel, a plantation owner in Matupi on
    New Britain, to the Museum für Völkerkunde, Dresden,
    Germany, in 1910 (no. 25907). Formerly in the
    collections of Everett Rassiga and Hélène Leloup, Paris
Acquired from Tambaran Gallery, New York, in 1988
Bibliography: Corbin 1990; Heermann 2001; Jeudy-Ballini
    1994; Parkinson 1907

Artists take months to fabricate the giant basketry headdresses that Sulka maskers wear to embody spirits during initiation rites for young men. There are two types of *susiu* masks: nonrepresentational headdresses (*o ptaek*), and figurative headdresses (*o nunu*) such as this one. The masks are complicated structures. Around an inner frame of rattan, the maker of this headdress meticulously attached tightly woven coils of reed pith to rattan struts. The conical face has elongated earlobes and a septum pierced for attachments, recalling Sulka men's adornments. Affixed to the mouth is a wood plaque showing bared teeth and the tongue. Above the protruding brow, which is crowned with a plume of cassowary feathers, a ridged head crest sweeps back as a long fishtail extension. The mask's startling colors derive from native plants and minerals; blacks and greens highlight details on the originally red surface that has faded to a pale pink. The back flap is associated with a spirit that the maker of the mask had seen in a dream. During performance, a cloak of vegetable material conceals the body of the masker, and a bright green collar of fresh leaves surrounds the headdress.

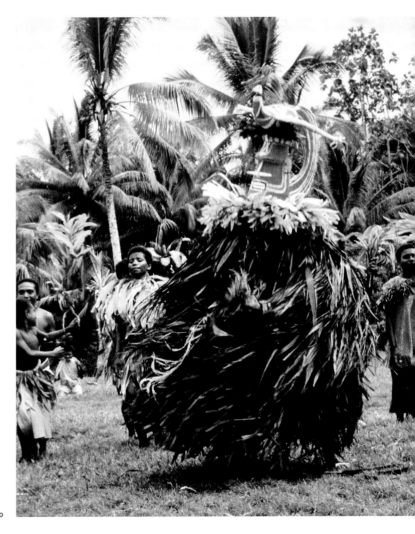

Sulka *susiu* mask and costume in a performance, 1980

## 55 Helmet mask (*kavat*)

Baining peoples, Gazelle Peninsula, New Britain, Papua
 New Guinea
Late 19th–early 20th centuries
Bark cloth, cane, fiber, pigments
Height 28½ inches
Collected by a German missionary. Formerly in the
 collection of Rev. Jan McA. Fardon, Sydney, Australia
Acquired from Maurice Bonnefoy, New York, in 1987
Bibliography: Corbin 1979; Heermann 2001; Newton 1999

Artists of the Baining peoples who inhabit the mountainous interior of the Gazelle Peninsula created some of the most startling masks of Melanesia. In prolonged day-and-night ceremonies that honored ancestors and occurred at harvests and young men's initiations, dancers manipulated huge masks of painted bark cloth on rattan frames, some up to forty feet high. Maskers with smaller helmet masks such as this one appeared in night dances as wild spirits of the bush, a term for the wilderness outside the realm of the human settlement. The masks possessed great spiritual power that was enhanced by their materials, forms, and design elements. The color red, for instance, alluded to the male domains of hunting and warfare, whereas black was associated with the female domain of the earth and fecundity. White was the color of the spirits.

This mask is composed of two major elements. The relatively flat, oval head bears a leaflike design painted on the forehead; red and black circles and cane rims frame enormous eyes. The protruding lower half is a snoutlike mouth with a broad, dangling tongue. An intricate geometric design in black and red appears on the back. The patterns are said to represent plants and various animals.

55 (back)

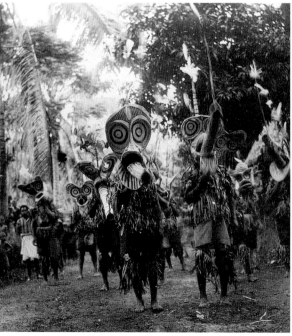

55

Maskers wearing Baining *kavat* and *vungvung* night-dance masks, 1906

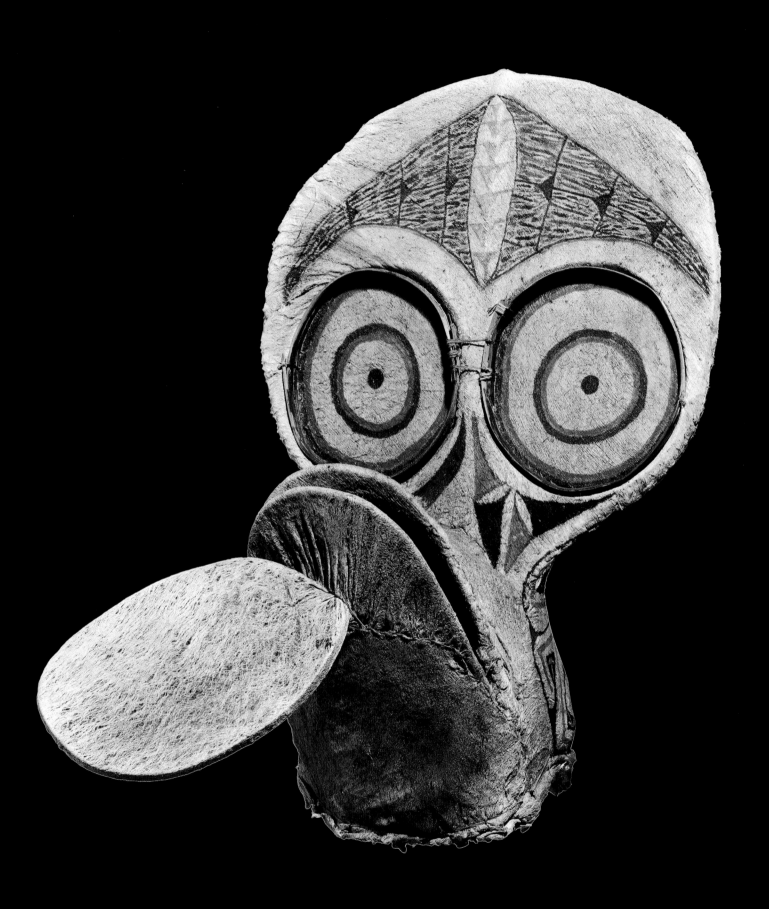

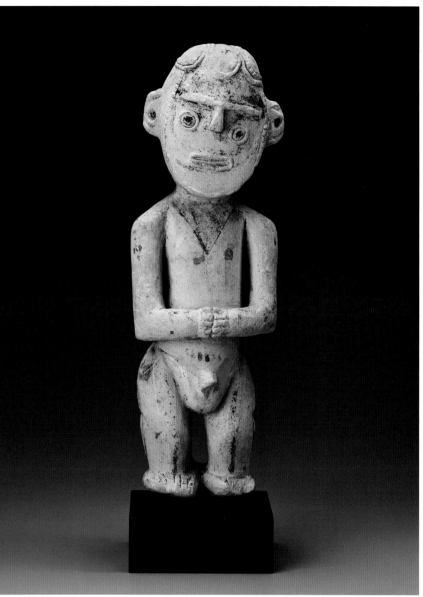

56

## 56 Figure (*kulap*)

Southern New Ireland, Papua New Guinea
Late 19th century
Limestone, pigment
Height 15 inches
Gift of William E. and Bertha L. Teel  1994.398
Collected about 1890. Sold by William Downing Webster
    in 1897. Formerly in the collection of the Pitt-Rivers
    Museum, Farnham, Dorset, England
Acquired from Wayne Heathcote, New York, in 1980
Bibliography: Gunn 1997; Stöhr 1987

Scholars have customarily divided New Ireland into three distinct stylistic regions corresponding to the northern, central, and southern areas of the island. In the south, small figures carved from white limestone resemble the stone images that the Tolai people of neighboring New Britain made for *iniet* rituals (see no. 50). Early European observers report that the figures were commissioned when an important person died. Guarded in ritual shelters, they served as a resting place for the deceased's spirit. After some time had passed, they were destroyed.

This figure, however, was spared and subsequently came to William Downing Webster, the British artifact dealer, and then to the Pitt-Rivers Museum, Farnham, where the caretakers inscribed it as follows: "New Ireland. BT. [bought] Webster. Sep. 97. P.I [Pacific Islands]." Stylistically, the sculpture resembles many others in European and American collections. The proportions of the male figure, standing with hands clasped to the abdomen, vary from nature only in the shortened legs and enlarged head. Below a three-part coiffure, the flat, circular face with notched edges offers a solemn, somewhat quizzical expression. Traces of color remain in the low-relief features and recessed areas. The production of *kulap* figures ceased about 1910, when missionaries began to convert the people in southern New Ireland.

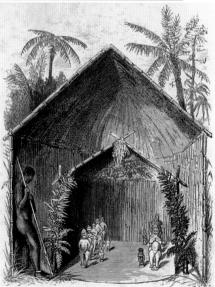

Engraving of a Tolai shrine with chalk figures, about 1883

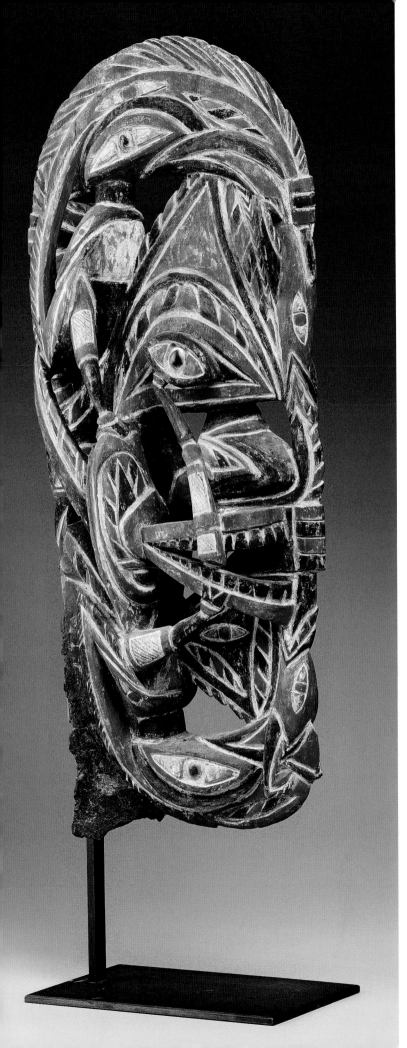

57

## 57 Canoe prow

Northern New Ireland, Papua New Guinea
Late 19th–early 20th century
Wood, pigments
Height 21½ inches
Gift of William E. and Bertha L. Teel 1991.1073
Formerly in the collection of a German museum
Acquired from Alain Schoffel, Paris, in 1987
Bibliography: Gunn 1997; Lincoln 1987

This work belongs to the context of *malagan*, which
is first and foremost a ceremonial cycle directing the
social and economic relationships of the peoples in
northern New Ireland. The term *malagan* also desig-
nates impressive works of art that are activated dur-
ing long ceremonies with dances and masquerades,
which occur at certain critical moments in a person's
life. Following the death of a prominent person,
for example, a series of lavish feasts and displays
evince the prestige and wealth of the sponsoring
family or clan. Spectacular wooden sculptures,
newly carved for this occasion, incorporate human
and animal images into elaborate openwork
configurations highlighted by brilliant coloring.
Canoe prows with these characteristics were the
earliest documented objects from New Ireland.
They could serve as part of a *malagan* display or as
fixtures on dugout canoes. This prow, which has
been partly overpainted, unites active space and
imagery along a vertical axis: a central human head
with protruding eyes linked to a toothed open
mouth is surrounded by intermingling bird and fish
forms. The effect is a synthesis of visual and sym-
bolic elements. At the conclusion of the events,
display carvings were destroyed or discarded or,
when European collectors arrived on the scene in
the late nineteenth century, sold in large numbers.

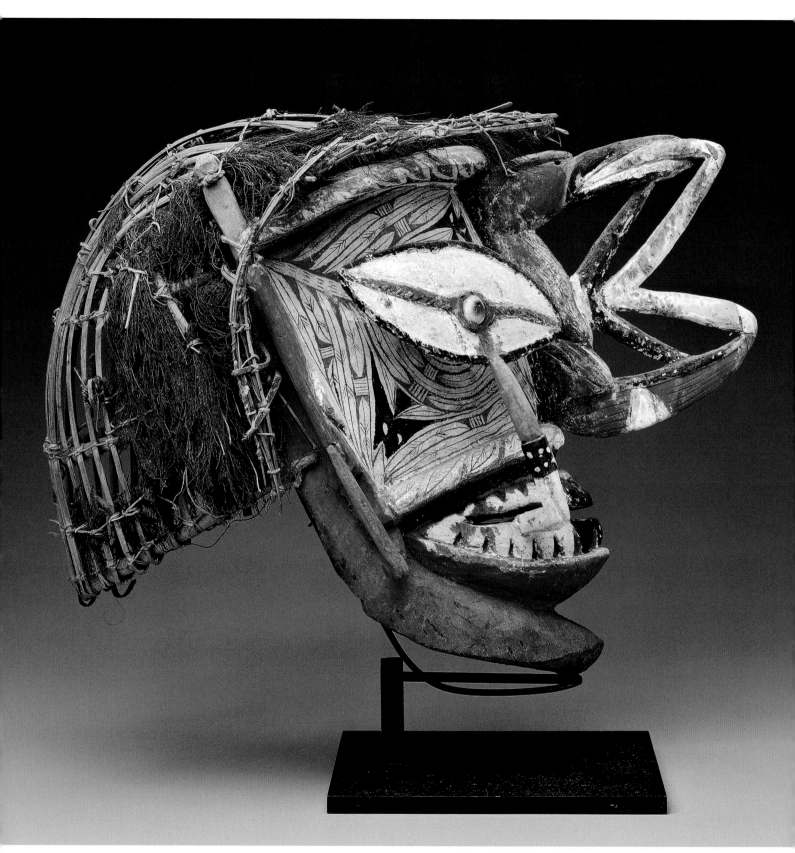

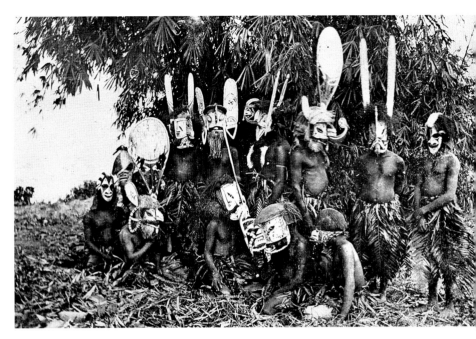

Men wearing *malagan* masks, about 1900

## 58  Mask (*kepong* or *ges*)

Northern New Ireland, Papua New Guinea
Late 19th century
Wood, cane, fiber, pigments
Height 14 inches
Gift of William E. and Bertha L. Teel   1991.1072
Collected in 1878 by German Consul Theodor Weber.
    Formerly in the collection of the Museum für
    Völkerkunde zu Leipzig, Germany (accession
    number ME10259)
Acquired from Alain Schoffel, Paris, in 1977
Bibliography: Gunn 1997; Lincoln 1987

Several types of masks are associated with the *malagan* commemorative ceremonies. Large masks called *matua* with extravagant projections and superstructures were made for *malagan* display and appeared at the end of ceremonies to remove taboos. Groups of men wearing smaller, crested types such as this one roamed the village and performed similar tasks, "cleansing" the community and bringing life back to normal. These masks might represent tree-dwelling wild spirits who live in the bush. Flanges linking the ears to the jaw and the eyes to the mouth partially frame this mask's head. The open mouth reveals white and black teeth, intertwined frigate-bird and serpent forms compose the nose, and sea-snail shells animate the protruding eyes. The ribbed cane structure of the head is visible beneath the remains of vegetable fiber that once fully covered it. Like many New Ireland objects, the mask came to Germany before World War I. It bears the inscription "ME10259, Neu-Mecklenburg, Weber," Neu-Mecklenburg being the German designation of the island. Its life history is one of the topics of the essay "From the South Seas."

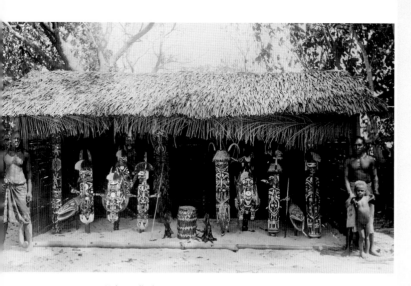

*Malagan* display, 1930

## 59 Figure (*totok*)

Northern New Ireland, Papua New Guinea
Late 19th century
Wood, pigments
Height 44 inches
Gift of William E. and Bertha L. Teel  1994.426
Formerly in the collections of Arthur Speyer, Berlin;
     Charles Ratton, Paris; and Claire Zeisler, Chicago
Acquired from Tambaran Gallery, New York, in 1993
Bibliography: Gunn 1997; Lincoln 1987

Sculptors spent months in isolation fashioning a
dazzling array of objects for *malagan* ceremonies.
The figures and masks have both individual and
type names derived from designs, usage, and the
spirits evoked. This cylindrical image called *totok* is
a cagelike, openwork construction incorporating a
female figure amid interlocking fish-bird forms.
A lower supporting stake melds into a curving fish
shape, from which vertical rods ascend to meet the
flexed limbs of the figure. The head has notably
elongated ears, a toothed open mouth, protruding
eyes, and a separately carved nose. The artist
painted large areas and delicate motifs in red, black,
and white; holes around the head permitted attach-
ments that are now lost. Extraordinary amounts of
time, wealth, technical virtuosity, and iconographic
meanings are embodied in such creations. During
the great feast they form a dazzling display, only to
be discarded afterward.

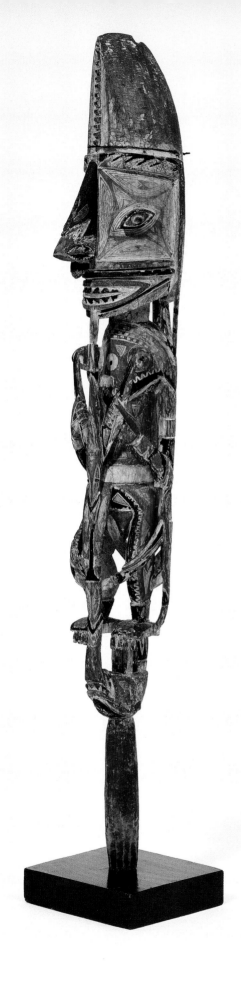

59

## 60 Dance paddle

Buka Island, Northern Solomon Islands, Papua New Guinea
Early 20th century
Wood, pigments
Height 64½ inches
Gift of William E. and Bertha L. Teel 1996.397
Formerly in the collection of Ludwig Bretschneider,
    Munich, Germany
Acquired from Maurice Bonnefoy, New York, in 1987
Bibliography: Newton 1999; Stöhr 1987

In the northern Solomon Islands, now politically part
of Papua New Guinea, a pervasive anthropomorphic
motif called *kokorra* appears on both ceremonial
and utilitarian objects. It may represent a divine
spirit being, although its precise meaning remains
unclear despite some association with men's secret
societies and clan rituals. *Kokorra* is depicted as a
crouching or standing figure whose large ovoid head
dwarfs its spindly legs and arms. Other features
include prominent ear pendants and a crowning
headdress resembling the large round *upi* head-
dress that young men wear during initiation. One
side of this ceremonial dance paddle shows a *koko-
rra* image seated at the top and reversed at the bot-
tom; the other side depicts standing figures. Faint
white pigment still adheres to the low-relief ground
and the diamond patterns.                      60

Men with headdresses, late nineteenth century

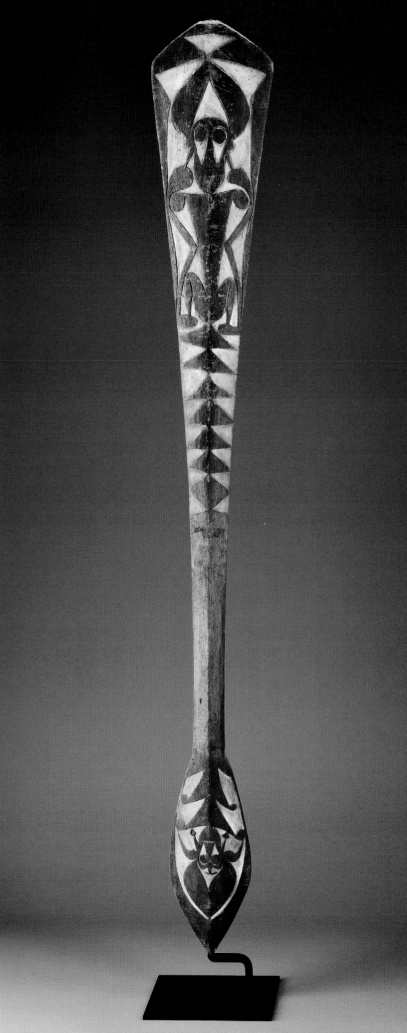

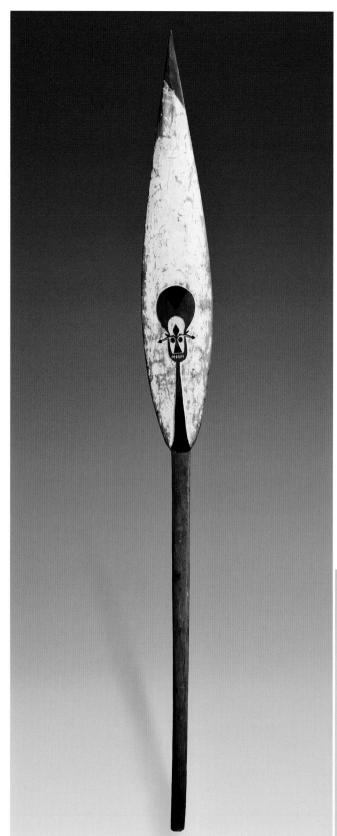

## 61 Canoe paddle

Buka Island or Buka Passage, Northern Solomon Islands,
 Papua New Guinea
Late 19th, early 20th century
Wood, pigments
Height 64 ½ inches
Formerly in the collections of the Museum of Ethnography
 (now Néprajzi Múzeum), Budapest, Hungary,
 and Emile Deletaille, Brussels, Belgium
Acquired from Marc Felix, Brussels, Belgium, in 1987
Bibliography: Bodrogi 1959; Waite 1983

Imagery occurs only on the gracefully shaped,
pointed blade of this lightweight wooden paddle
with a long, undecorated handle. Poised on a spike
that mirrors the handle's shape, a stylized *kokorra*
head appears in slightly raised relief on a white
background. The artist rendered flat facial features
in red and black pigment beneath the bulbous head-
dress, offering a subtle contrast of angular and cir-
cular forms: round eyes, triangular nose, serrated
mouth, and projecting ear ornaments. The recessed
white ground, produced by rubbing a type of sea-
weed on the paddle's surface, terminates at an
angled red tip on the front; on the back it serves as
background for a raised relief of a long spear. The
result is a sophisticated balance of conceptual
shapes and juxtaposed colors. Paddles from this
region have been popular with collectors since the
nineteenth century, and there are many examples
61   in private and museum collections.

Lithograph of
Melanesian and
Micronesian
weapons and
tools, 1890

Canoe with a *musumusu* on its prow, late nineteenth century

## 62 Canoe prow figurehead (*musumusu* or *nguzunguzu*)

Probably New Georgia, Solomon Islands
Late 19th–early 20th century
Wood, shell inlay
Height 8 inches
Gift of William E. and Bertha L. Teel  1996.393
Formerly in a British collection
Acquired from Alain de Monbrison, Paris, in 1978
Bibliography: Pelrine 1996; Waite 1983

Small carvings attached to the prows of large sea-going canoes represented guardians that protected the canoe against spirits, which might cause dangerous winds and waves. The most prominent features of these figureheads are a high forehead, a forward-extended face, and hands that often hold birds or smaller heads. In this example, probably from New Georgia, one hand has broken off. White nautilus-shell inlays remain in the deep-set eyes and along the jawline, in contrast to the blackened surface, but are missing around the eyes. The inlays recall the face-painting designs once common for warriors. Ear ornaments, which occur in most figures but have broken off here, also were typical adornments for warriors. Holes in the back permitted the figure to be lashed to the prow above the waterline.

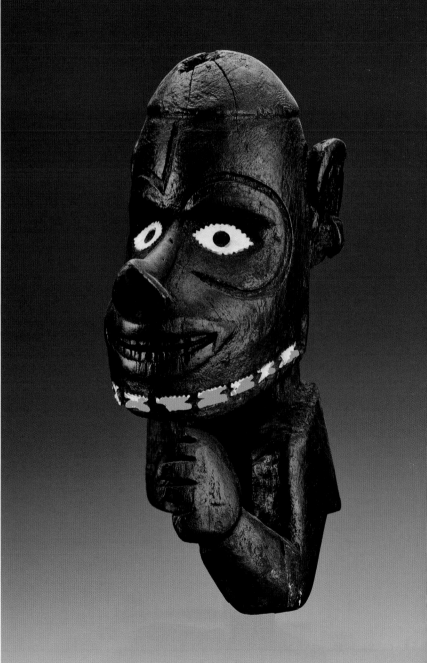

62

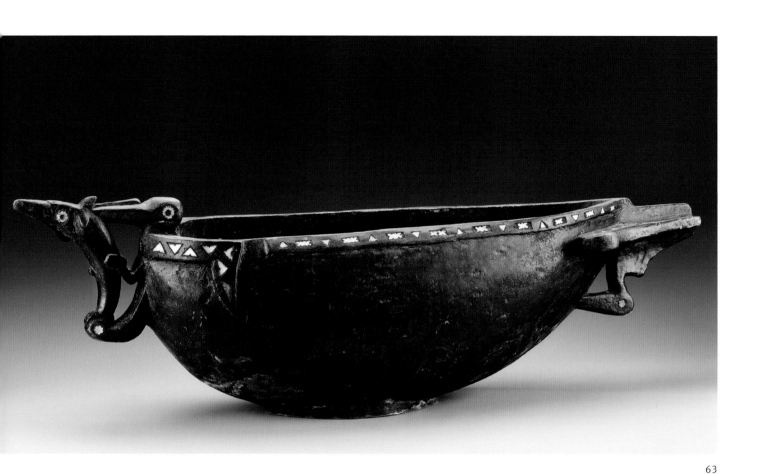

## 63  Bowl (*apira ni mwane*)

San Cristobal or neighboring islands, Solomon Islands,
  Papua New Guinea
20th century
Wood, shell inlay
Length 36 inches
Gift of William E. and Bertha L. Teel  1996.399
Acquired from Hurst Gallery, Cambridge, Mass., in 1990
Bibliography: Waite 1983

The sea and its creatures have always played a predominant role in the life of the Solomon Islanders. Marine motifs on ceremonial objects such as bowls allude to various sea spirits, which can appear in either threatening or benevolent manifestations. Spirits in the shape of the highly prized bonito and the guiding frigate bird were traditionally seen as supportive, because the frigate bird leads fishermen to schools of bonito fish, which provide abundant food. Large ceremonial bowls stored in cult houses were brought out on festive occasions; families owned and used smaller bowls. The maker of this hollowed-out, horizontal bowl on a footed base carved the body as a swelling frigate-bird form. He blackened the surface and edged the rim with delicate shell inlays, which also appear as eyes on the animal-shaped handles. An upside-down frigate bird supports the projecting tail; a bird's head grasping a curved fish forms the front handle and is a common motif in bowls from this region.

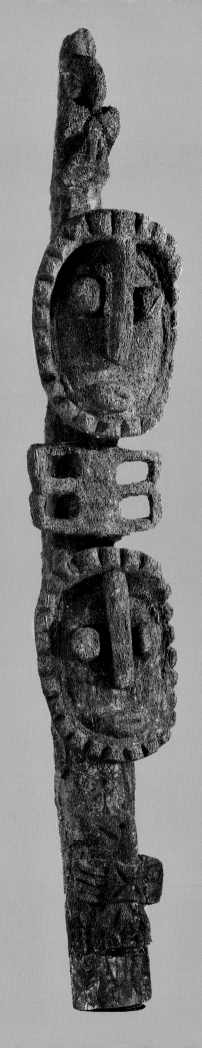

## 64 Grade figure

Gaua, Banks Islands, Vanuatu
Early 20th century
Fern tree
Height 89 inches
Formerly in a private Danish collection
Acquired from Wayne Heathcote, London, in 1998
Bibliography: Bonnemaison, Kaufmann, Huffman,
     and Tryon 1996; Speiser 1990; Stöhr 1987

Diversity characterizes the languages, social struc-
tures, and art forms of the more than eighty islands
of Vanuatu (formerly New Hebrides). In northeastern
islands such as the Torres and the Banks groups,
many art forms traditionally were associated with
men's grade-taking societies. Men showed their
economic prowess and leadership qualities through
"buying" themselves into a series of hierarchical
grades by sponsoring costly ceremonies. Each grade
required the mastering of ritual knowledge and
bestowed insignia of rank on its members. In the
*sukwe* grade society of the Banks Islands, high-rank-
ing members commissioned expert sculptors to
carve works from the pliable native fern tree, which
they displayed on their ceremonial houses, or
*gamal*, as emblems of advancement. These ritual
works were not only a mark of grade but also an
abode for ancestral spirits. This tall sculpture from
the island of Gaua consists of a vertical trunk bear-
ing high-relief carvings of two bird forms and circular
human faces. A notched edging accents the protrud-
ing eyes, nose, and mouth. The object resembles
sculptures collected in Gaua by the Swiss ethnogra-
pher Felix Speiser between 1910 and 1912, now in
the Museum der Kulturen, Basel, Switzerland.

64

Ceremonial house with a display of grade figures, 1912

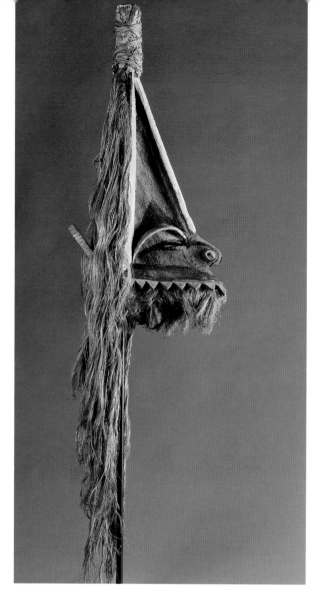

65

appear at dance performances on Ambrym to this day. Members of the men's grade societies purchased the rights to commission this type of headdress and its costume, as well as the license to perform with it during rituals, from their neighbors on Malakula at the beginning of the twentieth century. This mask was constructed over a light cane frame. Wood strips shape the arched brows and the serrated jawline and outline the tall forehead above the curved nose. The vivid greens and reds applied to alternate sides of the forehead and facial areas may have special significance. Raffia defines the short beard and long strands of hair, and feathers originally crowned the top. Old masks of this type are quite rare in collections, because they are extremely fragile and often were ritually destroyed after the performances.

## 66 Figure (*temes nevimbur*)

Southern Malakula Island, Vanuatu
20th century
Wood, cobwebs, clay-vegetal paste, boar tusks, pigments
Height 32 inches
Collected in 1971 by George Staempfli
Acquired from Staempfli Gallery, New York, in 1972
Bibliography: Deacon 1934; Stöhr 1987

This fascinating object functioned somewhat like a hand puppet. It belonged to the realm of the men's secret society *nevimbur*, whose members staged performances for women, children, and uninitiated men during the initiation of young men. Called *temes*, a term used for spirit beings and their material manifestations in objects, the head appeared on the long stick from behind a fence. The performers waved the piece to suggest dancing and stamped their feet to evoke the voices of spirits. The head is formed from fragile cobwebs, gathered in the forest by twirling the handle. Its maker stabilized the resulting cluster with an overlay of clay-vegetal paste and shaped it into bold facial features, including telescopic eyes. The artist then added boar tusks, a highly valued exchange item, and red, black, and white coloring. Some of these *temes* were destroyed during performance, but many others remained with their owners.

## 65 Headdress (*rom kon*)

Ambrym Island, Vanuatu
20th century
Wood, vegetal fibers, pigments, raffia
Height 24 inches
Gift of William E. and Bertha L. Teel  1996.395
Formerly in a German collection
Acquired from Wayne Heathcote, New York, in 1984
Bibliography: Bonnemaison, Kaufmann, Huffman, and
    Tryon 1996; Guiart 1963

A variety of ritual objects and materials have been associated with the grade-taking societies of the Ambrym and Malakula islands: fern-tree images, hardwood figures and drums, stone carvings, and fragile constructs of vegetal fibers. Triangular-shaped vertical headdresses such as this one

66

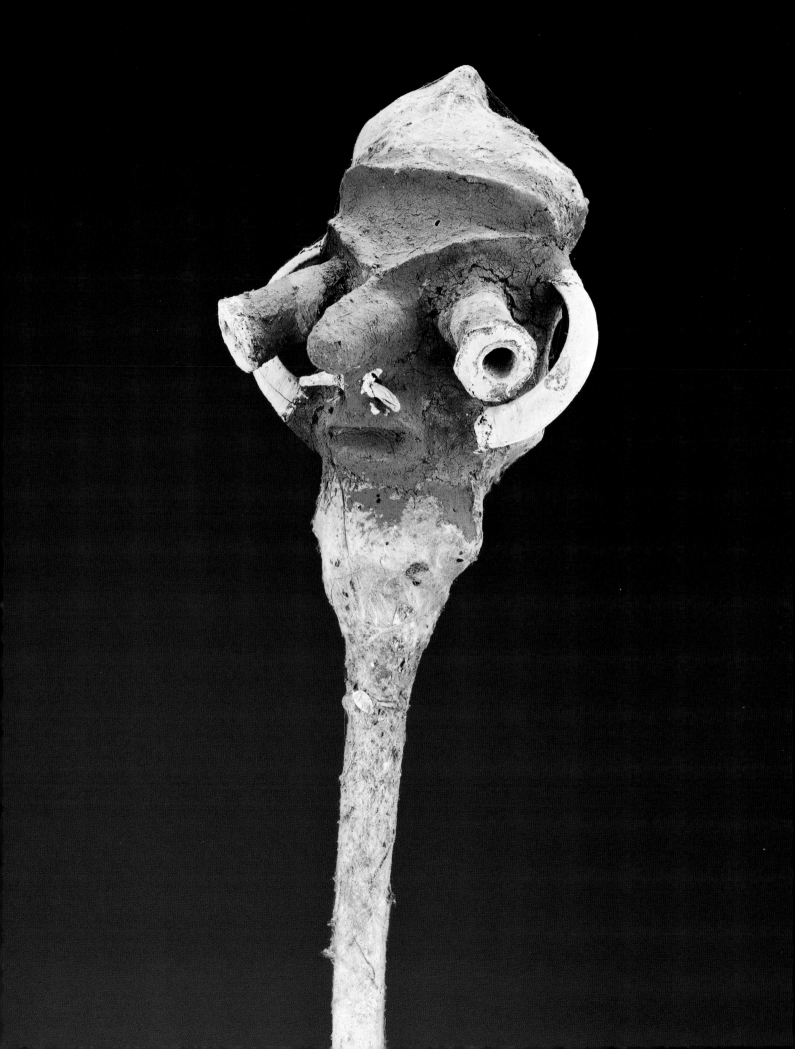

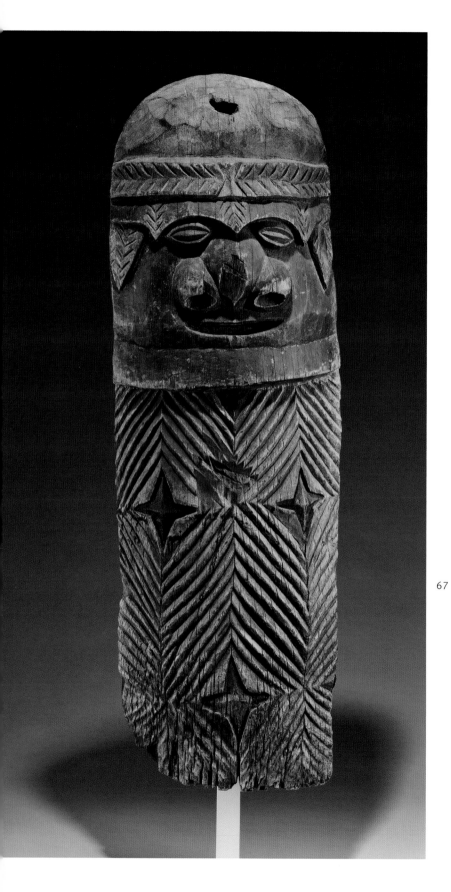

## 67  Door plank (*joyo jopo* or *tale*)

Kanak peoples, northern New Caledonia, Territory of
    New Caledonia and Dependencies
Late 19th century
Wood, pigments
Height 58 inches
Formerly in a private European collection and in the
    collection of Gallery Lemaire, Amsterdam
Acquired from David Rosenthal, San Francisco, in 2001
Bibliography: Boulay 1990; Guiart 1953; Sarasin 1929

The human figure is the principal motif in wood
sculpture of the Kanak peoples of New Caledonia, an
island named by Captain James Cook, who arrived
on its shores in 1774. The most impressive works are
architectural elements of the great chiefs' houses,
which served as the site of public functions and fes-
tivals. Carved roof finials, lintels, sills, and interior
posts and beams embellished these round struc-
tures with thatched, conical roofs. Door planks
(often referred to as jambs, although they have no
structural function) marked the entrance. Little is
known about their meaning. Scholars assume that
they were the abode of ancestral guardian spirits.
This massive plank was one of a pair that flanked
the entrance to a great house. The convex front is
divided into a limbless lower body with rows of
grooved, parallel lines emitting from starlike,
lozenge shapes. On the broad upper face, an incised
headband and ears frame the arched brow, almond-
shaped eyes, wide nose with flared nostrils, and slit
mouth. Red pigment remains on the body, black on
the head. As in many other door planks, the tip of
the nose was ritually severed after the chief died.

67

Chief's house with a roof finial and door planks, 1910–12

## 68  Roof finial (*gomoa*)

Kanak peoples, northern New Caledonia, Territory of
 New Caledonia and Dependencies
Late 19th–early 20th century
Wood pigment
Height 39 inches
Gift of William E. and Bertha L. Teel  1992.405
Formerly in a private American collection and the
 collection of J. J. Klejman, New York
Acquired from Pace Gallery, New York, in 1989
Bibliography: Boulay 1990; Guiart 1953

Roof finials on Kanak chiefs' great houses represent
protective spirit ancestors and allude to the commu-
nity of the dead who benevolently assist in the
affairs of the living. Both ends of this finial, which
was made from wood of the houp (*Montrouziera
cauliflora*), a tree endemic to New Caledonia, were
cut off after it was removed from the roof. The long
lower pole would have been part of the structure of
the house, and a triton shell would have adorned
the long spire at the top. The crowning and central
element of the house, it symbolically alludes to the
role of the chief. After his death, the finial (called
*gomoa*) may have marked his gravesite. This com-
plex, subtly balanced *gomoa* is carved on both
sides, allowing it to see or be seen in two directions.
The semi-abstract, slightly swelling form suggests a
human figure that has been reduced to silhouetted
elements. Projections surround the lower lozenge
shape that may represent a body; curving prongs
encircle a similar shape above the head. Schematic
raised arms and pierced ears draw attention to the
jowly face with its protruding eyes and prominent
nose. Traces of pigment remain on the neck and
faces; the reverse side is more weathered.

68

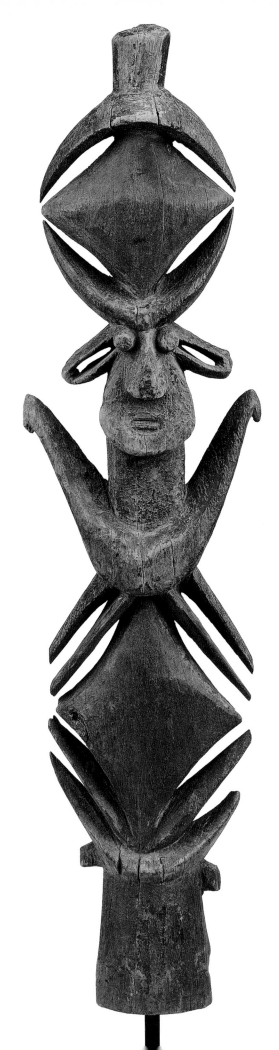

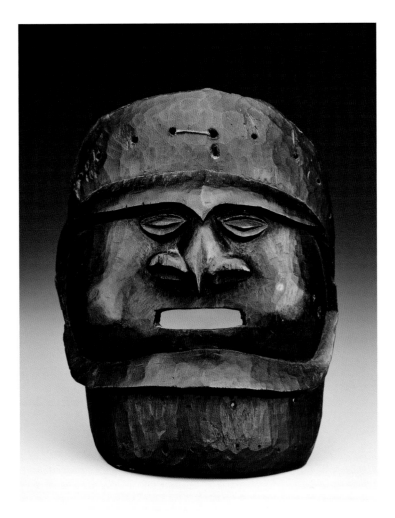

69

this one, have broad features similar to the faces on door planks; others are narrow and have exaggerated hooklike noses that extend to the chin. This relatively flat example was but a portion of an elaborate mask persona. A male masker cloaked in dark feathers reaching down to his knees brandished a club and spear during performances. He wore the mask affixed to a plaited backing and embellished with a beard and coiffure of human hair. The broad adze-marked face is edged by a sharp rim; a point on the heavy brow echoes the shape of the beaklike nose. Swelling cheeks, almond-shaped eyes, and a rectangular open mouth are other distinguishing features. Holes around the perimeter held attachments.

## 70  Club

Kanak peoples, New Caledonia, Territory of New Caledonia
    and Dependencies
20th century
Wood, cloth, fiber
Height 27 ½ inches
Formerly in the collections of Pierre Langlois, Paris, and
    Merton Simpson, New York
Acquired from Tom Alexander, St. Louis, in 1990
Bibliography: Force and Force 1971; Newton 1999

In the nineteenth and early twentieth centuries, warfare was endemic in many Oceanic societies. Groups sought territory and material resources for survival and growth, and they gained prestige after successful campaigns. Their weapons ranged from swords, spears, and bows and arrows to clubs, whose infinite variety reflects local styles and functions. Men also displayed elaborate weapons during ceremonial occasions. Whether utilitarian or ceremonial, most clubs are nonfigural. An exception is this New Caledonian ceremonial war club whose top takes the shape of a graceful, stylized bird head. A rounded crest surmounts the eye and the projecting, sharp-edged beak on the horizontal head. The lower half of the slender, vertical staff retains a wrapping of trade cloth and fiber string.

## 69  Mask

Kanak peoples, New Caledonia, Territory of New Caledonia
    and Dependencies
Late 19th–early 20th century
Blackened wood
Height 12 inches
Formerly in the collection of Josef Mueller, Geneva,
    Switzerland
Acquired from Christine Schoffel, Paris, in 1983
Bibliography: Guiart 1966; Stöhr 1987; Wardwell 1994

Heavy wooden masks from New Caledonia had names that referred to the spirits of deceased chiefs, to water deities, and to the realm where ancestors dwell. They may have exerted social control in secret, long extinct societies. Some masks, such as

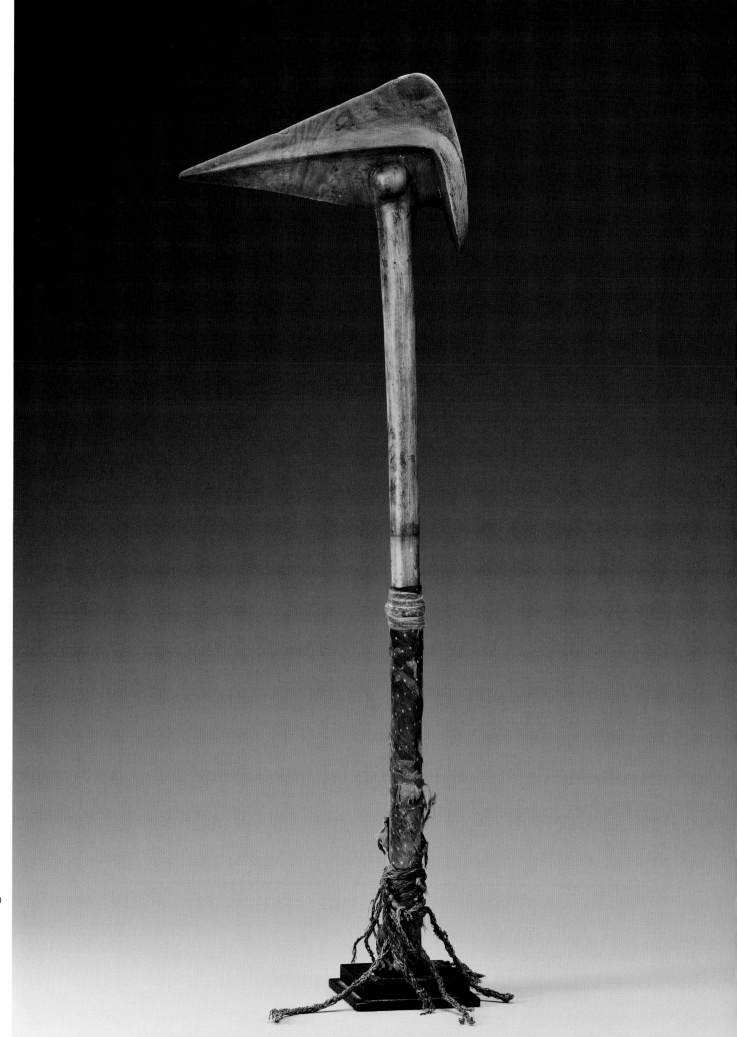

There is infinitely more water than land or people in the volcanic isles and coral atolls that make up Micronesia ("small islands"), a vast region delineated by early European ethnographers because the inhabitants share many cultural characteristics. The islands are scattered north of Melanesia and the equator in the expanse Ferdinand Magellan crossed in 1521 and called the Pacific. They include the Northern Mariana Islands, the Federated States of Micronesia (formerly Caroline Islands), the Marshall Islands, and the Kiribati (formerly Gilbert) atolls, along with outlying isles near New Guinea. Their geographic location and a complex history of settlement may account for traces of Indonesian, Melanesian, and Polynesian influences in the cultures, arts, and languages of the peoples in Micronesia. Navigating the ocean demands exceptional skills; the paucity of natural resources restricts the growth of the population and makes life precarious. At the beginning of the twentieth century, most Micronesian peoples resided in small kinship-based communities, producing the basic essentials for life and overseas trade. Male and female artists of this region are famed for crafting utilitarian objects of spare form and for their innovative use of many different materials.

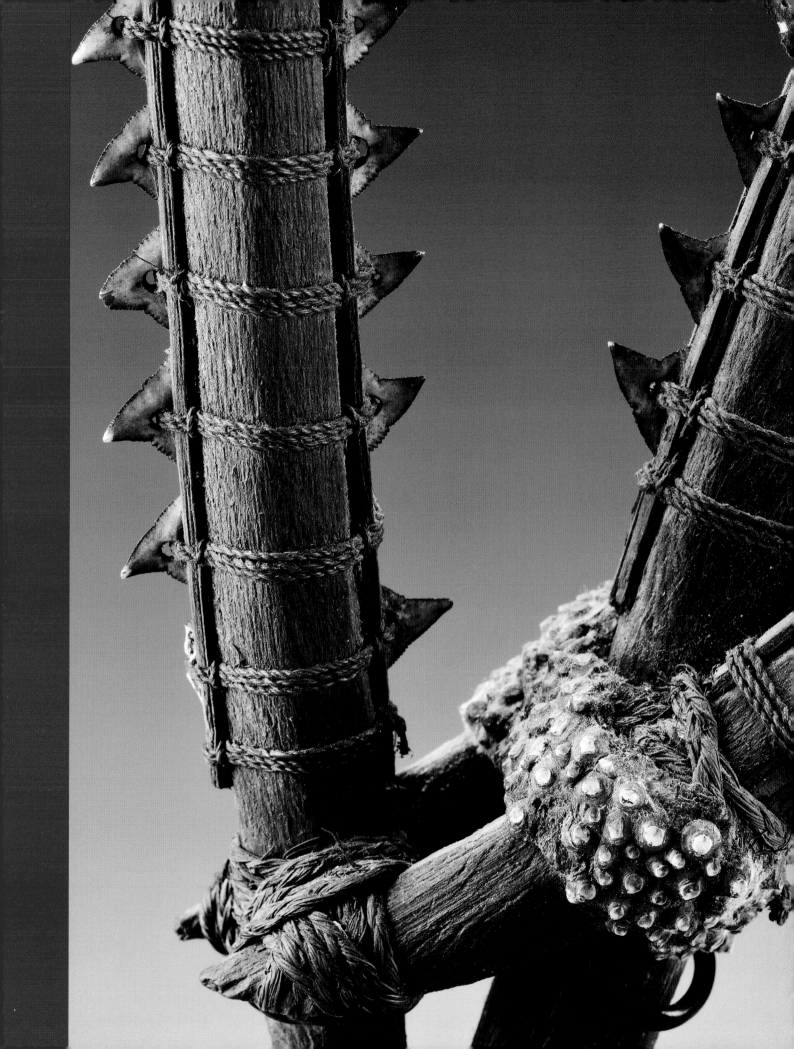

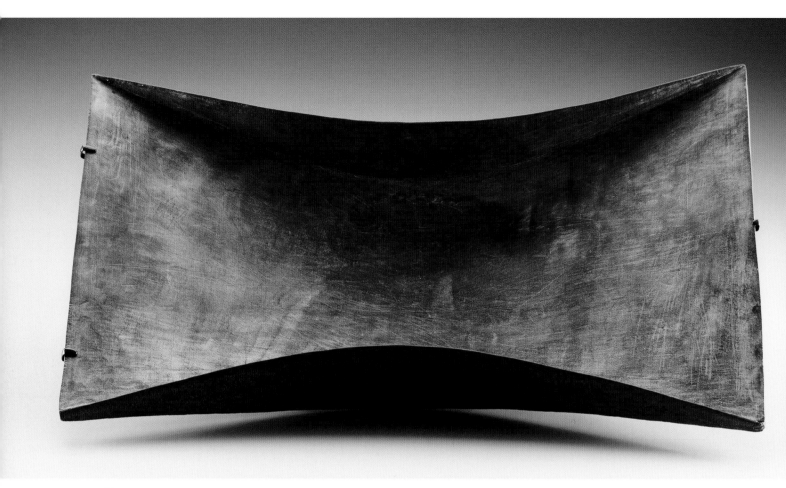

71

## 71 Dish

Wuvulu (Matty Island), Papua New Guinea
Late 19th–early 20th century
Wood
Length 19 inches
Formerly in the collections of the Ohio Historical Society
    Museum, Columbus, and Taylor Dale
Acquired from Channing, Dale, Throckmorton,
    Santa Fe, in 1991
Bibliography: Buschmann 2000; Kaeppler, Kaufmann,
    and Newton 1997

Among the simplest, most harmonious forms from Oceania are gracefully shaped bowls from Wuvulu (also called Matty Island) near the Admiralty Islands and New Guinea's northern coast. Wuvulu's cultural relationships to the rest of the distant Micronesian realm remain unclear and caused much speculation among early scholars. The minimalist aesthetic of the island's utilitarian objects is clearly allied to, if not exemplary of, Micronesian art. The maker of this bowl fashioned the wood into a very thin, scooplike shape. The base or bottom curves upward toward the ends, and the tapering, raised sides assume a subtle inward slant. No appendages or surface decoration distract from the restrained balance of this object designed for daily use. Stimulated by collectors' interest in these elegant works, Wuvulu carvers began producing the bowls for trade at the beginning of the twentieth century.

## 72  Spear

Kiribati (formerly Gilbert Islands), Republic of Kiribati
20th century
Palm wood, shark skin, shark teeth, reed, sennit
Height 27 ½ inches
Formerly in the collection of Taylor Dale
Acquired from Channing, Dale, Throckmorton,
    Santa Fe, in 1991
Bibliography: Feldman 1986; Koch 1986; Legge 1974

Micronesian arts have rich traditions of plait work,
matting, basketry, and ornamental cordage and
lashing, which men and women applied with equal
artistry to both functional and ceremonial objects.
Fiber arts reached a high degree of specialization
in Kiribati, where, during the era of island warfare in
the nineteenth century, men wore heavy protective
suits and head guards made from thick coils of
sennit, a thread produced from coconut fiber. This
intricate end of a long spear was formed of three
wooden prongs lashed together by shark skin and
sennit and was an accessory to the armor. A thin
reed edging secured by fine sennit threads passes
through small holes drilled in the shark teeth projec-
tions. The delicacy of this handiwork contrasts with
the intimidating nature of the object.

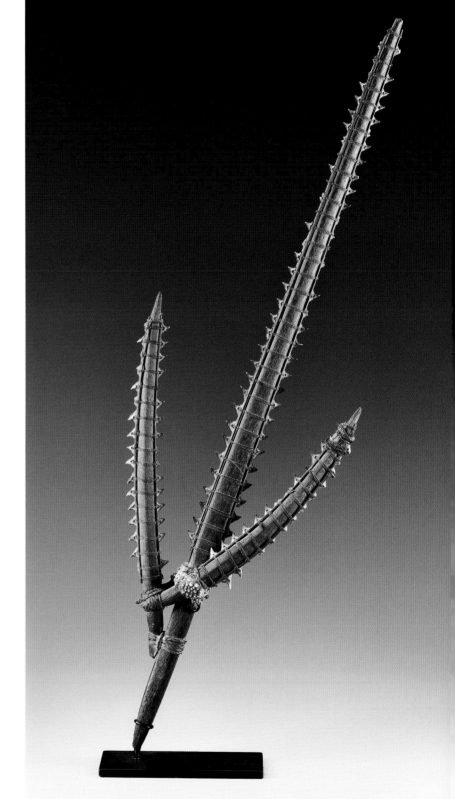

72

## 73 Navigational chart (*rebbelith*)

Marshall Islands, Republic of the Marshall Islands
Early 20th century
Palm leaf midribs, fiber, cowrie shells, modern mounting
Height 27 inches, length 29½ inches
Formerly in the collection of an American family whose
     father purchased it prior to 1945
Acquired from Steven Alpert, Dallas, in 1992
Bibliography: Davenport 1960; Feldman 1986

Throughout their history, the inhabitants of the
Marshall Islands were skilled sailors, able to
traverse vast distances in large outrigger canoes.
This is an example of the sailing charts that the navigators studied and memorized before venturing
forth. One of three different types of charts documented, this map, called *rebbelith*, indicates islands
with cowrie shells and represents the patterns of
waves with bent sticks. The unique design of these
functional objects has attracted the attention of
museums and collectors, who appreciate them for
their formal qualities. The Marshall Islanders abandoned such charts in the 1940s, when U.S. Navy
maps became available.

73

Multiple waves of Austronesian speakers arrived in oceangoing canoes to occupy the distant islands known as Polynesia ("many islands"). Fiji, Tonga, Wallis, and Samoa in western Polynesia were settled about 1200 B.C. Advances in navigational skills and techniques enabled the first people to reach the Society and Marquesas islands in central Polynesia some two thousand years ago. From central Polynesia, large canoes ventured on long-distance voyages to Hawai'i, Easter Island (Rapanui), and New Zealand (Aotearoa) in the first millennium A.D.

Polynesians share certain religious beliefs and a hierarchical social organization revolving around chiefs whose origins are considered divine. Powerful priests act as intermediaries between the gods and men. Artists or specialists, called *taonga*, and warriors also hold a special rank in society. One pervasive concept is *mana*, a generative power or spiritual potency bestowed in varying degrees upon all things and persons by deities. A related notion is *tapu*, restrictions governing actions to safeguard this *mana* of persons and objects. Throughout Polynesia, artists infuse some of their *mana* into their creations through exquisite workmanship. But objects acquire *mana* not only from their makers but also from their association with important individuals as they are passed from one generation to the next and preserved.

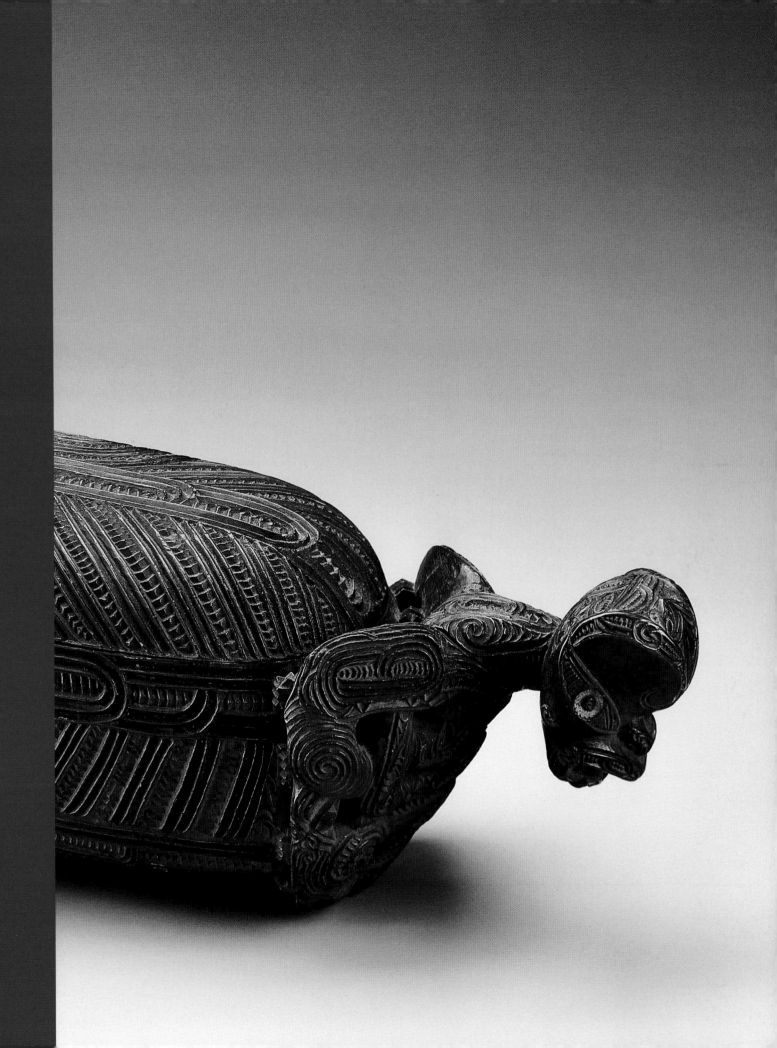

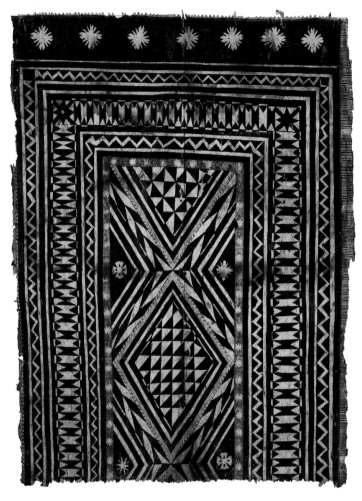

74

## 74 Bark cloth (*masi*)

Fiji Islands, Republic of the Fiji Islands
Late 19th–early 20th century
Bark cloth, pigments
Length 67 inches, width 49 inches
Formerly in a private Californian collection
Acquired from David Rosenthal, San Francisco, in 2004
Bibliography: Kaeppler, Kaufmann, and Newton 1997;
    Koojiman 1972

The inhabitants of the Fiji, Tonga, and Samoa archipelagos have interacted for centuries, and these relationships influenced their art forms. The practice of making *tapa* — a cloth produced from the inner bark stripped from mulberry trees (*Brusonnetia papyrifera*) — occurs throughout Polynesia but is particularly highly developed among the Fijians, who call the cloth *masi*. Women soak, beat, and join the bark into sheets, often of enormous size. Then they paint or stamp it with motifs in natural pigments. Various designs and forms of *tapa* exist. This example, half of a larger cloth, is called *masikesa* and features elaborate black and tan geometric patterns along with more naturalistic floral motifs at the end. Prominent men wear a profusion of *masi* on special occasions. Fijians also exchange the cloth ceremonially as one of their most valuable goods.

## 75 Ceremonial paddle (*hoe*)

Austral Islands, French Polynesia
Late 19th century
Wood
Height 37 inches
Formerly in a private Californian collection
Acquired from Hurst Gallery, Cambridge, in 1991
Bibliography: Wardwell 1994

In the hierarchical societies of central Polynesia, artists as well as their patrons and subsequent owners traditionally imbued objects with the spiritual power called *mana*. The artist's choice of materials and the appropriate fabrication and presentation enhanced a work's potency. In the Austral Islands, artists adorned wooden ladles, paddles, drums, and other ceremonial objects with geometric patterns evoking stylized anthropomorphic figures, chip-carved in low relief with metal tools. On each side of this paddle's fan-shaped blade, minute X-shaped chips surround a central row of circular motifs, said to represent the sun. The long handle with diamond-shaped incisions rises to a flared top bearing eight small schematic figures that are finely articulated. The layers of these figures may allude to successive generations. The original function of the paddles is unknown. According to one early source, they were displayed during chiefs' visits. Since the nineteenth century, Austral artists have carved such paddles for commercial purposes, having noticed that Western visitors admired and collected them.

75

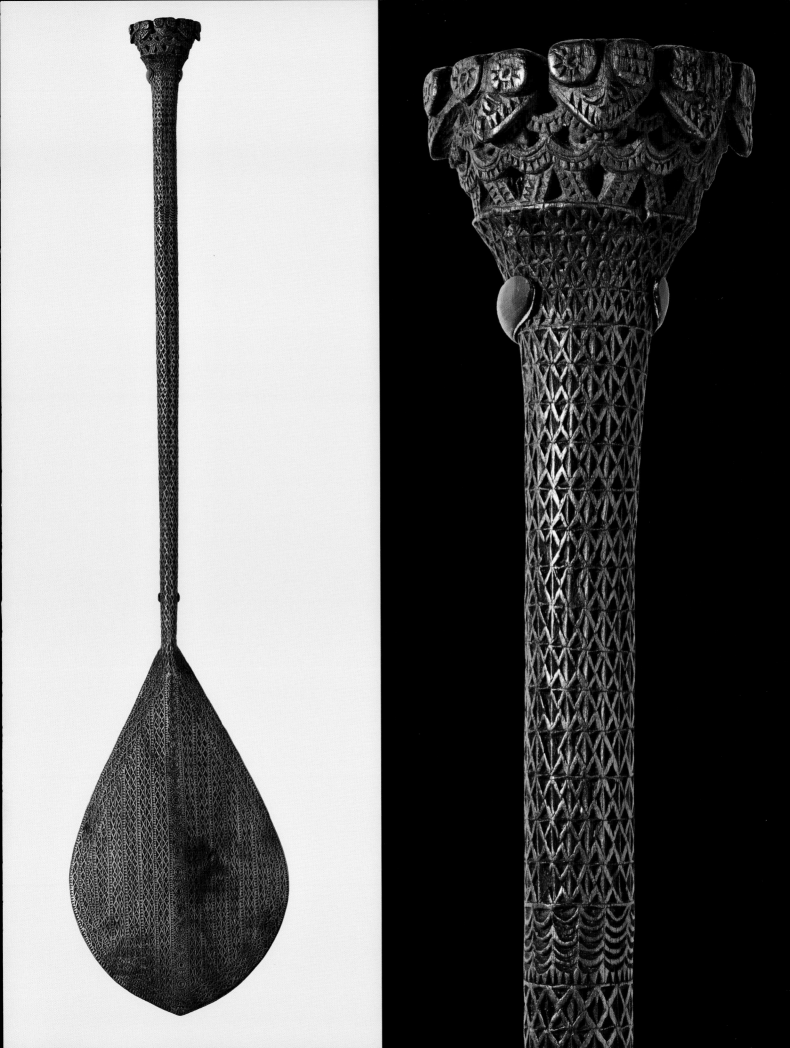

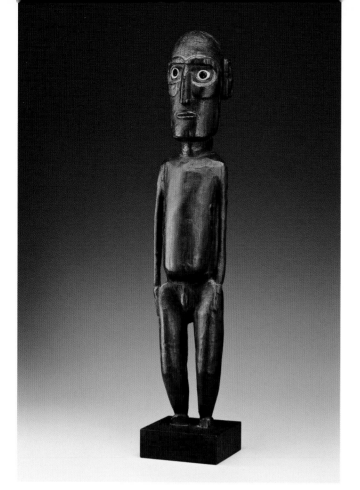

76

anthropomorphic images such as this one may be the representation of ancestors. The upright posture and thick torso support a large head with a long nose and square jaw. The prominent eyes inlaid with white shell and dark obsidian pupils effect a riveting gaze, which is characteristic of other Easter Island images and may be linked to the god *Makemake*.

Soon after the first contact with Westerners in 1722, Easter Island's population declined, and most of the remaining inhabitants suffered deportation and slavery in Peru starting in 1862. This disastrous history deeply impacted the arts. Western collectors prize objects collected before the 1860s for their extraordinary aesthetic qualities and fine carving by highly skilled specialists, but later works are less esteemed. Aided by missionaries and anthropologists, Easter Islanders eventually revived some of the ancient art traditions.

## 76  Male figure (*moai tangata*)

Rapanui (Easter Island), Chile
19th–20th century
Wood, shell, obsidian
Height 23 inches
Gift of William E. and Bertha L. Teel  1994.418
Sold at Drouet, Paris, in 1930. Formerly in the collections
    of Jacques Kerchache, Paris, and Robert Poupion,
    Neuilly, France
Acquired from Hélène Leloup, Paris, in 1991
Bibliography: Force and Force 1971; Kjellgren 2001;
    Orliac and Orliac 1995

Located more than two thousand miles east of Tahiti, Rapanui, or Easter Island, is remote, barren, and isolated. Its unique material culture, including the famous large stone figures known as *moai*, has long been subject to speculations, sometimes even to fiction. Sculptures in wood or bark cloth are less familiar. Wooden emaciated male and flat broad female figures may be a manifestation of the spirits of the dead, or *akuaku*, whereas more naturalistic

## 77  Stilt-step (*tapuva'e*)

Marquesas Islands, French Polynesia
Late 19th–early 20th century
Ironwood
Height 19¼ inches
Gift of William E. and Bertha L. Teel  1992.418
Acquired from Alain Schoffel, Paris, in 1987
Bibliography: Kjellgren 2005; Phelps 1976

Marquesan men performed on stilts both for entertainment and for ritual occasions, such as weddings, funerary ceremonies for chiefs and priests, and coming-of-age celebrations. Most performances were contests between opponents that took place on large public ceremonial platforms. Drums provided music for costumed dancers wearing feather headdresses. Audiences placed wagers on races, mock battles, and other competitions. The contestants on poles up to seven feet high attempted to dislodge each other. Footrests such as this one were lashed to the poles two or three feet from the bottom. The upcurved shape is supported by a stocky caryatid in the form of a *tiki*, the human image central to the Marquesan belief system. It displays the typical massive legs, closed arms, and large head with well-defined features. Shallow grooves covering the entire body recall the tattoos that beautify the Marquesan men's and women's bodies.

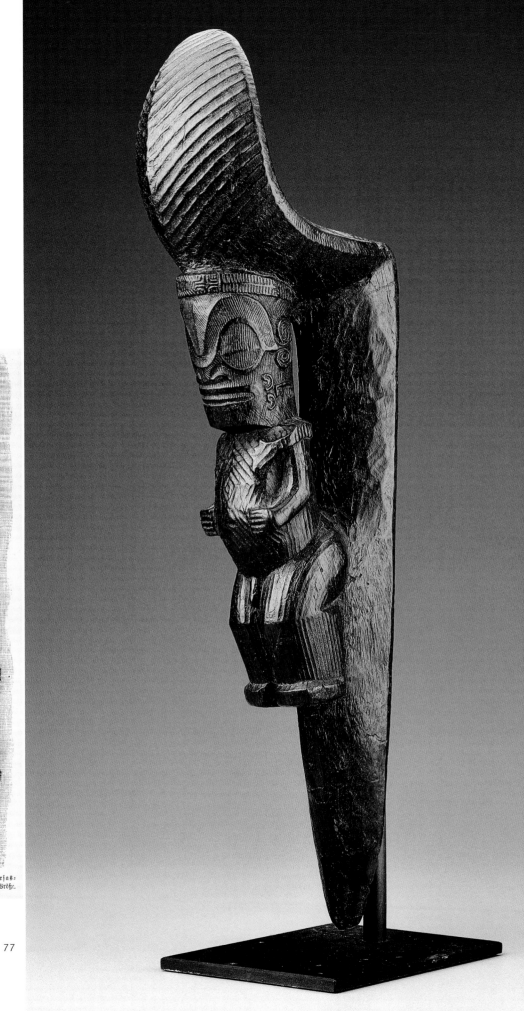

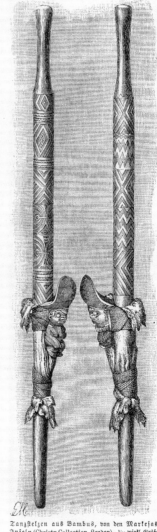

Engraving of stilt-steps, 1890

77

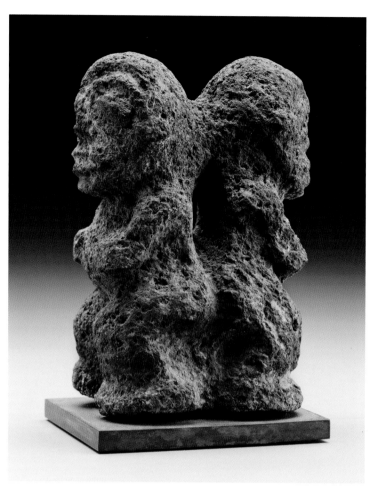

78

carving and tattooing, arts that center on the human body and are widespread throughout the eastern Pacific. They also created *tiki*, powerful figures carved in wood, stone, sperm whale ivory, and bone, which allude to the deity-creator of man. *Tiki* are distinguishable among other Polynesian figures by their thick legs, hands-to-the-abdomen posture, and large heads with raised features. Rings encircle the eyes, the nose is broad and flat, and the wide mouth often shows the tongue. Double figures such as this one made from volcanic tuff with a hole in the middle may have served as fishing charms and net weights, which fishermen dropped into the sea in the hope of plentiful catches.

## 79   Club (*u'u*)

Marquesas Islands, French Polynesia
19th century
Wood
Height 52 ¼ inches
Formerly in the collection of Margaret Webster Plass
Acquired from Sotheby's in 1997
Bibliography: Ivory 1995; Kjellgren 2005; Phelps 1976;
    Wardwell 1994

The most complex rendering of the pervasive *tiki* image occurs on Marquesan clubs, the exclusive property of warriors. On this and other examples, both sides of the flared upper end are shaped as large stylized human faces incorporating smaller faces carved in high and low relief. A face in low relief appears above the arching brows of the larger facial shape, whose ringed eyes have pupils composed of smaller human heads. Another head emerges from the middle of the protruding traverse bar, below which bands of geometric designs enclose oval eyes in low relief. The dark patina results from coconut-oil polishing, and fiber matting originally wrapped the bottom of the shaft.

Warfare with weapons such as clubs, spears, and slings was mainly due to territorial disputes, insults, or humiliation. Marquesan men not only fought with such clubs but displayed them as symbols of prestige and preserved them as valued heirlooms. The clubs are among the best-known works from the Pacific. Since the eighteenth century, Marquesan artists have produced them for export, and many examples are now in private and museum collections.

## 78   Double figure (*tiki*)

Marquesas Islands, French Polynesia
Late 19th–early 20th century
Volcanic tuff
Height 7 inches
Purchased by Pierre Langlois about 1960
Formerly in the collection of Jay Leff
Acquired from Alain Schoffel, Paris, in 1972
Bibliography: Ivory 2002; Kjellgren 2005; Wardwell 1994

In the Marquesas Islands, family lineage and chiefs, who were considered descendants of the ancestral gods that created the islands, historically determined control of land and resources. Huge ceremonial centers provided the stage for feasts and celebrations overseen by *takuna*, ritual specialists responsible for sacred objects and activities. Marquesan artists developed remarkable skills in

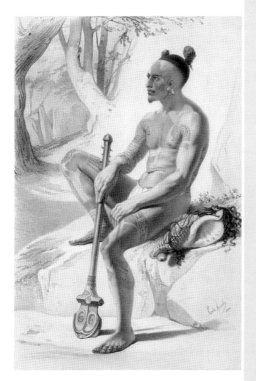

Engraving of a Marquesan man holding a club, 1846

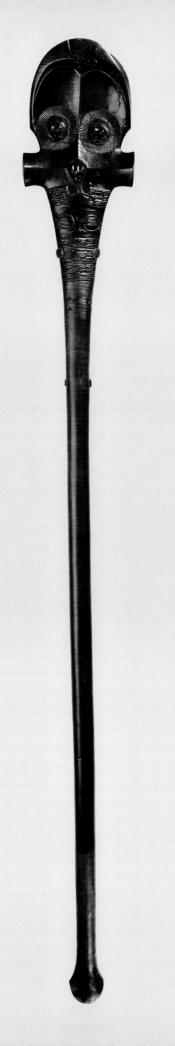

79

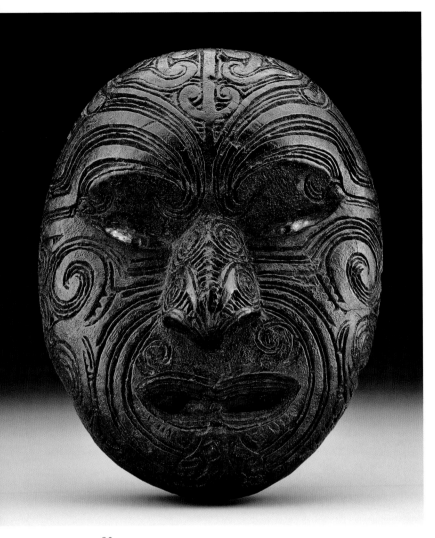

80

abundant resources, chiefs erected grand houses furnished with emblems of ancestral power. Both large architectural elements and small objects carved from wood combine figures with elaborate designs that are curvilinear, unlike the more linear style of central Polynesia.

In the past, the Maori carefully preserved their ancestors' skulls, and works such as this rare example may have been a substitute for a lost or damaged skull. Similar heads also occur as canoe attachments. Its features are relatively realistic: a deeply cut figure-eight mouth, nose with pierced septum, and slanted eyes with white shell inlay. The relief on the blackened surface represents the *moko*, or tattoo patterns, of the individual depicted. Typically, facial tattooing was a mark of prestige and a symbol of identity among the Maori. Specialists effected body tattoos with a needle comb; however this type of facial pattern was incised into the skin of the face with chisels, resembling the technique used in carving wood. While these facial tattoos belong to the past, certain types of tattooing continue to this day.

## 80  Wooden head

Maori people, North Island, Aotearoa (New Zealand)
Late 19th–early 20th century
Wood, shells, pigment
Height 8 inches
Gift of William E. and Bertha L. Teel  1994.424
Formerly in the Manoogian Collection
Acquired from Wayne Heathcote, New York, in 1992
Bibliography: Mead 1984

Maori legends recount that the early settlers of Aotearoa, or New Zealand, arrived from central Polynesia in a great fleet of canoes. Hereditary kingships, in strong competition with each other, emerged on the islands. In a temperate clime with

Postcard of a Maori warrior, New Zealand, twentieth century

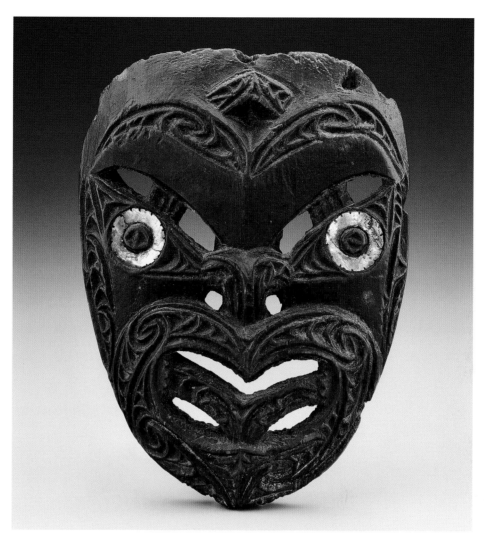

81

## 81 Carved face

Maori peoples, Aotearoa (New Zealand)
Late 19th–early 20th century
Wood, haliotis shell
Height 6 inches
Gift of William E. and Bertha L. Teel   1994.399
Formerly in the James Hooper Collection, London
Acquired from Alain de Monbrison, Paris, in 1981
Bibliography: Mead 1984; Phelps 1976; Wardwell 1994

Even though this enigmatic face is reminiscent of a
mask, the Maori did not wear masks, nor did other
Polynesians. In fact, this carving was originally
attached to a horizontal handle with a smaller head
at the other end. The complete object may have

been a bird perch, net holder, ritual object, canoe
prow, or even a bar for a latrine seat. Pierced open-
ings contrast with curving raised rims that outline
the open figure-eight mouth, widely spaced round
eyes, and prominent forehead peak. The fine surface
carving replicates tattoo patterns. Overall, this face
with openwork and low-relief carving and with eyes
inlaid with haliotis shell resembles the *manaia*
figures often depicted on wood carvings. Such
figures have fierce features enhanced by their men-
acing protruding tongue. Several objects similar to
this one exist in other collections, and many schol-
ars have speculated about their function.

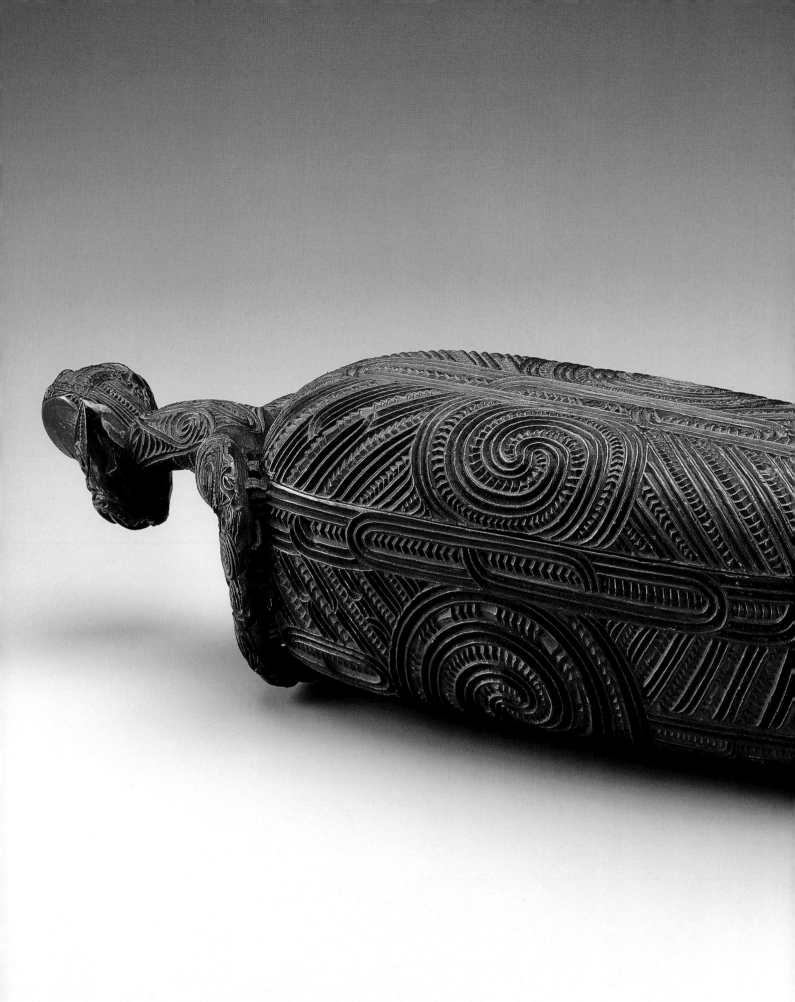

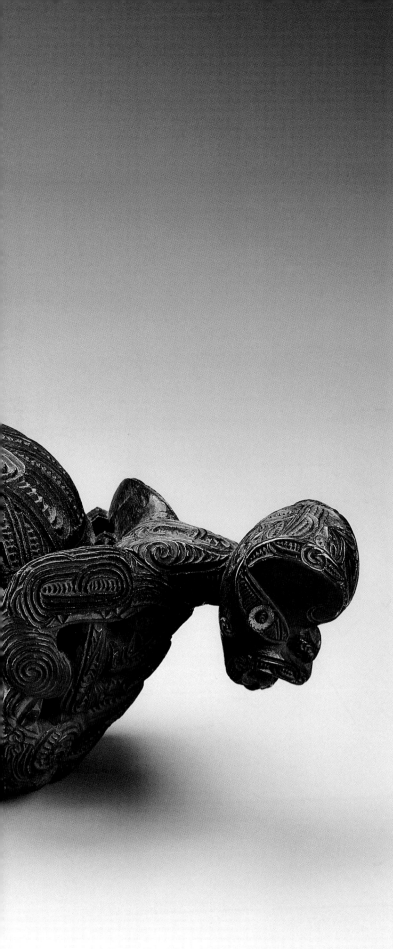

## 82 Treasure box (*wakahuia*)

Maori peoples, east coast of North Island, Aotearoa
(New Zealand)
19th century
Wood (probably Kauri pine, or *Agathis australis*),
haliotis shell, pigment
Length 22½ inches
Gift of William E. and Bertha L. Teel 1994.422
Collected by Major General Horatio Gordon Robley, 1864–66
Formerly in the collections of the Museum für Völkerkunde
Dresden, Germany (no. 13813), and Morris Pinto, Geneva
Acquired from Tambaran Gallery, New York, in 1992
Bibliography: Mead 1984; Neich 2002; Starzecka 1998

Chiefs used containers such as this to store personal
property and valuable family heirlooms, among them
nephrite pendants, ear ornaments, and bone combs.
Often referred to as feather boxes, the receptacles also
held the black-and-white tail feathers of the *huia* bird
(*Heteralocha acutirostris*), which served as hair decora-
tion emblematic of high rank. Since the boxes hung
from the rafters in chiefs' houses, their undersides were
visible and were usually as elaborate as the lids. An
owner could pass the box down as a family heirloom
or give it as an honoured gift to someone special. The
object sometimes also received its own name. As per-
sonal possessions of chiefs, the container and its con-
tents became imbued with *tapu*. Three types of treasure
boxes have been distinguished; this example is a
*wakahuia*, more frequent in central and eastern North
Island. All surfaces of the oblong container and its
detachable lid are embellished with raised reliefs of
double spirals and intertwined patterns called *unau-
nahi*. Projecting from each end is a carved figure with
a schematic body, aggressive features, and shell eyes.
This box was collected about 1864–66 at a time when
Maori relief carving became increasingly elaborate.

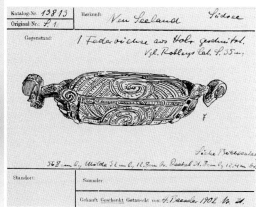

Inventory card for no. 82, from the Museum für
Völkerkunde Dresden, 1902

## 83  Feeding funnel (*koropata*)

Maori peoples, Aotearoa (New Zealand)
19th century
Wood
Height 7 inches
Gift of William E. and Bertha L. Teel  1991.1071
Formerly in the collections of W. O. Oldman, London;
     James Hooper, London; and Charles Ratton, Paris
Acquired from Christine Schoffel, Paris, in 1981
Bibliography: Mead 1984; Phelps 1976; Starzecka 1998

*Mana*, the spiritual power inherent in certain things
and persons, had to be preserved by strict rules and
prohibitions called *tapu* that fostered and main-
tained a personal state of purity or sanctity. Tattoo
specialists needed both skill and knowledge of
*tapu*, for tattooing was a dangerous procedure,
especially if the subject was the face of a chief or
person of high rank. Intricately carved funnels were
used to give semiliquid food to chiefs through the
long hours or days while their faces were being tat-
tooed, thus avoiding contact with the food, which
was thought to diminish or decrease *mana*. This
masterfully carved funnel consists of a tapering
spout that widens into a circular bowl with two
heads protruding from the rim. The entire outer
surface is covered with an interlocking design of
schematic faces and intricate spiral motifs. For
Maori today, treasures such as this one are precious
symbols of their identity.

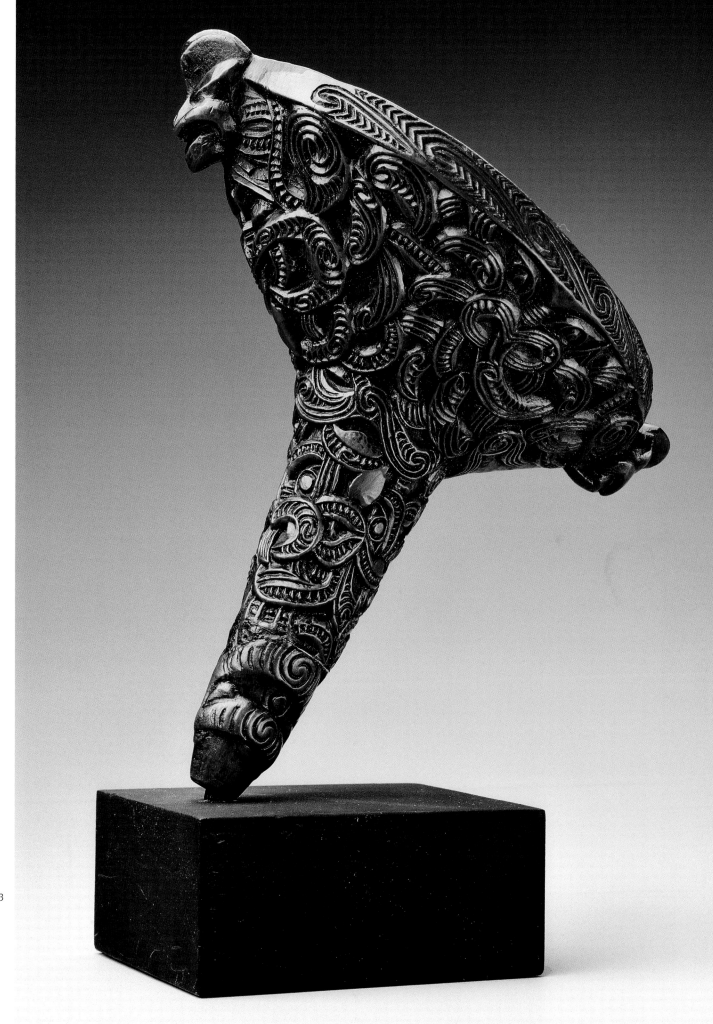

# Bibliography

Baaren, Theodoor Pieter van. 1968. *Korwars and the Korwar Style: Art and Ancestor Worship in North-West New Guinea*. The Hague and Paris: Mouton & Co.

Barbier, Jean-Paul, and Douglas Newton, eds. 1988. *Islands and Ancestors: Indigenous Styles of Southeast Asia*. Munich: Prestel.

Benitez-Johannot, Purissima. 2000. *Shields: Africa, Southeast Asia, and Oceania from the Collections of the Barbier-Mueller Museum*. Munich and New York: Prestel.

Beran, Harry. 2005. The Iconography of the War Shields of the Trobriand Islands of Papua New Guinea: An Interpretation Recorded by Malinowski and Explained by Paramount Chief Pulayasi. Paper presented at the Eighth Pacific Arts Association Symposium, Peabody Essex Museum, Salem, Mass.

Bodrogi, Tibor. 1959. *Oceanian Art*. Budapest: Corvina.

———. 1971. "Zur Ethnographie der Vitu- (French-) Inseln." *Baessler-Archiv*, Neue Folge 19:47–71.

Bonnemaison, Joël, Christian Kaufmann, Kirk Huffman, and Darrell Tryon, eds. 1996. *Arts of Vanuatu*. Honolulu: University of Hawai'i Press.

Boulay, Roger. 1990. *La maison kanak*. Paris: Editions Parenthèses.

Bowden, Ross. 1983. *Yena: Art and Ceremony in a Sepik Society*. Oxford: Pitt Rivers Museum.

Brake, Brian, James McNeish, and David Simmons. 1979. *Art of the Pacific*. Wellington, N.Z.: Oxford University in association with Queen Elizabeth II Arts Council of New Zealand.

Bühler, Alfred. 1969. *Kunst der Südsee: Beschreibender Katalog Museum Rietberg Zürich*. Zürich: Atlantis Verlag.

Bühler, Alfred, Terry Barrow, and Charles P. Mountford. 1962. *The Art of the South Sea Islands, Including Australia and New Zealand*. New York: Crown.

Buschmann, Rainer. 2000. "Exploring Tensions in Material Culture: Commercialising Ethnography in German New Guinea, 1870–1904." *In Hunting the Gatherers: Ethnographic Collectors, Agents and Agency in Melanesia, 1870s–1930s*, ed. Michael O'Hanlon and Robert L. Welsch, 55–79. New York and Oxford: Berghahn Books.

Buxton, Leonard Halford Dudley, ed. 1929. *The Pitt-Rivers Museum, Farnham: General Handbook*. Dorset: Farnham Museum.

Capistrano-Baker, Florina H. 1994. *Art of Island Southeast Asia: The Fred and Rita Richman Collection in the Metropolitan Museum of Art*. New York: Metropolitan Museum of Art.

Corbey, Raymond. 2000. *Tribal Art Traffic: A Chronicle of Taste, Trade and Desire in Colonial and Post-Colonial Times*. Amsterdam: Royal Tropical Institute.

Corbin, George. 1979. "The Art of the Baining." In *Exploring the Visual Art of Oceania: Australia, Melanesia, Micronesia, and Polynesia*, ed. Sidney M. Mead, 159–79. Honolulu: University of Hawai'i Press.

———. 1990. "Salvage Art History among the Sulka." In *Art and Identity in Oceania*, ed. Allan Hanson and Louise Hanson, 67–83. Honolulu: University of Hawai'i Press.

Crawford, Anthony L. 1981. *Aida: Life and Ceremony of the Gogodala*. Bathurst, Australia: National Council of Papua New Guinea in association with Robert Brown and Associates.

Dark, Philip. 1979. "The Art of the Peoples of Western New Britain and Their Neighbors." In *Exploring the Visual Art of Oceania: Australia, Melanesia, Micronesia, and Polynesia*, ed. Sidney M. Mead, 130–58. Honolulu: University of Hawai'i Press.

Davenport, William A. 1960. "Marshall Islands Navigational Charts." *Imago Mundi* 15:19–26.

Deacon, Bernard A. 1934. *Malekula, a Vanishing People in the New Hebrides*. London: G. Routledge & Sons.

Dwyer, Jane Powell, and Edward Bridgman Dwyer. 1973. *Traditional Art of Africa, Oceania, and the Americas*. San Francisco: Fine Arts Museums of San Francisco.

Feldman, Jerome. 1986. *The Art of Micronesia*. Honolulu: University of Hawai'i, Art Gallery.

———. 1994. *Arc of the Ancestors: Indonesian Art from the Jerome L. Jos Collection at UCLA*. Los Angeles: Fowler Museum of Cultural History, University of California, Los Angeles.

Force, Roland W., and Maryanne Force. 1971. *The Fuller Collection of Pacific Artifacts*. New York: Praeger.

Foy, Willy. 1900. *Tanzobjekte vom Bismarck Archipel: Nissan und Buka*. Publicationen aus dem Königlichen Ethnographischen Museum zu Dresden, vol. 1. Dresden: Stengel.

Gardi, René. 1960. *Tambaran. An Encounter with Cultures in Decline in New Guinea*. London: Constable.

Gathercole, Peter, Adrienne L. Kaeppler, and Douglas Newton. 1979. *The Art of the Pacific Islands*. Washington, D.C.: National Gallery of Art.

Geary, Christraud M. 2004. "On Collectors, Exhibitions, and Photographs of African Art: The Teel Collection in Historical Perspective." In *Art of the Senses. African Masterpieces from the Teel Collection*, ed. Suzanne Blier, 25–41. Boston: MFA Publications.

Gosden, Chris, and Chantal Knowles. 2004. *Possessing Culture: Museums, Anthropology and German New Guinea*. Oxford: Berg.

Gosden, Chris, and Yvonne Marshall. 1999. "The Cultural Biography of Objects." *World Archaeology* 31, no. 2:169–78.

Greub, Suzanne, ed. 1985. *Art of the Sepik River, Papua New Guinea: Authority and Ornament*. Basel: Tribal Art Centre, Edition Greub.

———, ed. 1988. *Expressions of Belief: Masterpieces of African, Oceanic, and Indonesian Art from the Museum voor Volkenkunde, Rotterdam*. New York: Rizzoli.

———, ed. 1992. *Art of North West New Guinea from Geelvink Bay, Humboldt Bay, and Lake Sentani*. New York: Rizzoli.

Guiart, Jean. 1953. *L'art autochtone de Nouvelle-Calédonie*. Nouméa: Éditions des études mélanésiennes.

———. 1963. *The Arts of the South Pacific*. New York: Golden.

———. 1966. *Mythologie du masque en Nouvelle-Calédonie*. Paris: Musée de l'homme.

Gunn, Michael. 1997. *Ritual Arts of Oceania in the Collections of the Barbier-Mueller Museum: New Ireland*. Milan: Skira.

Haberland, Eike. 1964. "Zum Problem der 'Hakenfiguren' der südlichen Sepik-Region in Neuguinea." *Paideuma* 10:52–71.

Haberland, Eike, and Siegfried Seyfarth. 1974. *Die Yimar am oberen Korowori (Neuguinea)*. Wiesbaden: Steiner.

Hammerton, J. A., ed. 1922–24. *Peoples of All Nations: Their Life Today and the Story of Their Past*. 7 vols. London: Fleetway House.

Hauser-Schäublin, Brigitta. 1989. *Leben in Linie, Muster und Farbe: Einführung in die Betrachtung aussereuropäischer Kunst am Beispiel der Abelam, Papua-Neuguinea*. Basel and Boston: Birkhäuser.

Heermann, Ingrid, ed. 2001. *Form, Color, Inspiration: Oceanic Art from New Britain*. Stuttgart: Arnoldsche Art Publishers.

Hiery, Hermann Joseph, ed. 2001. *Die deutsche Südsee, 1884–1914*. Paderborn: Schöningh.

Huppertz, Josefine. 1992. *Mobul, the Ancestor of the Kambot People in North-East New Guinea*. Aachen: Alano Verlag, Edition Herodot.

Ivory, Carol. 1995. "Marquesan 'U'u': A Stylistic and Historical Review." *Pacific Arts* 11–12 (July): 53–63.

———. 2002. "Marquesan Art at the Millenium." In *Pacific Art: Persistence, Change, and Meaning*, ed. Anita Herle et al. 394–404. Adelaide: Crawford House.

Jeudy-Ballini, Monique. 1994. "Masques Sulka." *Arts d'Afrique noire* 90:32–38.

Kaeppler, Adrienne L., Christian Kaufmann, and Douglas Newton. 1997. *Oceanic Art*. New York: H. N. Abrams.

Kaufmann, Christian. 1968. "Über Kunst und Kult der

Kwoma und Nukuma (Nord-Neuguinea)." *Verhand-lungen der Naturforschenden Gesellschaft Basel* 79:63–112.

———. 1972. *Das Töpferhandwerk der Kwoma in Nord-Neuguinea: Beiträge zur Systematik primärer Töpfereiverfahren*. Basler Beiträge zur Ethnologie, vol. 12. Basel: Pharos-Verlag H. Schwabe.

———. 1992. "Paul Wirz and the Appreciation of New Guinea Art." In *Art of North West New Guinea from Geelvink Bay, Humboldt Bay, and Lake Sentani*, ed. Suzanne Greub, 140–53. New York: Rizzoli.

———. 2003. *Korewori: Magic Art from the Rain Forest*. Basel and Sidney: Museum der Kulturen Basel and Crawford House Publishing.

Kaufmann, Christian, Christin Kocher Schmid, and Sylvia Ohnemus. 2002. *Admiralty Islands: Art from the South Seas*. Zürich: Museum Rietberg Zürich.

Kelm, Heinz. 1966–68. *Kunst vom Sepik*. 3 vols. Berlin: Staatliche Museen Preussischer Kulturbesitz, Museum für Völkerkunde.

Kirch, Patrick Vinton. 2000. *On the Road of the Winds: An Archaeological History of the Pacific Islands Before European Contact*. Berkeley, Calif.: University of California Press.

Kis-Jovak, Jowa Imre, Hetty Nooy-Palm, Reimar Schefold, and Ursual Schulz-Dornburg, eds. 1988. *Banua Toraja: Changing Patterns in Architecture and Symbolism among the Sa'dan Toraja, Sulawesi, Indonesia*. Amsterdam: Royal Tropical Institute.

Kjellgren, Eric. 2001. *Splendid Isolation: Art of Easter Island*. New York: Metropolitan Museum of Art; New Haven: Yale University Press.

———. 2005. *Adorning the World: Art of the Marquesas Islands*. New York: Metropolitan Museum of Art; New Haven: Yale University Press.

Koch, Gerd. 1982. *Iniet: Geister in Stein; Die Berliner Iniet-Figuren Sammlung*. Berlin: Staatliche Museen Preussischer Kulturbesitz, Museum für Völkerkunde.

———. 1986. *The Material Culture of Kiribati*. Suva, Fiji: Institute of Pacific Studies of the University of the South Pacific.

Konrad, Gunter, and Ursula Konrad, eds. 1996. *Asmat: Myth and Ritual; The Inspiration of Art*. Venice: Erizzo.

Kooijman, Simon. 1959. *The Art of Lake Sentani*. New York: Museum of Primitive Art.

———. 1972. *Tapa in Polynesia*. Honolulu: Bishop Museum Press.

Kooijman, Simon, and Jac. Hoogerbrugge. 1992. "Art of Wakde-Yamna Area, Humboldt Bay, and Lake Sentani." In *Art of North West New Guinea from Geelvink Bay, Humboldt Bay, and Lake Sentani*, ed. Suzanne Greub, 56–125. New York: Rizzoli.

Köpke, Wulf, and Bernd Schmelz, eds. 2003. *Hamburg: Südsee; Expedition ins Paradies*. Mitteilungen aus dem Museum für Völkerkunde Hamburg. Neue Folge 33. Hamburg: Museum für Völkerkunde Hamburg.

Kopytoff, Igor. 1986. "The Cultural Biography of Things: Commoditization as Process." In *The Social Life of Things: Commodities in Cultural Perspective*, ed. Arjun Appadurai, 64–91. Cambridge: Cambridge University Press.

Langmore, Diane. 1989. *Missionary Lives: Papua, 1874–1914*. Honolulu: University of Hawai'i Press.

Legge, Christopher. 1974. "Arms and Armour of the Gilbert Islands." *Field Museum of Natural History Bulletin* 45, no. 10:12–13.

Lincoln, Louise. 1987. *Assemblage of Spirits: Idea and Image in New Ireland*. New York: G. Braziller, in association with the Minneapolis Institute of Arts.

Linton, Ralph, and P. S. Wingert. 1946. *Arts of the South Seas*. New York: Museum of Modern Art.

Mamiya, Christin J., and Eugenia C. Sumnik. 1982. *Hevehe: Art, Economics and Status in the Papuan Gulf*. Monograph Series 18. Los Angeles: Museum of Cultural History, University of California, Los Angeles.

May, Patricia. 1990. "Art Styles among the Boiken." In *Sepik Heritage: Tradition and Change in Papua New Guinea*, ed. Nancy Lutkehaus, 501–11. Durham, N.C.: Carolina Academic Press.

McDowell, Nancy. 1991. *The Mundugumor: From the Field Notes of Margaret Mead and Reo Fortune*. Washington, D.C.: Smithsonian Institution Press.

McKeeson, John A. 1990. "In Search of the Origins of the New Caledonia Mask." In *Art and Identity in Oceania*, ed. Allan Hanson and Louise Hanson, 84–92. Honolulu: University of Hawai'i Press.

Mead, Sidney Moko, ed. 1984. *Te Maori: Maori Art from New Zealand Collections*. New York: H. N. Abrams in association with the American Federation of Arts.

Meier, Pater Josef. 1911. "Steinbilder des Iniet-Geheimbundes

bei den Eingeborenen des nordöstlichen Teiles der Gazelle-Halbinsel, Neupommern (Südsee)." *Anthropos* 6:837–67.

Meyer, Adolf Bernhard. 1889. *Masken von Neu Guinea und dem Bismarck Archipel*. Publicationen aus dem Königlichen Ethnographischen Museum zu Dresden, vol. 7. Dresden: Stengel.

Meyer, Adolf Bernhard, and Richard Parkinson. 1895. *Schnitzereien und Masken vom Bismarck Archipel und Neu Guinea*. Publicationen aus dem Königlichen Ethnographischen Museum zu Dresden, vol. 10. Dresden: Stengel.

Meyer, Anthony J. P. 1995. *Oceanic Art*. Köln: Könemann.

Moore, David R. 1968. *Melanesian Art in the Australian Museum*. Sydney: Trustees of the Australian Museum.

Musées de Marseille. 2000. *Art papou: Austronésiens et Papous de Nouvelle-Guinée*. Paris: Réunion des musées nationaux; Marseille: Musées de Marseille.

Museo di Antropologia e Etnologia di Firenze. 1992. *Oceania nera: Arte, cultura e popoli della Melanesia nelle collezioni del Museo di antropologia e etnologia di Firenze*. Florence: Cantini.

Neich, Roger. 2002. "Papahou and Wakahuia: Maori Treasure Boxes." *Arts and Cultures: Antiquity, Africa, Oceania, Asia, Americas* (Association of Friends of the Barbier-Mueller Museum, Geneva) 3:244–65.

Newton, Douglas. 1961. *Art Styles of the Papuan Gulf*. New York: Museum of Primitive Art.

———. 1971. *Crocodile and Cassowary: Religious Art of the Upper Sepik River, New Guinea*. New York: Museum of Primitive Art.

———. 1975. *Massim: Art of the Massim Area, New Guinea*. New York: Museum of Primitive Art.

———, ed. 1999. *Arts of the South Seas: Island Southeast Asia, Melanesia, Polynesia, Micronesia*. Munich, London, and New York: Prestel.

Newton, Douglas, and Hermione Waterfield. 1995. *Tribal Sculpture: Masterpieces from the Barbier-Mueller Museum*. New York: Vendome Press.

O'Hanlon, Michael, and Robert L. Welsch. 2000. *Hunting the Gatherers. Ethnographic Collectors, Agents and Agency in Melanesia*, 1870s–1930s. New York and Oxford: Berghahn Books.

Ohnemus, Sylvia. 1998. *An Ethnology of the Admiralty Islanders. The Alfred Bühler Collection, Museum der Kulturen, Basel*. Honolulu: University of Hawai'i Press.

Orliac, Michel, and Catherine Orliac. 1995. *Easter Island: Mystery of the Stone Giants*. New York: H. N. Abrams.

Parkinson, Richard. 1907. *Dreissig Jahre in der Südsee: Land und Leute, Sitten und Gebräuche im Bismarckarchipel und auf den deutschen Salomoninseln*. Stuttgart: Strecker und Schröder.

Pelrine, Diane. 1996. *Affinities of Form: Arts of Africa, Oceania, and the Americas from the Raymond and Laura Wielgus Collection*. Munich and New York: Prestel.

Peltier, Philippe. 1984. "From Oceania." In *"Primitivism" in 20th Century Art: Affinity of the Tribal and the Modern*, ed. William Rubin, 99–123. New York: Museum of Modern Art; Boston: Distributed by New York Graphic Society Books.

———. 1992. "Jacques Viot, the Maro of Tobati, and Modern Painting: Paris—New Guinea 1925–1935." In *Art of North West New Guinea from Geelvink Bay, Humboldt Bay, and Lake Sentani*, ed. Suzanne Greub, 154–75. New York: Rizzoli.

Phelps, Stephen. 1976. *Art and Artifacts of the Pacific, Africa, and the Americas: The James Hooper Collection, London*. London: Hutchinson.

Pitt-Rivers, General Fox. 1882–99. Catalogues of the Collection. 9 vols. Cambridge University Library. MS Add. 9455.

Powell, Wilfred. 1883. *Wanderings in a Wild Country, or Three Years Amongst the Cannibals of New Britain*. London: Sampson Low, Martson, Searle, and Rivington.

Ratzel, Friedrich. 1890. *Völkerkunde: Die Naturvölker Ozeaniens, Amerikas und Asiens*. Leipzig and Vienna: Bibliographisches Institut.

Sande, Gijsbert Adrian Johan van der. 1907. *Ethnography and Anthropology*. Nova Guinea 3. Leiden: E. J. Brill.

Sarasin, Fritz. 1929. *Ethnologie der Neu-Caledonier und Loyalty-Insulaner*. Munich: C. W. Kreidel.

Schefold, Reimar. 1966. *Versuch einer Stilanalyse der Aufhängehaken vom mittleren Sepik in Neu-Guinea*. Basel: Pharos-Verlag.

Scheps, Birgit. 2005. *"Das verkaufte Museum": Die Südsee-Unternehmungen des Handelshauses J. C. Godeffroy & Sohn, Hamburg und die Sammlungen "Museum Godeffroy."* Hamburg: Abhandlungen des Naturwissen-

schaftlichen Vereins in Hamburg. Neue Folge 40.

Schlaginhaufen, Otto, 1910. *Eine ethnographische Sammlung vom Kaiserin-Augustafluss in Neuguinea.* Leipzig: Teubner.

Schmitz, Carl August. 1971. *Oceanic Art: Myth, Man, and Image in the South Seas.* New York: H. N. Abrams.

Schneebaum, Tobias. 1990. *Embodied Spirits: Ritual Carvings of the Asmat.* Salem, Mass.: Peabody Museum of Salem.

Sibeth, Achim. 1991. *Living with Ancestors: The Batak; Peoples of the Island of Sumatra.* London: Thames and Hudson.

Smidt, Dirk. 1975. *The Seized Collections of the Papua New Guinea Museum.* Papua, New Guinea: Creative Arts Centre.

———. 1990. "Kominimung Sacred Woodcarvings (Papua New Guinea): Symbolic Meaning and Social Context." In *The Language of Things: Studies in Ethnocommunication in Honour of Professor Adrian A. Gerbrands,* ed. Pieter ter Keurs and Dirk Smidt, 77–112. Leiden: Rijksmuseum voor Volkenkunde.

———, ed. 1993. *Asmat Art: Woodcarvings of Southwest New Guinea.* Amsterdam and Leiden: Periplus Editions and the Rijksmuseum voor Volkenkunde, Leiden.

Smidt, Dirk, and Soroi Marepo Eoe. 1999. "A Festival to Honour the Dead and Revitalize Society: Masks and Prestige in a Gamei Community (Lower Ramu, Papua New Guinea)." In *Art and Performance in Oceania,* ed. Barry Craig, Bernie Kernot, and Christopher Anderson, 107–39. Honolulu: University of Hawai'i Press.

Sotheby's. 2004. *Art africain et océanien: Divers amateurs.* Auction catalogue, Paris, June 15. Lot 83, pp. 83–85.

Specht, Jim. 1999. "'The German Professor': Richard Parkinson." In *Thirty Years in the South Seas: Land and People, Customs and Traditions in the Bismarck Archipelago and on the German Solomon Islands,* ed. J. Peter White, xv–xxvii. Honolulu: University of Hawai'i Press.

Speiser, Felix. 1990. *Ethnology of Vanuatu: An Early Twentieth Century Study.* Translated by D. Q. Stephenson. Bathurst: Crawford House.

Starzecka, Dorota Czarkowska, ed. 1998. *Maori: Art and Culture.* 2nd ed. London: Published for the Trustees of the British Museum by British Museum Press.

Stevenson, Robert Louis, 1892. *A Footnote to History: Eight Years of Trouble in Samoa.* London: Cassell & Company.

Stöhr, Waldemar. 1972. *Melanesien, schwarze Inseln der Südsee.* Köln: Rautenstrauch-Joest-Museums für Völkerkunde der Stadt Köln.

———. 1987. *Kunst und Kultur aus der Südsee: Sammlung Clausmeyer Melanesien.* Köln: Rautenstrauch-Joest-Museum für Völkerkunde.

Thompson, Michael, and Colin Renfrew. 1999. "The Catalogues of the Pitt-Rivers Museum, Farnham, Dorset." *Antiquity* 73, no. 280:377–93.

Viot, Jacques. 1932. *Déposition de blanc.* Paris: Stock, Delamain, et Boutelleau.

Waite, Deborah. 1983. *The Art of the Solomon Islands from the Collection of the Barbier-Müller Museum.* Geneva: Musée Barbier-Mueller.

Wardwell, Allen. 1971. *The Art of the Sepik River.* Chicago: Art Institute of Chicago.

———. 1994. *Island Ancestors: Oceanic Art from the Masco Collection.* Seattle: University of Washington Press in association with the Detroit Institute of Arts.

Waterfield, Hermione. 2002. "Lt. General Augustus Henry Lane Fox Pitt-Rivers (14 April 1827–4 May 1900)." *Arts & Cultures: Antiquity, Africa, Oceania, Asia, Americas.* (Association of Friends of the Barbier-Mueller Museum, Geneva) 3:58–71.

Williams, Francis Edgar. 1940. *Drama of Orokolo: The Social and Ceremonial Life of the Elema.* Oxford: Clarendon.

Wingert, Paul, ed. 1970. *Oceanic Art.* Winchester, Mass.: University Prints.

Wirz, Paul. 1923. "Dies und jenes über die Sentanier und die Geheimkulte im Norden von Neu-Guinea." *Tijdschrift voor Indische Taal-, Land- en Volkenkunde* 63:1–80.

———. 1928. "Beitrag zur Ethnogie der Sentanier (Holländisch-Neuguinea)." *Nova Guinea* 16, 3:251–370, pls. 1–25.

———. 1929. *Bei liebenswürdigen Wilden in Neuguinea.* Stuttgart: Strecker und Schröder.

———. 1934. *Beiträge zur Ethnographie des Papua-Golfes, Britisch-Neuguinea.* Abhandlungen und Berichte der Museen für Tierkunde und Völkerkunde zu Dresden, vol. 19, no. 2. Dresden: Museen für Tierkunde und Völkerkunde zu Dresden.

Worsley, Peter. 1957. *The Trumpet Shall Sound: A Study of "Cargo" Cults in Melanesia.* London: MacGibbon & Kee.

# Acknowledgments

It was a privilege and a joy to research and write about the Oceanic objects in the Teel Collection. Stéphanie Xatart and I deeply appreciate the generosity and advice of William E. Teel, who never tired of sharing with us his enthusiasm for the arts of Oceania. His connoisseurship and detailed knowledge about the style and context of the objects form the basis of this book.

As the catalogue took shape, we relied on the kindness and support of many colleagues, friends, and fellow staff members at the Museum. Michael Gunn (St. Louis Art Museum) studied the collection and contributed one of the essays in this catalogue. Christian Kaufmann (recently retired from the Museum der Kulturen, Basel, Switzerland) carefully examined many works when he visited Boston, and his extensive remarks helped refine the captions. His comments on my essay proved equally valuable. During my recent visit to the ethnographic museums in Leipzig and Dresden, now under joint administration, Marion Melk-Koch literally took me by the hand and walked me through the literature and the collection, a most helpful experience since I am not a specialist in Oceanic art. She also reviewed my essay, and I am grateful for her input. Also at Leipzig and Dresden, Birgit Scheps allowed me to consult the manuscript of her forthcoming book about the Godeffroy Company, and Christine Seige and other colleagues facilitated my research. Virginia-Lee Webb (Metropolitan Museum of Art) provided advice and images, in a continuation of our collaboration that began many years ago. I thank all of them for their support.

In a strike of good luck, we were able to consult many Oceanic art specialists who attended the Eighth International Symposium of the Pacific Arts Association in Salem, Massachusetts, in July 2005. Harry Beran (Sydney) enlightened us about the Massim region and attributed some of the more enigmatic works in the collection to Massim artists. Philippe Peltier (Musée du Quai Branly, Paris), Hermione Waterfield (London), and Emmanuel Kasarhérou (Centre Culturel Tjibaou, New Caledonia) also gave us advice.

The publication of the book was facilitated by many MFA staff members and outside consultants. To name just a few, David Mathews creatively photographed the objects, Sarah Tremblay edited the texts, and Terry McAweeney managed the production. Susan Marsh, who designed the catalogue of the African portion of the Teel Collection several years ago, brought her expertise to this publication as well. Our thanks and appreciation go to all of them and their colleagues.

Finally, Stéphanie and I are indebted to Pascal and John for their support and patience.

CHRISTRAUD M. GEARY

# Figure Illustrations

Fig. 1.  Houses on stilts in a lagoon, Teluk Cenderawasih (formerly Geelvink Bay), Papua Province (formerly Irian Jaya), Indonesia, about 1880. Courtesy of the Photo Archive, Rautenstrauch-Joest-Museum, Cologne, Germany.

Fig. 2.  Inside a men's house in Kambot village, Middle Sepik region, Papua New Guinea, May 24, 1929. Photograph by Kurt Patterson Schmidt. Courtesy of The Metropolitan Museum of Art, New York, The Michael C. Rockefeller Memorial Collection, gift of Sidney N. Shurcliff, 1973 (1978.412.1725). © 2004 The Metropolitan Museum of Art.

Fig. 3.  Exterior of a men's house in Kambot village, Middle Sepik region, Papua New Guinea, 1955. Photograph by Dadi Wirz. Courtesy of The Metropolitan Museum of Art, New York, The Photograph Study Collection, Department of the Arts of Africa, Oceania, and the Americas (NA.2000.17.486). © Dadi Wirz.

Fig. 4.  Gardens in New Guinea mountains, Dani region, Papua Province (formerly Irian Jaya), Indonesia, 1989. Photograph by Michael Gunn. Courtesy of Michael Gunn and the Northern Territory Museum, Darwin, Australia.

Fig. 5.  Installing *malagan* ritual objects in a display house, Pekinberiu village, Tabar, New Ireland, 1984. Photograph by Michael Gunn. Courtesy of Michael Gunn and the Northern Territory Museum, Darwin, Australia.

Fig. 6.  Helmet mask from the Witu Islands, Papua New Guinea, second half of the nineteenth century. Wood, fiber, pigment. Height 21½ inches. Formerly in the collection of the Museum für Völkerkunde Dresden, now in the William E. and Bertha L. Teel Collection. Courtesy of William E. Teel.

Fig. 7.  Masks and headdresses, including no. 52 and the mask in fig. 6, from the Witu Islands, Papua New Guinea. Reproduced from Meyer and Parkinson 1895, plate VIII. Courtesy of Tozzer Library of Harvard College Library, Cambridge, Mass.

Fig. 8.  *Kakaparaga* helmet mask (no. 51) from the Witu Islands, Papua New Guinea. Reproduced from Foy 1900, plate I. Courtesy of Tozzer Library of Harvard College Library, Cambridge, Mass.

Fig. 9.  Drawing of *kovave* mask (no. 43) by A. Peacock. Reproduced from Pitt-Rivers 1882–99, 3:1039. Courtesy of University Library, University of Cambridge, England (MS Add.9455/3).

Page 40.  Singa image on side beam of a headman's house, Samosir Island in Lake Toba, northern Sumatra, Indonesia, 1980. Photograph by Jean-Paul Barbier. © abm-archives Barbier-Mueller, Geneva, Switzerland.

Page 42.  Dayak man with a shield, Borneo, Indonesia, late nineteenth century. Photograph by Charles Hose. Reproduced from Hammerton 1922–24, 2:817. Courtesy of Tozzer Library of Harvard College Library, Cambridge, Mass.

Page 44.  Kenyah shamans wearing *hudoq* masks, Sarawak, Indonesia, about 1900. Photograph by Jean Demmeni for A. W. Nieuwenhuis's Borneo Expedition, 1896–1900. Courtesy of the Collection Wereldmuseum Rotterdam, The Netherlands (Inv. No. 902976).

Page 45.  Man next to an offering post, Timor Island, 1953. Photograph by B. A. G. Vroklage. Courtesy of the Rijksmuseum voor Volkenkunde Leiden, The Netherlands (#10826-B1-31).

Page 46.  Family house (*Tongkonan nonongan*), Toraja peoples, Sulawesi, Indonesia, 1983. Photograph by C. H. M. Nooy-Palm. Courtesy of the KIT Tropenmuseum, Amsterdam, The Netherlands (AOT 33).

Page 51.  Roof adorned with panels, Lake Sentani, Papua Province, Indonesia, 1924. Photograph by Paul Wirz. Courtesy of the Rijksmuseum voor Volkenkunde Leiden, The Netherlands (#10757-179).

Page 52.  Young man holding a carved figure, Lake Sentani, Papua Province (formerly Irian Jaya), Indonesia, 1921 or 1926. Photograph by Paul Wirz. Courtesy of The Metropolitan Museum of Art, New York, The Photograph Study Collection, Department of the Arts of Africa, Oceania, and the Americas (PSC 2000.2.27). © Dadi Wirz.

Page 54.  Woman's grave in Saboiboi village with a *maro* on display, Lake Sentani, Papua Province (formerly Irian Jaya), Indonesia, about 1926. Photograph by Paul Wirz. Courtesy of The Metropolitan Museum of Art, New York, The Photograph Study Collection, Department of the Arts of Africa, Oceania, and the Americas (PSC 2000.2.146). © Dadi Wirz.

Page 56.  Interior of the Asmat men's house of Amman, Amanamkai village, Papua Province (formerly Irian Jaya), Indonesia, June 28, 1961. Photograph by Michael Rockefeller. With the permission of the Rockefeller Family Office. Courtesy of The Metropolitan Museum of Art, New York (NG-5 Amanamkai B-44).

Page 60.  Religious procession with feather masks leaving the sacred enclosure at Awar, New Guinea, about 1910. Photograph by A. B. Lewis. © The Field Museum, Chicago (#CSA33515).

Page 63.  Interior of a Kambot men's house, Papua New Guinea, 1930. Photograph by Franz Kirschbaum. Courtesy of the Photo Archive, Rautenstrauch-Joest Museum, Cologne, Germany.

Page 67.  *Yipwon* hook figure display, Papua New Guinea, 1973. Photograph by Annemarie and Christian Kaufmann-Heinimann. Courtesy of Christian Kaufmann and the Museum der Kulturen Basel, Switzerland.

Page 69.  Iatmul men assembled around an orator's stool, Papua New Guinea, 1953. Photograph by Des Bartlett. Courtesy of The University of Queensland Anthropology Museum, Brisbane, Australia (31946).

Page 70 (center).  Sawos men's house, Torembi village, Papua New Guinea, 1959. Photograph by Alfred Bühler. Courtesy of the Museum der Kulturen Basel, Switzerland (Inv. No. [F]Vb 100764).

Page 70 (bottom).  Gable of a men's ceremonial house, Torembi, Papua New Guinea, July 23, 1964. Photograph by Douglas Newton. Courtesy of The Douglas Newton Archive. © Virginia-Lee Webb. All rights reserved.

Page 71.  Suspension hooks in a house, Sepik region, Papua New Guinea, 1956. Photograph by René Gardi. Courtesy of the Museum der Kulturen Basel, Switzerland (Inv. No. [F]Vb 13044.1).

Page 75.  Interior of an Abelam men's ceremonial house, Papua New Guinea. Photograph by Adrian A. Gerbrands. Courtesy of Adrian A. Gerbrands.

Page 76.  Ceremonial dancers in Lonem, an Abelam/Arapesh border village, Papua New Guinea, 1980. Photograph by Jörg Hauser. Courtesy of Brigitta Hauser-Schäublin.

Page 78.  Kwoma *yina* figures on display in a Wayipanal men's house, Bangwis village, Papua New Guinea, 1973. Photograph by Ross Bowden. Courtesy of Ross Bowden.

Page 82.  Kwoma paintings in a Wayipanal men's house, Bangwis village, Papua New Guinea, 1973. Photograph by Ross Bowden. Courtesy of Ross Bowden.

Page 86.  Gogodala man painting a canoe prow with a pandanus nut brush, Papua New Guinea, June–August 1930. Photograph by Paul Wirz. Courtesy of The Metropolitan Museum of Art, New York (1992.417.137). All rights reserved, The Metropolitan Museum of Art.

Page 89.  Anthropomorphic Turamarubi figure, Papua New Guinea, August or October 1930. Photograph by Paul Wirz. Courtesy of The Metropolitan Museum of Art, New York, funds from various donors, 1992 (1992.417.175). © 2003 The Metropolitan Museum of Art.

Page 91.  Skull rack with *gope* boards and crocodile skulls inside a ceremonial house (*daima*), Kinomere village, Urama Island, Gulf Province, Papua New Guinea, about January 1923. Photograph by Frank Hurley. Courtesy of the Australian Museum, Sydney (AMS320/V4785).

Page 94.  Masker wearing a *kovave* on a beach, Biai (Orokolo), Papua New Guinea, 1937. Photograph by Francis Edgar Williams. From the collection of the National Archives of Australia, Canberra (A6004, 242H).

Page 101.  Men performing with a dance shield, Trobriand Islands, Papua New Guinea, 1915–18. Photograph by Bronislaw Kaspar Malinowski. Courtesy of Helena Wayne and the London School of Economics and Political Science, England.

Page 113.  Sulka *susiu* mask and costume in a performance, Wide Bay, New Britain, Papua New Guinea, 1980. Photograph by Monique Jeudy-Ballini. Courtesy of Monique Jeudy-Ballini.

Page 114.  Maskers wearing Baining *kavat* and *vungvung* night-dance masks, December 29, 1906. Photograph by Thiel. © Museum für Völkerkunde Hamburg, Germany.

Page 116.  Engraving of a Tolai shrine with chalk figures, New Ireland, Papua New Guinea, about 1883. Reproduced from Powell 1883, frontispiece. Courtesy of Tozzer Library of Harvard College Library, Cambridge, Mass.

Page 119.  Twelve men wearing *malagan* masks, New Ireland, Papua New Guinea, about 1900. Photograph by Richard Parkinson. Courtesy of the Linden-Museum Stuttgart, Germany (Glass plate no. 875).

Page 120.  *Malagan* display at Medina, New Ireland, Papua New Guinea, 1930. Photograph by Felix Speiser. Courtesy of the Museum der Kulturen Basel, Switzerland (Inv. No. [F]Vb 608).

Page 121.  Men with headdresses, Buka Island, Northern Solomon Islands, Papua New Guinea, late nineteenth century. Reproduced from Hammerton 1922–24, 2:928. Courtesy of Tozzer Library of Harvard College Library, Cambridge, Mass.

Page 122.  Lithograph of Melanesian and Micronesian weapons and tools. Reproduced from Ratzel 1890, 2:pl. opp. 249. Courtesy of Christraud M. Geary.

Page 123.  Canoe with a *musumusu* on its prow, Solomon Islands, late nineteenth century. Reproduced from Hammerton 1922–24, 2:930. Courtesy of Tozzer Library of Harvard College Library, Cambridge, Mass.

Page 125.  Ceremonial house with a display of grade figures, Gaua, Banks Islands, Vanuatu, 1912. Photograph by Felix Speiser. Courtesy of the Museum der Kulturen Basel, Switzerland (Inv. No. [F]Vb 1908).

Page 128.  Chief's house with a roof finial and door planks, Tchambouenne, Oubatche, New Caledonia, Territory of New Caledonia and Dependencies, 1910–12. Photograph by Fritz Sarasin. Courtesy of the Museum der Kulturen Basel, Switzerland (Inv. No. [F]Vb 4550).

Page 143.  Engraving of stilt-steps, Marquesas Islands, French Polynesia. Reproduced from Ratzel 1890, 2:134. Courtesy of Christraud M. Geary.

Page 145.  *Naturel de Nouka-Hiva* (Native of Nuka-Hiva), Marquesas Islands, French Polynesia. Engraving by Emile Lassalle, 1846. Courtesy of the Library, American Museum of Natural History, New York.

Page 146.  Postcard of a Maori warrior, New Zealand, twentieth century. Photograph by Tanner Bros. Courtesy of The Metropolitan Museum of Art, New York, The Photograph Study Collection, Department of the Arts of Africa, Oceania, and the Americas (PSC 2004.5.1). © 2006 The Metropolitan Museum of Art.

Page 149.  *1 Federbüchse aus Holz geschnitzt* (1 feather box carved from wood), 1902. Reproduction of inventory card no. 13813. Courtesy of the Museum für Völkerkunde Dresden, Germany.

MANUSCRIPT EDITED BY SARAH McGAUGHEY TREMBLAY | COPYEDITED BY DENISE BERGMAN

DESIGNED BY SUSAN MARSH | PRODUCED BY THERESA McAWEENEY | PHOTOGRAPHY BY DAVID MATHEWS

TYPESET IN META BY FRAN PRESTI-FAZIO | PRINTED BY GRAPHICOM, VERONA, ITALY